# *Chinese Jades :*

*from The Minneapolis Institute of Arts*

# Archaic and Modern

Foreword by Samuel Sachs II

Introduction by Dr Na Chih-liang

Lund Humphries
London

Copyright ©1977
The Minneapolis Institute of Arts, Minneapolis, Minnesota

First edition 1977
Published by
Lund Humphries Publishers Ltd
26 Litchfield Street London WC2

SBN 85331 401 2

Designed by Herbert Spencer

Made and printed in Great Britain by
Lund Humphries, Bradford and London

**Harold Peterson,** editor
**Nancy Akre,** associate editor
**Vera Shu-Ning Sun-Bailey,** translator and researcher
**Gary Mortensen,** photographer

# CONTENTS

# ACKNOWLEDGMENTS

As early as 1916 and shortly after the first purchase of jades, it was felt that further investigation of these pieces was needed. Curiosity and interest in the collection grew as the collection itself grew; it was not, however, until 1970 when Roger Mandle, then the Assistant Director, Barbara Shissler, the former editor of the *Bulletin*, and Merribell Parsons, the Bell Curator of Decorative Arts, began planning this catalogue. In 1972 Dr Na Chih-liang, curator of the jade collection of the Taiwan National Palace Museum, came to Minneapolis to catalogue the collection. He was assisted by Vera Shu-Ning Sun, who later became a curatorial member of the Oriental Department.

I particularly want to thank Nancy Akre, who edited the catalogue with me, for so generously giving her time, judgement, and expertise at every step in the preparation of this book.

Thanks are also due to Susan Brown for her work in the early stages of the catalogue; Professor Richard Mather, East Asian Languages Department of the University of Minnesota, who translated the Introduction; and Professor Richard Poor, Art History Department of the University of Minnesota. To Lorelei Schleis and Esther Nelson of The Minneapolis Institute of Arts Conservation Department we owe much. A word of thanks is due to Barbara Gilbert, who typed the manuscript and, of course, to Gary Mortensen, who is responsible for the beautiful color transparencies as well as the black and white photographs.

Finally, I want to thank John Taylor and Charlotte Burri at Lund Humphries, and Samuel Sachs II, Director of The Minneapolis Institute of Arts, for their faith in our work, and their endless patience.

Harold Peterson
Minneapolis
December 1976

# FOREWORD

The collections of Oriental jade objects in The Minneapolis Institute of Arts are known the world over for both their depth and quality; the collection of archaic forms is said to be the finest outside mainland China. It is thus fitting that we here publish for both the scholarly and the general public the pieces preserved in Minneapolis.

The first pieces of jade to enter the collections were purchased in 1916 through The William Hood Dunwoody Fund. It is important to recall the enthusiasm with which particularly Chinese artifacts were met in the early part of this century; collecting such objects was a special mark of distinction. It was indeed with distinction that two private collections were assembled in the following years, and it is those collections which now form the core of the museum's displays.

Mr and Mrs Augustus L. Searle formed, and over a period of years gave, a splendid collection of jades the emphasis of which was primarily on masterpieces of eighteenth-century China. Exquisite Imperial pieces such as the green *Incense Burner* (No.198), the large white *Vase with Cover* (No.187), and the *Pair of Covered Bowls* carved of a jadeite picturesquely described as "moss entangled with melting snow" (Nos.229–30) are prime examples of their sophisticated taste.

Alfred F. Pillsbury made his first trip to China following the end of the First World War and subsequently devoted his life to collecting works of art from the Asian continent. From 1918 to 1938, with advice from C. T. Loo, he concentrated on archaic jades; for many years these objects were on loan to the museum and, on his death in 1950, were bequeathed to join the permanent collection. His taste ran to the highly ritualistic and specialized jades – weapons, ornaments, implements and figurative pieces – and the collection lacks only depth in *Chin-Ts'un* jades, which discoveries were made after Mr Pillsbury had turned his attention to Chinese bronze collecting.

Additions to the jade materials have also been made by Charles L. Freer and in recent years by Mr and Mrs Everett Andreson.

Thus it is with pride that this unique grouping is here presented in complete form. The project could never have been undertaken or completed without the support and financial assistance of the National Endowment for the Arts, a federal agency, the John D. Rockefeller III Fund, and the late Richard P. Gale of Minneapolis.

Samuel Sachs II

# INTRODUCTION

The study of carved jades has been pursued for over eight hundred years in China. It is a tradition that encompasses the work of the Northern Sung scholar Lü Ta-lin, who included a section on jade in his *K'ao-ku t'u* (Illustrations for the Study of Antiquity), as well as the works of many scholars since his time. The impressive antiquity of this tradition notwithstanding, suitable methods for the study of jade have yet to be found. Historically there have been several reasons for this delay. Initially a close relationship developed between Chinese archaeology and paleography, with the result that ancient objects with inscriptions were valued much more highly than those without; most jades have no inscriptions and consequently were neglected by archaeologists. Further, scholars who studied jades were traditionally either classics scholars or historians, for whom jade was an auxiliary in their attempts to authenticate the classics or verify the histories. Through the centuries, numerous scholars endeavored to find ritual jades that would match the descriptions of those recorded in the pages of the *Chou-li* (Rites of Chou), a classic purporting to describe the rulers, rituals, and ritual objects of the Chou Dynasty. Unfortunately for the development of jade scholarlship, such studies, in addition to being unscientific, concentrated on ritual jades to the exclusion of pieces carved for secular usage. And finally, most traditional jade scholars, rather than formulating new hypotheses, turned blindly to old theories and old classifications when attempting to identify objects.

By the Ch'ing Dynasty (A.D. 1644–1911) there were a number of scholars who attempted, albeit unsuccessfully, to extricate themselves from the influences of these old theories: Wu Ta-ch'eng in his *Ku-yü t'u-k'ao* (Illustrated Study of Ancient Jades), published in 1889, Ch'ü Chung-jung in his *Ku-yü t'u-lu* (Illustrated Catalogue of Ancient Jades), published in 1832, and several others. Their lack of success left the contemporary jade scholar with no alternative but to devise new methods for jade study. To this end the following methods have been suggested:

(1) manufacturing styles characteristic of successive periods should be identified on the basis of information concerning sources of raw jade, color and luster, and carving and engraving techniques;

(2) the sources of decorative motifs should be sought in natural phenomena and archaeological artifacts, and the evolution of the motifs verified through the study of archaeological findings;

(3) archaeological and ethnographic studies should provide the basis for understanding types of jade objects;

(4) dating standards should be established on the authority of scientifically excavated artifacts as well as connoisseurship.

# JADE MANUFACTURE

## Sources of Jade

The term *jade* is commonly applied to two different minerals: jadeite and nephrite. Jadeite, called *fei-ts'ui* (kingfisher plumage) by the Chinese, is found in southern China from Yunnan southward as far as Burma; nephrite is found in Sinkiang in the far western part of China. It is to nephrite that the term *yü* ('jade') generally refers.

Thus far it has been impossible to determine when nephrite was first transported from Sinkiang to the interior. Recent mineralogical analysis of the jades that have survived from the Chou period (trad. 1122–221 B.C.) shows them to be made of a stone identical to that which is now found in Sinkiang, a finding in consonance with the history of the Chou people, who migrated to the interior from an area in the west relatively close to Sinkiang. But whether or not there was any importation of Sinkiang nephrite in the preceding Shang period (trad. 1766–1122 B.C.) is uncertain. In 1952 Dr Li Chi reported that mineralogical tests of the seven Shang-Yin 'jades' excavated at Anyang, Honan, revealed that the seven pieces were made not of Sinkiang nephrite but of *Nan-yang yü* ('Nan-yang jade'), a stone that is native to Honan, but is not jade. Although much research remains to be done, it is certain that any importation of nephrite from Sinkiang in Shang times could not have been on a large scale.[1]

The greatest quantities of nephrite reached the interior from Sinkiang during the Chou and Han Dynasties (1122 B.C. to A.D. 220) and during the Ch'ing Dynasty (A.D. 1644–1911), with importation remaining relatively light during all other periods. Whether these periods of light importation were due to political unrest in the interior, to changes in the western boundary that resulted in the exclusion of Sinkiang from Chinese territory, making the deposits inaccessible, or to diminished demands for jade objects during these periods is uncertain. Nevertheless, the many jades that have survived from the Chou and Han Dynasties alone attest to rich nephrite deposits; and the pieces that were manufactured during the Ch'ing period indicate both that sources were numerous and that extremely large pieces of the stone were transported from the west to the interior. The Palace Museum in Peking has a Ch'ing piece, *Jade Mountain Depicting Yü the Great Controlling the Flood Waters*, that measures 2.24 meters in height, 0.96 meters in width, and weighs about seven tons. The transport of such an extremely large piece of jade without the aid of modern vehicles or highways must have been extraordinarily difficult. In order to haul jade to the main jade emporium, Lan-t'ien in Shensi, small pieces of the stone were carried on horses' or camels' backs, and larger pieces were dragged behind the animals. From Lan-t'ien the raw jade was later transported to other destinations in China.

In contrast, the importation of jadeite to the interior must have been of relatively late date and in much smaller quantities. One of the Sung literati, Ou-yang Hsiu (1007–72), had a *kang* ('vat') made of what he thought plain green jade (*pi yü*) in his home. Until the stone was identified by a palace eunuch who had seen other jadeite (*fei-ts'ui*) objects in the palace, Ou-yang Hsiu knew only that the material was very hard and could break metal – an incident that suggests that jadeite articles were still uncommon in Sung times.

## Color and Luster

In judging the color and luster of nephrite, non-adulteration is considered the most valuable attribute. Ideally any single piece of nephrite is of only one color, a preference expressed by the ancients in the sayings:

'Red as a cock's comb'
'Yellow as steamed millet'
'White as sliced lard'
'Black as unmixed lacquer.'

Actually mineralogical analysis has since revealed that what was thought to be red nephrite (*ch'ih-yü*) is agate, although yellow, white, and black are colors characteristic of nephrite; nor are these the only colors common to it. Green nephrite is exceedingly plentiful, particularly a deep green known in Chinese as *pi-yü* ('jaspidian'). White nephrite with a trace of blue-green, similar to the celadon color of porcelain wares, is called *ch'ing-yü* ('blue-green jade'), and that of a grey-black color is called *hui-yü* ('grey jade').

In any single piece of jadeite, on the other hand, there may be as many as three colors: green, white, and red.

When determined by scientific methods the differences between jadeite and nephrite lie in their degrees of hardness and specific gravities. Jadeite, which is harder and denser, is in the pyroxene group of minerals, and nephrite is in the amphibole group. Even with the naked eye it is easy to distinguish between them. The white of nephrite, as the ancients noted, is supposed to be that of 'white lard', with a smooth, soft, creamy feeling; whereas the white of jadeite often has cloudy areas in it and a glassier texture. Simiarly, in comparing the greens of nephrite and jadeite, the green of nephrite is darker, close to a green-black, while the green of jadeite is pale and is considered most valuable if it has a glassy feeling, as its name, *po-li ts'ui* ('glass halcyon'), indicates. These colors are all characteristic of jade in its natural state, but because jade objects suffer chemical changes if buried with a corpse or buried under soil for a length of time, the surface colors of many pieces have changed, in some instances to a color more beautiful than the original.

## Carving and Engraving

Since jade is extremely hard and cannot be cut with metal, the Chinese method of carving it has always been to 'attack stone with stone', using an abrasive sand with an even greater degree of hardness to grind the jade. The general term for the sand that is used is *chieh-yü sha* ('jade-cutting sand'), although the sand is actually a mixture of abrasive agents the composition of which varies according to the task to be done and the preference of the jade carver. The method used to divide large jade stones into smaller pieces is similar to that used by a carpenter to saw wood; after mounting the jade on a frame, two men pull a large, toothless saw back and forth across the stone, activating the sand which very slowly grinds the stone into two pieces (Fig.1).

After the stone has been cut to specifications it is 'carved' with a simple machine. As illustrated in Fig.2, a round bar with a leather belt wrapped around it is mounted horizontally on a rectangular table. The two ends of the leather belt pass through a hole in the center of the table and are attached to two treadles underneath which, when pushed by the jade worker, cause the horizontal bar above to spin back and forth. A metal disc mounted on one

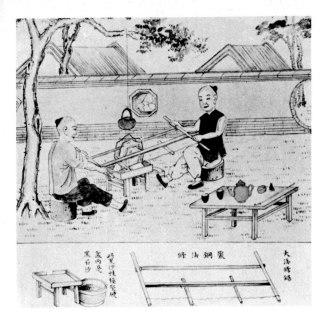

Fig.1
The four-handed, toothless saw used to reduce
large pieces of jade to sizes suitable for carving.

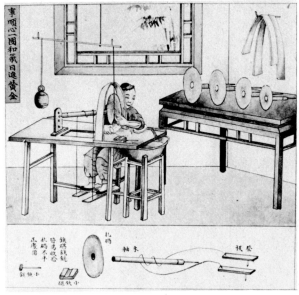

Fig.2
A treadle-operated disc-grinder with a catch
basin for re-usable jade-cutting sand. Various
grinding discs with corresponding eye guards
can be seen on the table behind the jade carver.

end of the bar spins as the bar spins and, in combination with the jade-cutting sand, which is
kept in a container close at hand, slowly grinds the outline of the object from the stone. Again,
the cutting is done by the abrasive sand, not by the disc used to activate the sand.

There are two operations that necessitate the use of other tools: a drill with a diamond point
is used to make perforations, and a carpenter's bow (*sou-kung*) is used to carve intricate surface
decorations. Otherwise, from the initial grinding of the outline of the object, to its completion,
this very simple treadle machine is used. Only the shape of the disc and the coarseness of the
abrasive sand vary: outlines are carved with a large metal disc with a sharp rim; surface sheen
is produced with a large metal disc with a fairly thick rim; engraving is done with an
extremely small metal disc with a sharp rim, shaped like a nail head; vessels are hollowed by
removing cores of jade with a metal tube rather than a disc; and polish and luster are
achieved with a wooden disc, often with thick leather nailed to it. For all of these processes
jade-cutting sand of varying degrees of abrasiveness is indispensable.

## Virtuosity

As jade workers acquired greater skills and were able to take advantage of the color and luster
of the jade material to carve ingeniously lifelike objects, a 'virtuosity' developed. I once saw a
piece of jade carved to represent an old fisherman with a shining white face, a red, wide-
brimmed rain hat, and green clothes, the whole cleverly carved to exploit the three colors of
the jadeite. Inasmuch as all three colors are not always present in any single piece of jadeite,
and even if present vary in quantity and position, it is extremely difficult to plan in advance
how best to utilize the stone. If the stone from which the old fisherman was carved had been
mostly white, with very little green, or if the white had not been in the center, the piece could
not have been planned to represent an old fisherman. The jade worker must be able to plan

the finished object on the basis of the accidental configuration of the material – a feat that is clearly impossible without ingenuity.

There is no way of applying such virtuosity to nephrite since any single piece is basically of one color. Agate, which may exhibit a variety of colors within a single piece, presents the true challenge to the carver's expressive powers. The red and white agate Buddha-hand citron, No.235 in The Minneapolis Institute of Arts Collection, is a splendid manifestation of virtuosity. The jade worker utilized the white in the center to carve both a large and a small Buddha-hand citron (*Citrus sacrodactylus*); and he used the red part of the stone to carve out pomegranates (symbols of fecundity), peaches (longevity), and a bat (good fortune), the red and white complementing each other to produce an extraordinarily beautiful effect.

In an attempt to duplicate the results of such virtuosity without having to rely on the accidental configuration of colors, a 'baked-surface' (*k'ao p'i-tzu*) technique was developed. This technique changes the coloring of the jade artificially, thus enabling the jade worker to choose the areas of the piece that are to be re-colored and those that are to remain their natural color. Since this technique produces an artificial coloration it has an unnatural feeling and was commonly practised only during the brief period of the reigns of the Ch'ien-lung and Chia-ch'ing emperors (1736–1821). The brownish color on the upper surface of the water basin (*shui-yü*) in this collection (No.203) is the result of the baked-surface technique.

## Indian Jade

The Ch'ien-lung emperor, who reigned from 1736–1795, was exceptionally fond of jade objects made in the Indian style. In addition to writing many poems on Indian jades, he established the 'Western Barbarian Shop' (*Hsi-fan tso*), which specialized in making Indian-style jade carvings in the palace atelier. During his reign appreciation of this style spread amongst the people until Indian jades had a wide currency. It is a style that is well represented in The Minneapolis Institute of Arts Collection and can be seen to differ from Chinese styles in several respects: Indian jades are thin, often to the point of transparency; they are usually decorated either with gilt or with inlaid precious stones; and they often reflect an Indian influence in design and decor.

## STYLE

In China's long history of jade carving, each period has developed a distinct style. Although it remains difficult to trace stylistic evolution in ritual objects, pieces manufactured for ordinary usage, such as girdle pendants or burial jades, exhibit marked stylistic changes. In a single category of pendants, the *huang* ('crescent-shaped') pendants, for instance, distinctive stylistic developments occurred from the Shang period (1766–1122 B.C.) to the Han (221 B.C. to A.D. 206).

Numerous jade pendants in the shape of a crescent or partial circle, often with representations of humans, birds, animals, or fish, have survived from the Shang period. Figure 3 illustrates four *huang*-shaped pendants and others can be seen in various jade collections and illustrated catalogues.[2]

Fig.3
*Huang*-shaped pendants with bird (*a*), human
(*b*), animal (*c*), and fish (*d*) representations.
From Huang, *Heng-chai ts'ang chien ku-yü-t'u-lu*
(*a*); Chen, *Chin-k'uei lun-ku ch'u-chi* (*b*);
Salmony, *Archaic Chinese Jades from the Edward
and Louise B. Sonnenschein Collection*, pl.14:2
(*c*); Huang, *Yeh-chung p'ien-yü* (*d*).

Fig.4
Two Western Chou *huang*-shaped pendants
with representations of humans. From Huang,
*Ku-yü t'u-lu ch'u-chi*, ch.3, pp.3 and 6 (*a*);
Loo, *Chinese Archaic Jades*, pl.22:9 (*b*).

In addition to pendants, other *huang*-shaped ornaments have survived; for instance, the two
plaques in this collection, Nos.38 and 39, both of which are carved with bird-body and
human-head configurations. On the basis of these *huang*-shaped pendants the following
observations may be made:

(1) amongst Shang jade pendants the *huang* shape is extremely common;
(2) if the *huang*-shaped pendant has a human figure depicted on it, the human is usually in a
squatting position, a posture customarily assumed by the Shang people;
(3) if the *huang*-shaped pendant has a human or bird figure depicted on it, the headdress of
the human or the crest of the bird is extremely ornate and capacious to accommodate
the crescent shape;
(4) if the *huang*-shaped pendant is carved with a representation of an animal, the design
usually has an unnatural feeling since it lacks the convenience of a headdress or crest to
accommodate it to the shape of the pendant;
(5) Shang *huang*-shaped pendants carved to represent humans frequently have a ⊖ or
⊕ mark on the buttocks of the figure, the meaning of which has yet to be discovered.

During the Western Chou period (1122–722 B.C.) the *huang*-shaped pendant underwent
gradual transformation. The design became much freer and was no longer contained within
the crescent or partial circle. In the pendant illustrated in Fig.4*a* the human is still in the
squatting position, and the pendant is still crescent-shaped, but the crescent shape is not
articulated as clearly as before; in other pieces, the way in which the human was represented
can be seen to have changed: notably in a piece in the C. T. Loo collection that shows only the
head of the human, the carver having elongated the head to fit the crescent shape (Fig.4*b*).

In the Eastern Chou period (722–221 B.C.) pendant styles changed again. *Huang*-shaped pendants were made with decreasing frequency, while *S*-shaped pendants became common. The *huang*-shaped objects surviving from this period indicate by the awkwardness of their design and decor that it was difficult for jade workers who were adept at carving *S*-shaped objects to extend their artistry to the creation of *huang*-shaped objects.[3] An exception is No.124 in this collection in which the dragon's *S*-curves were masterfully given the overall form of a *huang*-shaped pendant, an accomplishment attesting to an exceedingly adept jade worker.

Later, during the Warring States period (422–221 B.C.), jade workers carved a head, either animal or human, at each end of the pendant and added very short, stylized bodies between the two heads (Nos.103 and 104).

And lastly, during the Han period (206 B.C.–A.D. 220) and after, *huang*-shaped pendants became considerably less common.

It should be noted that this method of searching out and collecting materials, analyzing them, and identifying the style of each period is a process closely connected to and indeed inseparable from both the dating of the object and the study and identification of shapes.

## Decorative Motifs

Nature was the source of the decorative motifs used on most jade objects, with the incredibly rich decorative motifs of later times evolving from combinations of earlier, simpler representations of animals and natural phenomena.

## Natural Phenomena

The transformations of nature were both fascinating and important to the ancients. When the day grew bright a round sun rose on one side of the earth and later set on the opposite side. After nightfall stars gleamed and twinkled across the heavens. Sometimes the moon was round, sometimes a semi-circle, and sometimes a mere thread. Clouds covered the sky, bringing rain, thunder, and lightning. These phenomena were marvelous to the ancients and the earliest decorative motifs were representations of them.

In fact, as Fig.5 illustrates, the transformations of the cloud motif were even more numerous.

## Totems

In ancient China totems functioned as the organizational principle for federations of tribes that united in opposition to federations of other tribes, as signs of identification for outsiders, as objects of worship, and as sources of decorative motifs. The most familiar totemic representation (and that which perhaps identifies the federation that became the ancestor of the modern Chinese people) is the dragon (*lung*).

In attempting to identify early forms of the dragon motif there are two courses that may be taken: the first is to collect examples of the *lung* graph as it appears on extant oracle bones and compare these pictograms with depictions of the dragon in early jade carvings; the second is to examine depictions of the dragon as it appears in jade carvings that have been scientifically excavated from Shang tombs, since jades found in Shang tombs are Shang or earlier in date.

Motifs evolved from depictions of the sun:

, the *single-circle motif*

, the *double-circle motif*

, the *triple-circle motif*

, the *square motif*

, the *hui-character motif*

, the *cloud-and-thunder motif (lei-wen)*

Motifs evolved from depictions of the moon:

, the *scale motif (lin-wen)*

, the *double-scale motif*

, the *triple-scale motif*

, the *triangle motif*

, the *variant-triangle motif*

Motifs evolved from depictions of the stars:

, the *nipple motif (ju-ting wen)*

, the *grain motif (k'u-wen)*

Motifs evolved from depictions of drifting clouds:

, the *cloud motif (yün-wen)*

Fig.5
Transformations of the cloud motif.

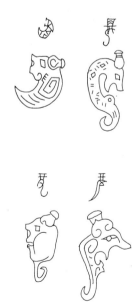

Fig.6
Variations of the *lung* ('dragon') graph copied from oracle-bone inscriptions and set over carved jades with similar shapes.

Taking the first course, collecting examples of the *lung* graph as it appears on oracle bones and comparing them with dragon-shaped jades, reveals that there are jade objects with shapes that are strikingly similar to the *lung* graphs on the oracle bones (Fig.6).

Taking the second course and comparing the dragon-shaped jades of assumed Shang date with dragon-shaped jades scientifically excavated from Shang tombs, as confirmation of the identification (Fig.7), the similarities in shapes enable us to note the following characteristics of Shang dragon-shaped jades:

    (1) the dragons' bodies are short and the heads large, the two seeming ill-proportioned;

    (2) the heads have horns;

    (3) the eyes are fashioned with the lozenge-shaped eye motif;

    (4) one leg is carved as an indication that the dragon has legs.

The dragon-shaped pieces of this type in The Minneapolis Institute of Arts Collection are: No.24, a girdle pendant; No.22, a *hsi* pendant; Nos.29 and 30, bow ornaments; and Nos.41 and 42, handles.

Moving on, the dragon design can be seen to have undergone several more transformations. First, during the Western Chou period, the dragon's body became longer, with more complex ornamentation (axe-tooth patterning was often used as decoration on the dragon's back), and then during the Warring States period the animal's body became more snakelike, frequently with sinuous single-*S* or double-*S* curves.

And finally, from Han times onward the dragon motif was used with less frequency in jade carvings, although it continued to be used in other art forms, where it was represented as a dragon with a horselike head and either a coiling or a quadruped body. This development caused Wang Ch'ung (A.D. 27–*c*.100) to note in his *Lun-heng* (Critique of Discussions), 'Most people in the world, when drawing a dragon, give it a horse's head and a serpent's tail.' In jade carvings, however, the hydra motif (*ch'ih-wen*) in the form of a wall-lizard (*pi-hu*) became an ubiquitous replacement for the dragon design.

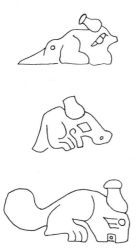

Fig.7
Dragon-shaped jades excavated from Shang tombs: *a* was excavated at Yin-hsü in Anyang, Honan; *b* and *c* from a Yin tomb at Ta-ssu-k'ung-ts'un village in Anyang, Honan. From Umehara, *Shina kogyoku zuroku*, pl.69 (*a*); *KKHP*, 1955, no.9, pp.25–90 (*b* and *c*).

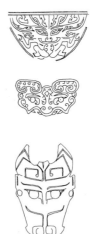

Fig.8
Three animal masks: man-eating animal from stone tripod excavated at Anyang (*a*); ferocious animal (*b*); and water buffalo (*c*). From Umehara, *Kanan Anyō ibutsu no kenkyū*, p.38, fig.19 (*a*), Na, *Yü-ch'i t'ung-shih*, vol.2, p.128, figs. a and b (*a* and *b*); Minneapolis Institute of Arts Collection, No.25 (*c*).

## Animals

A favorite subject for the jade carver has always been those animals which are particularly loved or feared by man. Figure 8*b* illustrates an animal mask that is frequently encountered on bronze and jade objects; the huge mouth with sharp teeth indicates that the head is that of a fierce animal, probably that of a tiger since in antiquity the tiger was considered to be the most ferocious animal. On occasion, when it was felt that merely to depict the head of the animal would not sufficiently reveal the animal's savage nature, a man-eating animal mask would be created. Such a mask can be seen on a stone tripod excavated at Anyang (Fig.8*a*): the animal's large, gaping mouth holds a man within it; the upper half of the man has already disappeared, while his four limbs and the lower half of his body remain yet to be devoured.

Jade carvings with animal representations more frequently depict the animals that man loved than those that he feared. Deer, dogs, horses, hares, pigs, chickens, birds, fish, frogs, cicadas, and water buffalo (Fig.8*c*) all captured the imagination and attention of the jade carver.

Originally the tiger-head, water-buffalo head, or ram-head designs could be recognized easily by their eyebrows; this: ⌒ was a tiger; this: ⌣ was a water buffalo; and this: ⌒⌒ was a ram. But in the host of existing animal masks stylization has made it impossible to identify the animal depicted. No.33 in this collection presents this kind of quandary: although the ears are similar to tiger ears, the broad inner edges and pointed outer edges also give them the appearance of ram horns; the face of the animal, however, is broad, ill-omened and malevolent, making it unlikely that it is a ram head. In such a dilemma it can be said only that the carving is an animal mask, and the attempt to identify the animal must be abandoned.

## TYPES

Fortunately for jade scholarship, many hitherto insoluble problems have found their solutions through archaeological investigations, thereby relieving jade scholars of their previously unsatisfactory but unavoidable dependence on the works of earlier scholars for the answers to such questions as 'What is this?' or 'How was it used?' Nonetheless, in selecting reference books for jade study, discretion must be used. Yü Yüeh, a man of the Ch'ing Dynasty, once wrote a book entitled *Yü-p'ei k'ao* (A Study of Jade Girdle Pendants), in which he quoted the speculations of previous writers on the subject of girdle pendants and also drew a set of pictures to illustrate the pendants. He himself harbored some suspicions about the accuracy of his drawings and wrote: 'It is regrettable that we simply cannot find any detailed information about the shapes of the *hêng*, the *huang*, the *chü*, and the *yü*; so I have made provisional drawings based on my own ideas.' The *hêng*, *huang*, *chü*, and *yü* were all important parts of a girdle pendant, but without detailed descriptions of their shapes, the drawings inevitably bore only questionable resemblance to actual objects. Two additional unfortunate choices of reference works would be the Sung Dynasty writings the *San-li-t'u* (Illustrations of the Three Books on Ritual) by Nieh Ch'ung-i and the *K'ao-kung chi chieh* (Explanation of the Record of Crafts) by Lin Hsi-i. The *San-li-t'u* provides both explanations and drawings of the types of ritual objects described in the *Chou-li* (Rites of Chou), and the *K'ao-kung chi chieh* contains drawings of objects mentioned in the section of the *Chou-li* known as the 'K'ao-kung chi' (Record of Crafts). Certainly both of these works represent methodological improvements,

since illustrations remove the necessity of relying solely on verbal descriptions, which by their very nature are inadequate and potentially misleading. But again, regardless of intentions, the drawings must be viewed only as imaginary representations of objects, bearing little or no resemblance to actual jades.

Illustrated catalogues that reproduce drawings, rubbings, or photographs of actual objects are more reliable, although even here there is a potential hazard. Ten or fifteen years ago I saw a group of antique jades in a curio shop. Upon being asked my feelings about the pieces, I told the shop manager that I felt that they were counterfeits. He indignantly brought out a book for me, claiming that each of the ancient pieces was catalogued in it, apparently without realizing that the book had been published solely in an attempt to authenticate that particular group of counterfeits. Fortunately for anyone who has looked at large numbers of such illustrated catalogues, this kind of fraudulent book can be detected easily.

After reading enough illustrated catalogues to acquire a familiarity with and understanding of jade objects, more advanced research may be conducted incorporating archaeological and ethnographical evidence. A study of the *hsi* ('pendant in the shape of a tooth or horn') is presented as an example of the recommended method.

There are four standard sources on the *hsi* in China's ancient literature.

(1) The *Shuo-wen* (Explanation of Graphs), an ancient dictionary of about A.D. 120, states: 'The *hsi* is a girdle-horn with a pointed end with which one may untie knots.'

(2) The *Li-chi* (Book of Rites) in the section entitled 'Nei-tse' (Pattern for the Family) says: 'A son serving his father and mother wears a small *hsi* on the left side of his girdle and a large *hsi* on the right.'

(3) The *Shih-ching* (Book of Songs) in the song entitled 'Huan-lan' (The Branches of Huan-lan) says: 'The boy wears a *hsi* at his girdle.'

(4) The *Shuo-yüan* (Garden of Tales), attributed to the first-century B.C. writer Liu Hsiang, states in the section entitled 'Hsiu-wen' (Cultivating the Civic Arts): 'One who is able to put vexations and disorder in order wears a *hsi* at his girdle.'

From these sources it would seem that the *hsi* was a horn-shaped object that was worn at the girdle and functioned to untie knots. The *Shuo-wen* explanation, which states that the *hsi* could be used to untie knots, more than likely refers to the ancient practice of recording events by tying knots. Tying a knot was easy and untying it was bothersome, so the *hsi* was used to untie the knot. Likewise, the statement in the *Shuo-yüan*, 'One who is able to put vexations and disorder in order wears a *hsi* at his girdle,' is also an explanation derived from an extension of the meaning of untying knots.

It must be admitted, nevertheless, that these explanations seem very unsatisfactory, since the likelihood of a man's wearing both a small and a large *hsi* at his girdle solely for the purpose of untying knots is highly improbable. To continue to search for the solution to this problem in ancient texts would be futile, but modern archaeological and ethnographic reports reveal several interesting facts relevant to the *hsi*.

Chang Jên-hsia's *Chung-kuo ku-tien i-shu* (The Ancient Art of China) states: 'During the age of hunting and fishing, people used the claws and teeth of animals for ornaments. Right down to the present day this custom still survives. For undeveloped societies, of course, it is unnecessary to mention it, but even in the society of the modern Chinese village it is not uncommon to find instances of the use of boars' teeth or tigers' teeth as girdle ornaments for small boys. According to some, Japan's prehistoric *magatama* ("crescent jades") were also evolved from claws and teeth.'[4]

Chia Lan-p'o states in *Shang-ting tung-jen* (Cavemen of the Mountaintops): 'At the cave entrance and as far back as the upper chamber were discovered: one molar tooth with a hole bored through it, . . . twenty-eight fox or badger canine teeth with holes bored through them.'[5]

Li Chi's article 'Chi Hsiao-t'un ch'u-t'u chih ch'ing-tung ch'i' (Studies of Bronze Objects Excavated at Hsiao-t'un, Honan) says: 'During the Shang-Yin period [trad. 1766–1122 B.C.] there obviously was a custom, just as there was among warriors of later ages, of using captured booty of war and the hunt to commemorate achievements or glorify martial prowess. The water buffalo-head inscriptions and deer-head inscriptions expressed this long ago. And there was also a tradition of human-head inscriptions, the existence of which, even without actual excavated records, is entirely believable.'[6]

Natural history museums constitute another source of information on the origin of the *hsi*. In both the United States and China natural history museums exhibit reconstructions of the lives of primitive peoples. Frequently the models in these reconstructions are shown wearing neck and waist ornaments made from animal teeth. A small museum by the shores of Sun-Moon Lake in Taiwan has a clay model of a young man who is fighting a wild boar. The explanation at the side states: 'Whenever a local youth encountered a wild boar that he wished to capture or kill, he was only allowed to fight the boar singlehandedly. Even if he was injured doing so, others could not assist him until after he had killed the boar. Then he extracted the boar's tusks and suspended them from his belt as a memento of his victory. The more animal teeth a man had suspended from his belt, the braver he was thought to be.'

This archaeological and ethnographic evidence, in combination with the historical references, leads to the following conclusions about the *hsi*:

(1) Sharp teeth, horns, and claws are the only implements with which wild animals can defend themselves against their enemies. After the ancients had caught and killed a wild animal, they took the teeth, horns, and claws and fashioned them into girdle ornaments that could be worn as mementoes of the battle.

(2) When people no longer wore real claws and teeth at their girdles, but fashioned them of jade or some other material, they preserved these original forms, giving the *hsi* a perforation above and a point below in imitation of the earlier claws and teeth and giving the *ko* ('dagger') the shape of an animal horn.

(3) The *hsi* was merely a commemorative object or girdle ornament, but its shape gave it practical value so that it could also be used to perform some tasks. Consequently, when sons served their parents they always wore a *hsi*, which, along with other items worn at the girdle, was ready for use in any contingency, such as untying knots.

(4) After the *hsi* became a girdle ornament, people began to pay attention to its beauty and to carve designs on it; but the general outline, with the perforation above and the point below, never changed (Nos.82, 89, and 90).

The method used to uncover the functions of the *hsi* is, of course, also useful for understanding other types of jade objects, as the following study of the *yüan* ('bracelet') illustrates. There are four references to the *yüan* in the ancient texts.

(1) The *Hsun-tzu* (third century B.C.) states: 'One uses the *yüan* to summon people.'

(2) The *Shuo-wen* (Explanation of Graphs) from about A.D. 120 states: 'The *yüan* is a *pi* disc with a large hole. When the ruler of men ascends the steps to the throne he is drawn up with a *yüan*.'

(3) In *Yung-feng hsiang-jen kao chia, Yün-ch'uang man-kao*, in the section entitled

'Shih-yüan,' Lo Chen-yü states: 'The *yüan* is a *pi* disc with a large hole that can accommodate the hands of two people. When the ruler of men ascends the steps to the throne, in order to prevent tripping and losing his composure, the ruler holds onto the *yüan*, which is held by a minister who precedes him and leads him. The reason that it was necessary to use the *yüan* was that the minister, being of humble origin, did not dare to touch the ruler's hand directly.'[7]

Scholars inferred all of these explanations from the meaning of the primary graph *yüan* (without the 'jade' classifier), which, when written with the classifier for 'hand' means 'to lead up.' Therefore they imagined that *yüan* were used both to summon a person and to lead the ruler of men up the steps to the throne. Even with no thought of contradicting these explanations, it is difficult to escape the feeling that the *yüan* that have survived in the world are simply too many to have had this as their only function.

Again archaeological excavations have shed light on the problem. At the Large Mound ruins of Ssu-hu-chen of P'ei Prefecture in Kiangsu, two 'stone bracelets' (*shih-cho*), one on either arm of a skeleton, were found in Tomb 26 from the Neolithic period, and another 'stone bracelet' was found on the right arm of a skeleton in Tomb 30. In both of these finds, what were called 'stone bracelets' in the archaeological reports are actually *yüan*.[8] In another tomb from the Neolithic period, Tomb 15 at Yeh-tien in Shantung, still another stone bracelet was found.[9]

In 1960 Shih Chang-ju reported that in the Yin tomb of Ping-tsu at Hsiao-t'un in Honan, 'the places where *huan* and *yüan* bracelets were found were horse and chariot pits; they must have been connecting links for some kind of joined objects. The places where *pi* discs were found were human graves; they must have been used for girdle pendants.'[10]

Among archaeological excavations, therefore, at least two additional uses for the *yüan* have been found: as bracelets and as connecting links.

## DATING

In an archaeological excavation the date of a tomb is deduced both from the various types of objects that are excavated and from the manner of burial, and then the jade funeral objects from the tomb are dated accordingly (it is reasonable, for example, to assume that there are no post-Han funeral objects in a Han tomb). Subsequently these excavated artifacts serve as standards for dating the numerous jade pieces of unknown provenance in museums and private collections around the world.

Since this method of dating is solely dependent on comparison with excavated objects, which rarely exhibit enough variety to provide standards of comparison for each problematic piece in a collection, the jade scholar, much in the manner of previous jade scholars, must also rely on his experience and connoisseurship. Although this leaves room for error, time has shown the method to have some reliability, since many of the judgments of past jade scholars, who worked at a time when opening graves was prohibited, have been verified by recent archaeological findings.

## Dating by Shape

The changes that have occurred from period to period in the shapes of the objects that jade carvers have produced provide useful indices for dating objects. For example, the *kuei* scepter is described in the *Chou-li* as 'shuttle-topped (*chu-shang*) with hammer-head' (*chung-k'uei shou*). 'Shuttle-topped' means that the piece is sharpened on one side; 'hammer-head' means that one side is broad and square. From archaeological studies we know that this shape was evolved from a stone axe that had a nearly rectangular body with one side sharpened to a cutting edge, a shape that corresponds exactly to the description in the *Chou-li*. *Kuei* scepters with pointed heads were rare in Shang and Early Chou times, but were common in the Warring States period. Thirty-three stone *kuei* scepters with pointed heads were excavated from the buried remains of an Eastern Chou covenant of alliance at Hou-ma in Shansi. Sixteen stone *kuei* scepters with pointed heads were excavated from an Eastern Chou tomb at Shang-ma village in Hou-ma; and stone scepters were found in each tomb that contained funerary objects at Fu-lin-pao in Pao-chi, Shensi: seven scepters in the tomb with the fewest and twenty-seven in the tomb with the most.[11] With the exception of the comparatively wide *kuei* scepters excavated from the buried remains of the covenant at Hou-ma, all of the others were long and narrow, as are the hand-held *kuei* scepters depicted in Han stone engravings. It would seem, therefore, that although all of the shuttle-topped, hammer-headed *kuei* scepters that were excavated were funerary objects, this shape must have been common from the Warring States period through the Han.

Likewise, other developments, such as the preference for girdle pendants with a *huang*-shape during the Shang period and an *S*-shape during the Warring States period, or the absence of belt hooks (*tai-kou*) until the Warring States period, and inscribed rectangular talismans (*kang-mao*), old-man figurines (*öng-tz'on*), and dove-shaped staff heads (*chiu chang-shou*) until the Han, should be taken into consideration when dating a piece of jade.

Another historical development that can be used as a base line when dating some pieces is the Taoist introduction of a new composite scepter-disc during Han times. There is a passage in the *Chou-li* that states: 'The *kuei*-[and] *pi*-scepter [and] disc, [each] five inches (*ts'ung*), are used in sacrifices to the sun, moon, planets, and constellations.' Although the meaning of the passage is simply that a scepter and a disc, each five inches in length, are used in sacrifices to the sun, moon, planets, and constellations,[12] in the seventh century, Chia Kung-yen stated in his commentary on the passage: 'Here the *kuei-pi* scepter-disc refers to the use of a *pi* disc as the base with a *kuei* scepter at its side.' The Taoists, who frequently produced jade objects with bizarre shapes in compliance with their rather perverted interpretations of the *Chou-li*, produced composite scepter-discs by grinding *kuei* scepters and *pi* discs from single pieces of jade and then engraved the five planets, eight trigrams, mountains, and rivers on them. All such pieces are Han or later in date, with absolutely no examples surviving from the Shang or Chou periods.

A large, although not insurmountable obstacle to accurate dating is presented by the numerous counterfeit jades that have been made in imitation of ancient objects and then given an artificial coloration to simulate the effects of aging. Counterfeits that are made for profit can be spotted by an experienced person, since the jade worker, in his haste, is unable to expend the craftsmanship or time necessary to produce a convincing surface appearance. But with counterfeits that are not made for profit, detection is more difficult. The Palace Museum in Taiwan has a jade cup in a small wooden box in its collection. A note on the top of the box in

the imperial autograph of the Ch'ien-lung emperor (1736–95) relates both the history of the cup and the manufacture of counterfeit jades. It reads:

> This jade cup, which has been made the color of morning, given the luster of violet, and made to shimmer and glow in its markings, when looked at closely, seems, from the slow erosion of earth-flowers, to be an object of Han date or even earlier . . . . When I showed it to the jade worker, Yao Tsung-jen, he exclaimed, "Ah! It was made by my grandfather! Our family has practiced this process for generations; that's why I recognized it."
>
> I said, "If that is the case, then the counterfeit Han jades now in the world are many indeed. Why wouldn't they be the same as this one?"
>
> He replied, "How could they be the same? Long ago when my father was instructing me in the art of finishing the surface, he would say, 'If the color-master used to take three months to dye the feathers [for the queen's carriage], how much longer is required for jade! The method of dying jade is to select a vessel that is spoiled or rejected; if it is summer to select one with a warm feel [good jade is cool]. Burn it by night the *yin* will sink and the *yang* will rise to the surface. If no noble spots and no flaws appear, this means that the material is hard and difficult to penetrate. Now take a diamond drill the size of a bell-teat (*chung-ju*) and make fine pricks like [the stings of] a wasp or scorpion, then smear the surface with amber paste. Now place it in a furnace but don't let the fire blaze fiercely and don't let it go out by night or by day. A whole year must pass before the process is complete. The makers of counterfeits today who know this process are few indeed. Even if they know it, since they're in a hurry they can't wait for the highest bidder, or their impatience is so great they can't stand to wait at all. So how are they any different from plasterers plastering a wall? That's why their products aren't anything like this . . . ."

Although pieces made by the method described by Yao Tsung-jen are not easy to recognize, an experienced person can detect subtle defects in the finish even though the technique has been masterful.

## Dating by Decorative Motifs

The evolution of the decorative motifs used on jade objects has been greater than the evolution of the shapes of the objects. The method that is used to date carvings on the basis of the decorative motifs that appear on them is similar to the method that is used to date them according to their shapes: designs on objects from documented archaeological excavations are used as standards of comparison by which to date designs on objects in museum or private collections. A brief look at the evolution of the double-bodied animal-mask motif will illustrate this method.

The single animal head with two bodies is a design originating from two side views of an animal set opposite one another. In the double-bodied animal mask illustrated in Fig.9*a* two tigers in side view can be perceived. Eliminating the two side-view bodies, the two heads can be seen to combine into one front-view animal mask, and the two 'cloud-shaped' figurations meeting above the eyes can be seen to represent ears rather than horns. Viewed as a whole, the decoration is a double-bodied animal mask.

The earliest examples of double-bodied animal masks all have large heads and small bodies – or actually what are only indications of bodies. A good example can be seen on the upper part of the bowl of a Shang *ts'un* vessel that was excavated from the Yüeh-erh River near Kao-nan in Anhui.[13] In the center is a tiger head with two short, flanking tiger bodies. Double-bodied

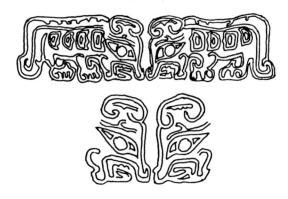

Fig.9
Double-bodied animal masks. From Na,
*Yü-ch'i t'ung-shih*, vol.2, p.129, figs.30a and b.

animal masks in this style are common decorations on bronzes from the Shang and Chou
periods, although if the animal mask forms part of a band design or a design below the rim of
the vessel, the body is adapted to its position by elongation or sinuousity.

Amongst jades from the Shang period, on the other hand, the double-bodied animal mask is
rare, not becoming common until the Eastern Chou through the Han periods (Nos.149 and 151
in this collection). A statistical count of the animal-mask decorations on the jades illustrated
in Alfred Salmony's *Carved Jade of Ancient China* reveals that there are both stylized animal
masks and double-bodied animal masks from Shang and Early Chou times, but no realistic
animal masks.[14] Although the statistics are accurate only for the objects illustrated in
Salmony's book, they serve, nevertheless, to illustrate in a general way the evolution of the
animal-mask motif, and also why designs can function as dating standards.

### Dating by Manufacture

Modern instruments such as the microscope have made it possible to perceive very fine
distinctions in carving and engraving techniques that can be used as criteria for dating jades. In
the Shang period there was a type of surface decoration that was carved by cutting away the
two sides of a linear design so that the design would appear to be a double, concave linear
design, even though the sole function of the lines was to highlight the ridge that ran between
them. On others, the double highlighting lines were cut to slope gradually toward the
convex ridge with the deepest part of the incising nearest the ridge, in order to make the ridge
more pronounced. In this collection the two bow ornaments, Nos.29 and 30; the comb,
No.27; the pendant with animal-mask decoration, No.23; the water buffalo-head pendant,
No.25; and the ornament with frog design, No.40, all appear to have been carved by this
method. However, they appear so only to the naked eye. Through a microscope it can be seen
that of the six objects, the bow ornaments, the comb, and the pendant with animal mask have
convex linear decoration that is flanked by many cross-hatched short lines having the
appearance of random blades of grass. Such a distinction, which is invisible to the naked eye,
obviously indicates different carving and engraving techniques.

Again, the two *pi* discs from the Warring States period, Nos.98 and 100, when examined
under a microscope, reveal that the grain motif that decorates their surfaces is concisely carved

in shallow relief against an extremely smooth background, distinguishing a mastery of carving and engraving techniques by the carvers.

These hitherto undetected differences in the manufacture of carved jades serve as further clues which, along with the shapes of the objects and the varying styles of their decor, aid jade scholars in their efforts to date the many carved jades that have been inherited from the past.

Na Chih-liang
1973

### Notes

[1] Li Chi, 'Yin-hsü yu-jen shih-ch'i t'u-shuo,' *BIHP* 23 (1952), 526.

[2] There is a *huang*-shaped jade pendant with human decoration illustrated in my book, *Yü-ch'i t'ung shih*, vol.1 (Hong Kong, 1964), pl.53. A 'human-shaped jade pendant ornament' was excavated at Yin-hsü (near Hsiao-t'un) and is illustrated in *Wen-wu*, 1960, no.2, pl.76. A 'jade human figure of the Yin period' is illustrated in Mizuno Seiichi, *In-sho seidoki yo gyoku* (Tokyo, 1959), pl.70. Also, a *huang*-shaped pendant with human design is illustrated in Alfred Salmony's article, 'Collecting Ancient Chinese Jades,' *Hobbies* (Buffalo, 1944), fig.5.

[3] For an example of this awkwardness see the *huang*-shaped pendant with a phoenix design that was excavated at Hui-hsien and is illustrated in Hsia Nai *et al.*, *Hui-hsien fa-chüeh pao-kao*, Archaeological Field Reports, no.1 (Peking, 1956), pl.66:18.

[4] Chang Jên-hsia, *Chung-kuo ku-tien i-shu* (Shanghai, 1954), p.37.

[5] Chia Lan-p'o, *Shang-ting tung-jen* (Shanghai, 1951), p.51.

[6] Li Chi, 'Chi Hsiao-t'un ch'u-t'u chih ch'ing-tung ch'i,' *KKHP*, 1949, no.4, p.26.

[7] Lo Chen-yü, 'Shih-yüan,' *Yung-feng hsiang-jen kao chia; Yün-ch'uang man-kao* (Tientsin, 1918). Reprinted in *Lo Hsüeh-t'ang hsien shêng ch'uan chi*, vol.1 (Taipei, 1968), p.2.

[8] 'Chiang-su P'ei hsien Ssu-hu-chen ta tun-tzu i-chih ts'ai-chüeh pao-kao,' *KKHP*, 1964, no.2, p.21.

[9] 'Shan-tung Yeh-tien hsin shih-ch'i shih-tai mu-tsang i-chih shih-chüeh chien-pao,' *Wen-wu*, 1972, no.2, p.26.

[10] Shih Chang-ju, 'Hsiao-t'un Yin-tai Ping-tsu chi-chih chi ch'i yu-kuan hsien-hsiang,' *BIHP*, Special Issue, vol.4, part 2 (1960), 783.

[11] *Wen-wu*, 1972, no.4, pp.28–30; *Kao-ku*, 1963, no.10, p.232; *Kao-ku*, 1963, no.10, p.537.

[12] Na Chih-liang, *Yü-ch'i t'ung-shih*, vol.1 (Hong Kong, 1964), 318.

[13] *Wen-wu*, 1972, no.11, p.64.

[14] Alfred Salmony, *Carved Jade of Ancient China* (Berkeley, 1938).

# COLOR PLATES

Plate I

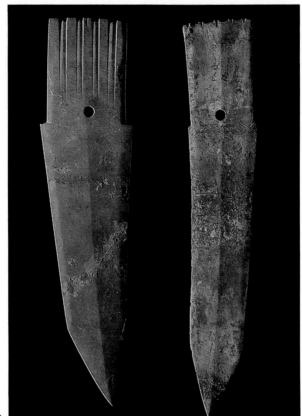

a

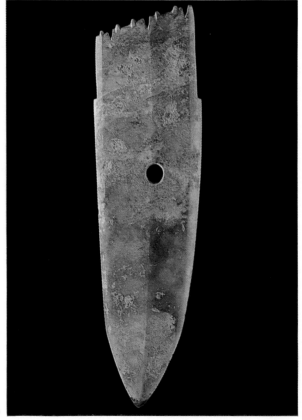

b

Plate II

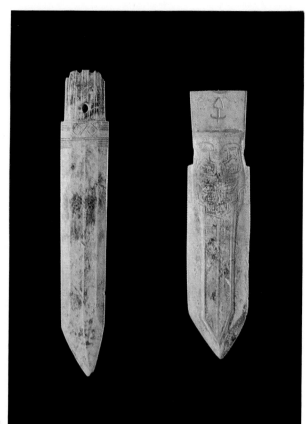

a

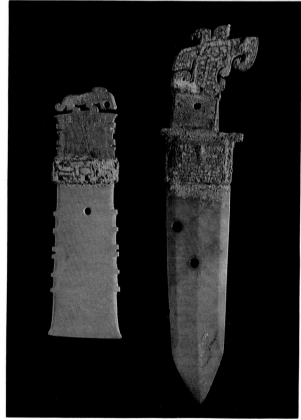

b

Plate III

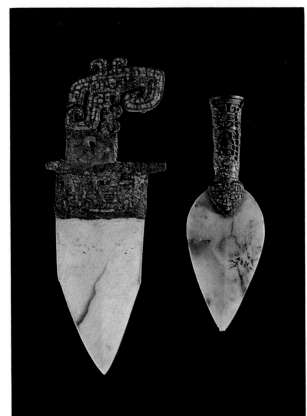

a

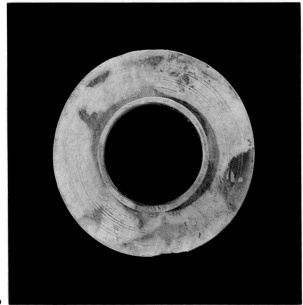

b

Plate IV

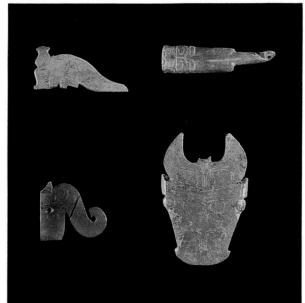

a

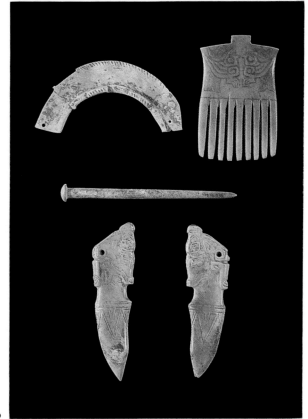

b

Plate V

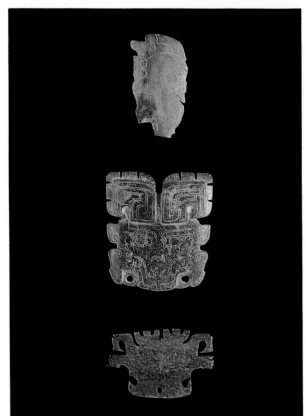

a

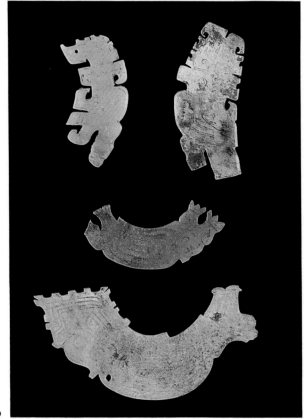

b

Plate VI

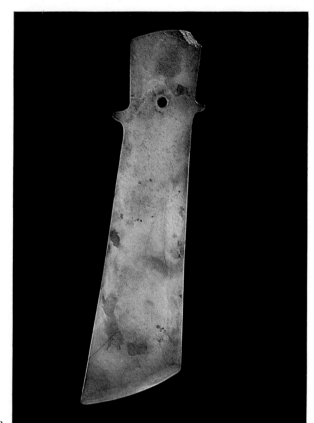

a

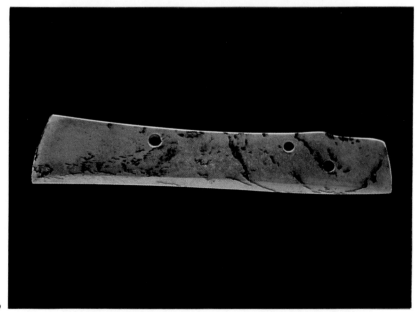

b

Plate VII

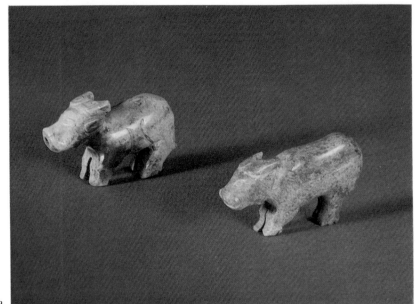

a

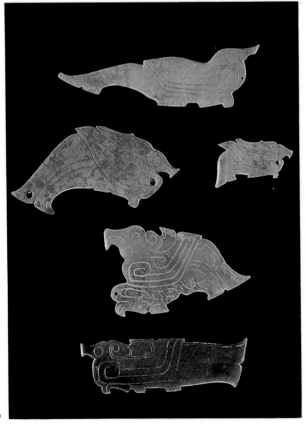

b

Plate VIII

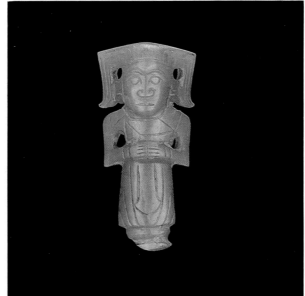

a

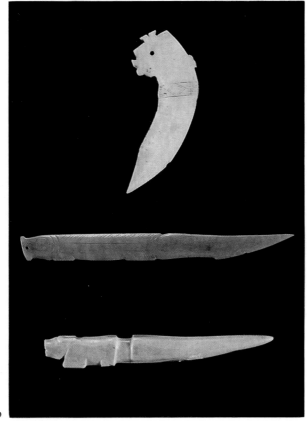

b

Plate IX

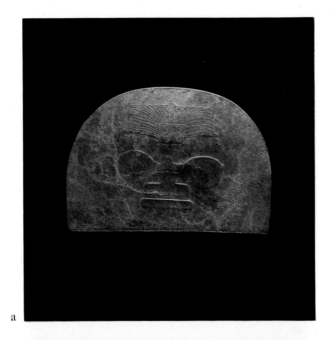

a

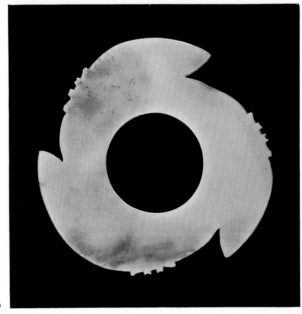

b

Plate X

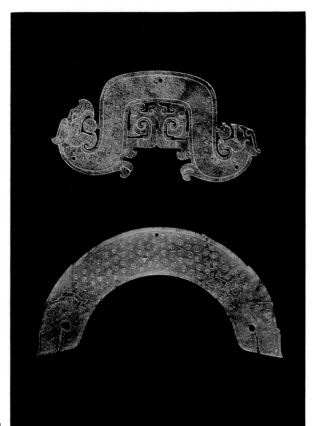

a

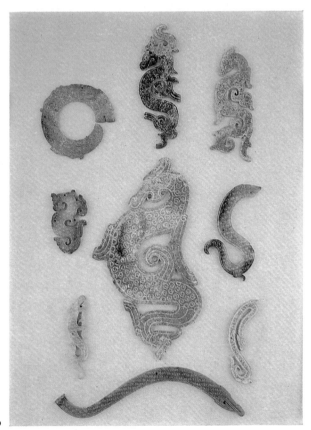

b

Plate XI

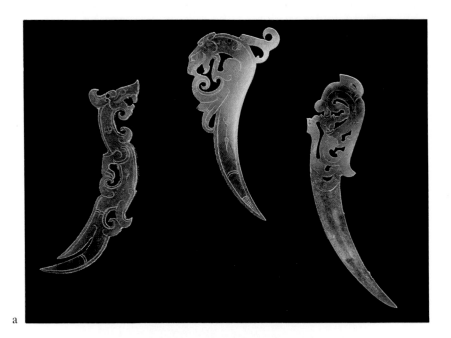

a

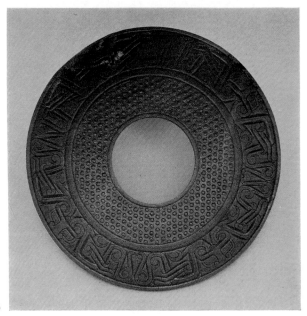

b

Plate XII

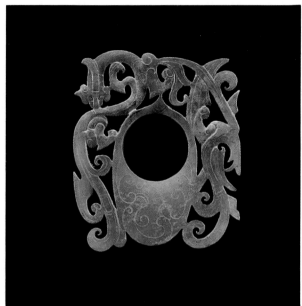

a

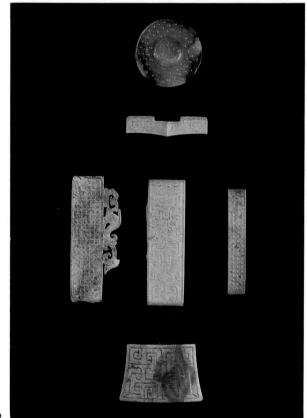

b

Plate XIII

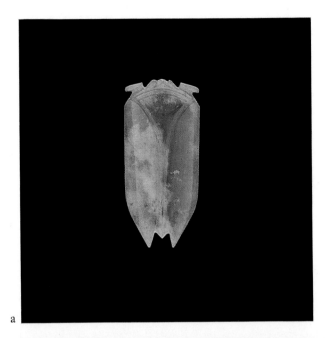

a

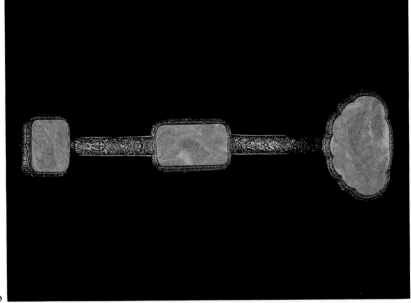

b

Plate XIV

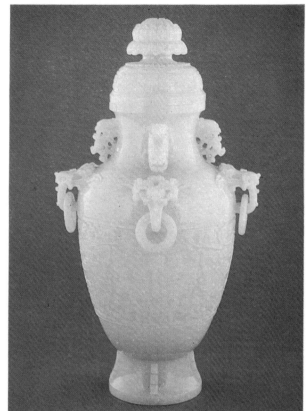

a

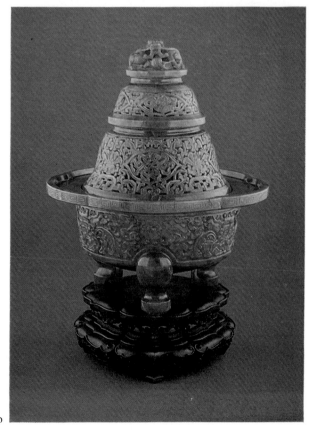

b

Plate XV

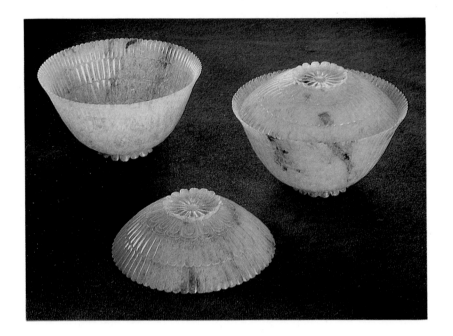

# CATALOGUE

The following catalogue subjects are also reproduced in the color section:

# 1 CEREMONIAL *KO* DAGGER

**Calcified, opaque tan jade; traces of red pigment and earthlike substance.**
**Length $14\frac{7}{16}$ in; width $3\frac{5}{8}$ in; thickness $\frac{7}{32}$ in.**
**Bequest of Alfred F. Pillsbury, 50.46.318**

The *ko* dagger, or halberd, was a popular weapon in ancient China. The dagger was affixed to a long handle especially suited for attacking by hooking or pecking. Because of the slight curve in the blade body and the sharpness of the arrow tip, one may speculate that the *ko* dagger originated as an animal horn and then underwent considerable modification to eliminate the cylindrical shape when it was later made of stone or bronze.

It was during the Shang period that fine stone, or jade, was first differentiated from other types of stone,[1] and daggers similar both in form and material to the *ko* daggers in this collection have been excavated at many of the Shang sites.[2] Li Chi has cautiously stated that in classifying ancient Chinese jade stones, objects which are as well preserved and well made as the *ko* daggers were probably for burial purposes rather than practical use.[3]

There are ten *ko* daggers in The Minneapolis Institute of Arts Collection. Both in quantity and quality these daggers are the most outstanding among all ancient jades in important collections.[4] The *ko* dagger shown here has a thin, slightly beveled blade which narrows at the tip to a long, sharp arrow point. The tang with its long stem ends at the base with a series of five protruding, rectangular teeth. These teeth continue vertically along the entire tang as five flat ribs separated by four grooves, a decorative motif which is identical on both sides of the blade. A round perforation has been drilled from one side in the center of the stem of the tang. Some restoration on the blade is visible. Shang.

[1] Li Chi, 'Yin-hsü yu-jen shih-ch'i t'u-shuo,' *BIHP* 23 (1952), 534, 614.
[2] *Kao-ku*, 1973, no.1, p.27, pl.6.
[3] Li Chi, *op. cit.*, 523–620. The author states that ancient stone tools can be divided into three functional types: tools used for utilitarian purposes; tools used for practical, ceremonial, and burial purposes; and tools used only for ceremonial or burial purposes.
[4] Important collections of ancient jades are: (1) the A.W. Bahr collection in the Field Museum of Natural History, Chicago, published in B. Laufer, *Archaic Jades Collected in China by A.W. Bahr* (New York, 1927); (2) the Edward and Louise B. Sonnenschein collection in the Art Institute of Chicago, published in A. Salmony, *Archaic Chinese Jades from the Edward and Louise B. Sonnenschein Collection* (Chicago, 1952); (3) the British Museum collection, London, published in R.S. Jenyns, *Chinese Archaic Jades in the British Museum* (London, 1951); (4) the Royal Ontario Museum collection, Toronto, published in D. Dohrenwend, *Chinese Jades in the Royal Ontario Museum* (Toronto, 1971); (5) the Avery Brundage collection at the M.H. de Young Memorial Museum, San Francisco, published in René-Yvon Lefebre d'Argencé, *Ancient Chinese Jades in the Avery Brundage Collection* (San Francisco, 1971); (6) the G.L. Winthrop collection at the Fogg Art Museum, Cambridge, Massachusetts, published in M. Loehr, *Ancient Chinese Jades* (Cambridge, Massachusetts, 1975); (7) the collection at the Freer Gallery of Art, Washington, D.C., pieces from which are illustrated in A. Salmony, *Carved Jade of Ancient China* (Berkeley, 1938) and C.T. Loo, *Chinese Archaic Jades* (New York, 1950).

# 2 CEREMONIAL *KO* DAGGER

**Calcified ivory jade, *chi-ku-pai* ('as white as chicken bone'); traces of red pigment and earthlike substance.**
**Length $14\frac{1}{2}$ in; width $2\frac{11}{16}$ in; thickness $\frac{1}{8}$ in.**
**Bequest of Alfred F. Pillsbury, 50.46.384**

The extreme thinness of this *ko* would indicate that it was created for a strictly non-functional purpose. The dagger has a beveled surface created by a long central ridge and two side ridges extending along the blade's entire length. Five pairs of small teeth project slightly from the base of the square-cornered, rectangular tang. A diamond pattern engraved between an incised double-line band creates a decorative field between the hilt and the blade body on both the front and back sides. A single centralized perforation has been drilled from one side in the stem, slightly above the decorated area. Evidence of some restoration is visible along a crack line in the upper section of the blade.

Daggers with articulated teeth at the base, similar to this one, have been excavated at most Yin-hsü sites,[1] further substantiating the dating of these pieces to the Shang period. However, the delicate diamond design on the dagger bespeaks a finer workmanship than that of most excavated daggers. Shang.

Published: Paul Pelliot, *Jades archaïques de Chine appartenant à M.C.T. Loo* (Paris and Brussels, 1925), pl.4 and pp.15–20.

[1] Li Chi, 'Yin-hsü yu-jen shih-ch'i t'u-shuo,' *BIHP* 23 (1952), 523–621. Compare especially with illus. 15–16; *Kao-ku*, 1973, no.1, p.27, pl.6.

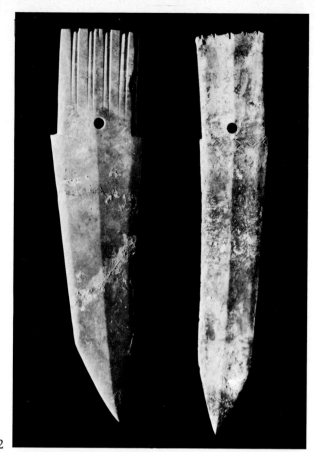

1,2

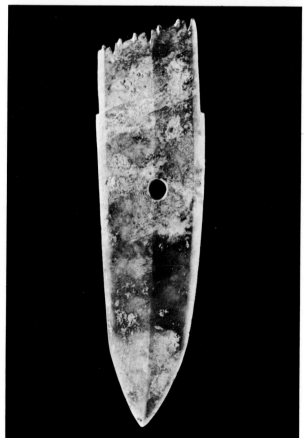

3

## 3 CEREMONIAL *KO* DAGGER

**Mottled green jade; traces of earthlike substance.**
**Length 9½ in; width 2⅝ in; thickness 5/16 in.**
**Bequest of Alfred F. Pillsbury, 50.46.352**

Although unusually short in proportion to its width, this dagger is finely modeled and has well-articulated, projecting teeth at the base. The blade curves slightly as it tapers to a broad arrow point. A raised central ridge and two side ridges run the entire length of the blade and create a beveled surface. The diagonally slanted tang has six small, protruding teeth and three deep notches evenly spaced along the base. The blade is without any incised surface decoration and has an unusually placed biconical perforation drilled almost at the center of the object. Some well-done restoration remains visible along a crack line that runs across the upper section of the blade through the perforation. A kinship can be found between this dagger and many excavated examples from Shang sites, especially from Cheng-chou in Honan.[1] Shang.

[1]*Kao-ku*, 1965, no.10, p.500.

## 4 CEREMONIAL *KO* DAGGER

**Grey jade spotted with black-moss veins; traces of earthlike substance.**
**Length 14 15/16 in; width 3¼ in; thickness ¼ in.**
**Bequest of Alfred F. Pillsbury, 50.46.386**

The simple but finely carved shape of this dagger is reminiscent of the animal horn from which the *ko* dagger evolved. The blade has a slightly beveled surface with a central groove and terminates in an arrow tip. The slanted base of the long-stemmed tang is accentuated by slightly sharpened edges. Two toothlike grooves subtly separate the tang from the blade body. A centralized perforation has been drilled from one side in the lower section of the stem. Restoration of some breakage near the center of the blade is clearly visible. Although this dagger has no surface decoration, the great beauty of the jade itself makes this piece a distinguished example of Shang craftsmanship and aesthetics. The fine lustrous quality of the jade in this dagger is also present in similar *ko* daggers excavated at Yin-hsü.[1] Shang.

[1]Li Chi, 'Yin-hsü yu-jen shih-ch'i t'u-shuo,' *BIHP* 23 (1952), 523–621.

## 5 CEREMONIAL *KO* DAGGER

**Calcified white jade, *chi-ku-pai* ('as white as chicken bone'); traces of earthlike substance.**
**Length 10⅝ in; width 2⅜ in; thickness 5/16 in.**
**Bequest of Alfred F. Pillsbury, 50.46.389**

In the early stages of the development of the *ko* dagger, both edges of the blade were nearly equal in length, as they are in this ceremonial weapon. In the Early Western Chou period, however, one edge of the blade was extended and eventually became a side necking called a *hu*,[1] which facilitated attaching the dagger to a handle. Comparison of this piece with the bronze *ko* excavated at Hsiao-t'un[2] will further support its dating to the Shang period.

In appearance this *ko* is similar to other ceremonial daggers that date from the Shang period in this collection (Nos.2 and 4); however, the convexly beveled surface of the piece appears softer. Both blades of this dagger, moreover, are quite thick, a contrast to the thin, sharp edges of the other *ko* in the collection. Shang.

[1]Li Chi, 'Yü-pei ch'u-t'u ch'ing-t'ung kou-ping fen-lei t'u-chieh,' *BIHP* 22 (1950), 1–18.
[2]Li Chi, 'Chi Hsiao-t'un ch'u-t'u chih ch'ing-tung ch'i,' *KKHP*, 1949, no.4, p.58 and pls. 25–46.

## 6 CEREMONIAL *KO* DAGGER

**Mottled ivory jade, *chi-ku-pai* ('as white as chicken bone'), calcified, with black and brown spots; traces of red pigment.**
**Length 6 6/16 in; width 1 1/16 in; thickness ¼ in.**
**Bequest of Alfred F. Pillsbury, 50.46.262**

This small, narrow dagger has a convexly beveled surface created by a midrib and two raised side ridges. The short tang is also beveled and has a small, centralized biconical perforation in the lower section. The base of the tang terminates in three protuberant teeth, and pairs of parallel relief thread bands are arranged vertically along its entire length. Below the tang a pair of incised double-line diamonds and short striations create a well-articulated decorative field horizontally across the blade, a complex motif that is identical on both sides. Striations and criss-cross patterns were often used during the Shang period for decoration both on lapidary work[1] and on white pottery.[2] However, it is quite unusual to find such elaborate decoration on a single object of such small size, thus making this *ko* dagger a unique and important piece in an outstanding collection. Shang.

[1]Li Chi, 'Yin-hsü yu-jen shih-ch'i t'u-shuo,' *BIHP* 28 (1957), fig.6, A 123.
[2]Li Chi, 'Yin-hsü pai-tao fa-chan chih', *BIHP* 28 (1957), 853–876.

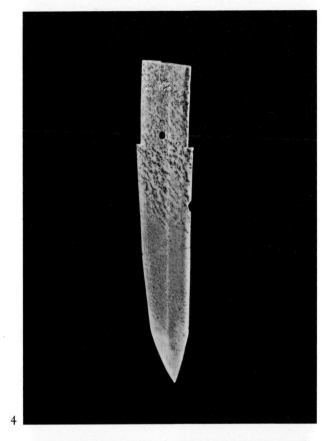

4

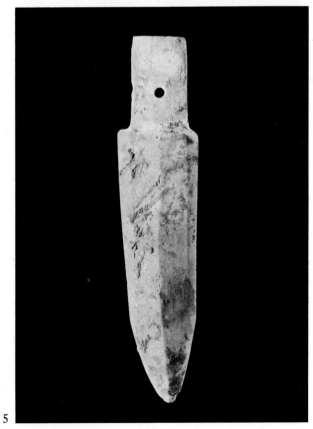

5

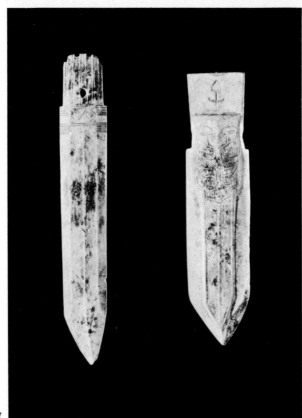

6,7

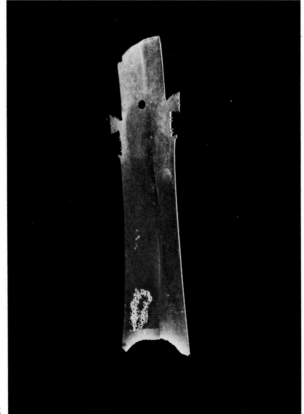

8

## 7 CEREMONIAL *KO* DAGGER

**Calcified ivory-white jade, *chi-ku-pai*
('as white as chidken bone'); traces of red
pigment and earthlike substance.
Length $5\frac{1}{2}$ in; width $1\frac{3}{8}$ in; thickness $\frac{15}{32}$ in.
Bequest of Alfred F. Pillsbury, 50.46.275**

Unlike other *ko* daggers in The Minneapolis
Institute of Arts Collection, this short, straight
*ko* has a horizontal biconical perforation or
shaft hole[1] through its entire width. This
unusual horizontal perforation, located in the
narrow area of the tang between the bulging
upper stem and the blade body, is perhaps
indicative of an early stage of the *ko*'s
development during the late Shang period,
before the secondary element of the *hu* was
added.[2] An engraved character appears on the
upper stem of the tang and, although this
character is indecipherable,[3] perhaps it could be
the name of a clan.

Below the tang on the upper section of the
tongue-shaped blade is an animal-mask design.
The animal mask is shown in the usual Shang
manner with bottled horns and *chêng-wen*, or
*mu-lei-wen* eyes.[4] Extending from the mouth of
the animal mask are three slightly raised thread
lines which follow the outline of the blade and
define an inner core. The decorative motif is
identical on both sides of the blade.

This small *ko*, made of such a precious
material and carved so beautifully, was most
likely made as a ceremonial or funerary object.
Similar *ko* daggers in bronze have been
excavated at late Shang sites, particularly
Hsiao-t'un.[5] Shang.

Published: Arden Gallery, *3000 Years of
Chinese Jade* (New York, 1939), No.34, pl.55:1;
Sueji Umehara, *Inkyo* (Tokyo, 1964), pl.39:4.

[1] B. Karlgren, 'Some Weapons and Tools of the
Yin Dynasty,' *BMFEA* 17 (1945), 127.
Karlgren classified this type of weapon as a
'shaft-hole axe' (Class VI).
[2] Li Chi, 'Chi Hsiao-t'un ch'u-t'u chih ch'ing-
tung ch'i,' *KKHP*, 1949, no.4, p.49; *idem*,
'Yü-pei ch'u-t'u ch'ing-t'ung kou-ping fen-lei
t'u-chieh,' *BIHP* 22 (1950), 5.
[3] Karlgren, *op. cit.*, pl.13:68–9; M. Loehr,
*Chinese Bronze Age Weapons* (Ann Arbor, 1956),
p.155, illus.28.
[4] The *mu-lei-wen* pattern that is used to represent
eyes is also referred to as the *chêng-mu-wen*.
[5] Li Chi, 'Chi Hsiao-t'un ch'u-t'u chih ch'ing-
tung ch'i,' *KKHP*, 1949, no.4, pl.26, no.54;
*idem*, 'Yü-pei ch'u-t'u ch'ing-t'ung kou-ping
fen-lei t'u-chieh,' *BIHP* 22 (1950), pl.ɪ: Fl;
C.T. Loo, *Chinese Archaic Jades* (New York,
1950), pl.16:7.

## 8 *FU* AXE SCEPTER

**Brown jade with granulation.
Length 14 in; width $3\frac{5}{16}$ in; thickness $\frac{5}{32}$ in.
Bequest of Alfred F. Pillsbury, 50.46.312**

The composition of the ancient Chinese axe
scepter is quite likely derived from both the *ko*
dagger and the axe.[1] The wide hilt and the
articulated shoulder of the axe scepter strongly
resemble those of the *ko* dagger; the broad
lunar-shaped curve of the scepter's cutting edge,
on the other hand, contrasts sharply with the
*ko*'s tapered arrow tip. Although taking its
trapezoidal shape from the utilitarian axe, the
scepter's extremely thin blade, concave cutting
edge and delicately carved petal-like teeth
adorning the shoulder are sufficient to indicate
that the piece was not meant for actual use, but
served a purely ceremonial or funerary
function,[2] an observation which is equally true
for the three axe scepters which follow
(Nos.9, 10 and 11).

Despite the abundance of objects of this type
in museums, there are virtually no excavated
examples from ancient Chinese sites,[3] axe
scepters apparently having been one of the
prizes of ancient tomb robbers. This presents
a difficult problem when dating the scepters,
and tentative dates can be determined only by
stylistic analysis and technical examination. It is
on such a basis that the relative chronology of
The Minneapolis Institute of Arts scepters
has been established.

As was noted above, the axe scepter most
likely developed from the *ko* dagger. In the
evolution of the *ko* dagger, it can be seen that
the articulated shoulder of the blade
(equivalent here to the two stylized teeth
projecting from the sides of the axe scepter,
near the handle) was characteristic of the *ko*
in the earliest phases of its development,[4] but
occurred most commonly during the Shang
period. During the Chou Dynasty, ceremonial
objects were formalized and artistically
simplified; the absence of surface decor was not
only preferred, but the severity of the object
also came to represent the solemnity
surrounding the occasion of its use.

The beautifully carved petal-like teeth of this
axe scepter suggest an ornamental quality which
was eliminated from ceremonial objects in the
Chou period, and this piece, therefore, must
be dated prior to that time. In addition,
decorative projections similar both in
execution and artistic expression to the ones
shown here can be found on other Shang
artifacts,[5] reinforcing the date ascribed to this
scepter. Further archaeological evidence and
scholarly research, however, will be necessary
before an accurate chronology can be
determined to our satisfaction. Shang.
Published: Alfred Salmony, *Carved Jade of
Ancient China* (Berkeley, 1938), pl.vɪ–3; Ling

Shu-sheng, 'Chung-kuo ku-t'ai jui-kuei tê yen-chiu,' *Bulletin of the Institute of Ethnology* 20 (1965), pl.II:C.

[1] B. Laufer, *Jade: A Study in Chinese Archaeology and Religion* (Chicago, 1912), p.96. Taking Wu Ta-ch'eng's view, Laufer suggests that this kind of scepter is derived from a hammer head, a lance head, or a similar type weapon. A discussion of the traditional theory on the use of scepters of this type as tally emblems is presented in Na Chih-liang, *Yü-ch'i t'ung-shih*, vol.1 (Hong Kong, 1964), 41–48.

[2] A. Salmony, *Chinese Jade Through the Wei Dynasty* (New York, 1963), pp.81–83 and pl. x:3. The author suggests that this kind of scepter could have been used to scale fish.

[3] Other collections with similar scepters are: (1) the A.W. Bahr collection in the Field Museum of Natural History, Chicago; (2) the Edward and Louise B. Sonnenschein collection in the Art Institue of Chicago; (3) the Musée Guimet, Paris.

[4] Li Chi, 'Yü-pei ch'u-t'u ch'ing-t'ung kou-ping fen-lei t'u-chieh,' *BIHP* 22 (1950), 13.

[5] S. Umehara, *Inkyo* (Tokyo, 1964), pl.141:3 (the object is reported to be from Yin-hsü); Liang Ssu-yung and Kao Ch'ü-hsün, *Hou Chia Chuang*, vol.2, *HPKM 1001* (Taipei, 1962).

## 9 AXE SCEPTER

**Grey-black jade with white veins.**
**Length 12⅛ in; width 5⅛ in; thickness 7/32 in.**
**Bequest of Alfred F. Pillsbury, 50.46.310**

Shorter and wider than the preceding axe scepter, this piece has a distinctive trumpetlike shape which flares into a lunar-arc cutting edge. The handle and two pairs of notched, rectangular teeth show the relationship of the axe scepter to the *ko* dagger noted in the previous entry. Incised horizontal striations, identical on both front and back, cross the area above the square-cornered handle, connecting the pairs of projecting teeth and providing the scepter's only surface decoration.

There is a question concerning the material of both this piece and the preceding one. The color of this scepter, grey-black with white veining, is more characteristic of agate or marble than of jade. The preceding piece, No. 8, is extremely lightweight, a suspicious feature in an object of this size, and its surface is waxy, suggesting that the piece may be made of horn. Li Chi encountered a similar problem in his examination of the stone objects from Yin-hsü and concluded that questions of material can be answered definitely only after scientific testing by a mineralogist.[1] Shang.

[1] Li Chi, 'Yin-hsü yu-jen shih-ch'i t'u-shuo,' *BIHP* 23 (1952), 525.

## 10 AXE SCEPTER

**Dark olive-green jade with light brown clouds.**
**Length 17¼ in; width 3½ in; thickness ¼ in.**
**Bequest of Alfred F. Pillsbury, 50.46.387**

Although the shape of this scepter is in striking contrast to that of the previous piece, the two pieces share an aristocratic elegance achieved by the artists' skillful carving and sensitive uses of proportion. The scepter's long, narrow blade curves slightly and ends in a nearly symmetrical lunar-shaped cutting edge. A much more elaborate motif than those seen on the two preceding scepters decorates the area between the blade and the handle. Pairs of ornate, rectangular teeth project beyond the edges of the scepter and are connected by incised horizontal bands. A central perforation has been drilled from one side at the stem of the handle. Shang.

Published: Alfred Salmony, *Carved Jade of Ancient China* (Berkeley, 1938), pl.VI:1; Ling Shu-sheng, 'Chung-kuo ku-t'ai jui-kuei tê yen-chiu,' *Bulletin of the Institute of Ethnology* 20 (1965), pl.1:B.

## 11 AXE SCEPTER

**Green jade with light ochre spots.**
**Length 15¾ in; width 4 5/16 in; thickness ¼ in.**
**Bequest of Alfred F. Pillsbury, 50.46.392**

Related in its overall composition to the three previous axe scepters, this piece, however, varies slightly from them in the motif used in the area between the scepter's blade and handle. Protruding prominently from both sides are two flanges, each composed of five small teeth, and above these, each edge is serrated by a row of five more rectangular teeth. On both the front and back of the scepter, shallowly engraved horizontal striation bands connect the five individual teeth, and a diamond pattern is incised between the two middle bands. From the obvious elegance of this scepter and the careful attention to such details as the incised patterns and the carved teeth and flanges, it is apparent that the object was created for burial or ceremonial occasions rather than for practical use. A similar type of scepter has been excavated from the Shang site of Cheng-chou[1] and serves to substantiate the dating of the piece shown here.

Shang axe scepters continued to be used into the Chou period when the various ancient rituals and ceremonies were being formalized and the objects associated with those events were being modified and standardized. It is quite likely that during this period of transition the *ya-chang*, an insignia for administering military troops, originated from the Shang

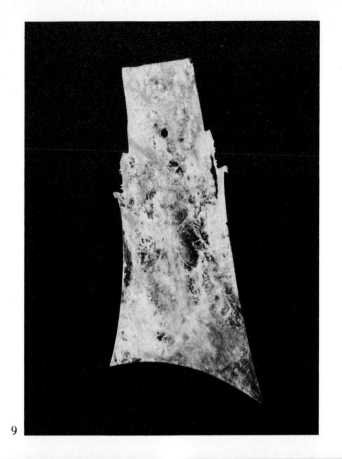

9

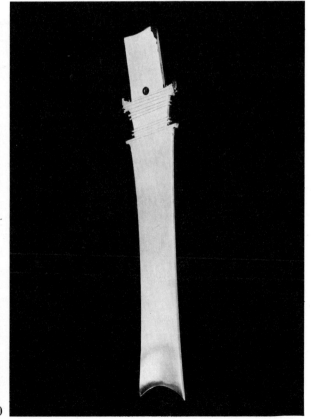

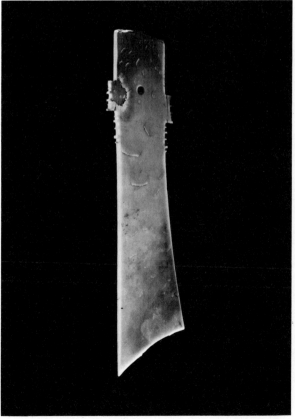

11

scepter prototype, a possibility which has been discussed by Wu Ta-ch'eng.[2] There is a very great similarity between the Shang scepter and the *ya-chang*, the primary distinction between them being the complete absence of surface decor on the *ya-chang* (see No.43). This abandonment of decoration on objects intended for ceremonial use, such as the administration of troops, reflected the attitude which developed in the Chou that the solemnity of a ritual should be reinforced by the severe simplicity of the symbols associated with it. Shang.

Published: Alfred Salmony, *Carved Jade of Ancient China* (Berkeley, 1938), pl.VII–1; Ling Shu-sheng, 'Chung-kuo ku-t'ai jui-kuei tê yen-chiu,' *Bulletin of the Institute of Ethnology* 20 (1965), pl.1:C; Joan Hartman, *Chinese Jade Through the Centuries* (New York, 1968), p.18.

[1] *Wen-wu*, 1966, no.1, p.58.
[2] Wu Ta-ch'eng, *Ku-yü t'u-k'ao* (modern reprint edited by Na Chih-liang, Taipei, 1971), p.21; D. Dohrenwend, *Chinese Jades in the Royal Ontario Museum* (Toronto, 1971), p.46.

## 12 CEREMONIAL AXE

**Dark olive-green jade with dark striations.**
**Length $3\frac{7}{8}$ in; width $1\frac{3}{8}$ in; thickness $\frac{23}{32}$ in.**
**Bequest of Alfred F. Pillsbury, 50.46.276**

The trapezoidal axe head[1] is divided into two parts, the blade and the tang, with a long shaft hole drilled horizontally through the entire width of the tang. The blade is wider than the tang and ends in a thin, slightly curved cutting edge. Four grooved lines extend from the middle of the blade to the tip, accentuating its beveled surface. Thread lines in low relief create a stylized monster mask, or *t'ao-t'ieh*, on the upper part of the blade body and the tang. Both animal masks have *mu-lei-wen* eyes;[2] however, the mask on the tang has two projecting bottled horns. The decoration on both sides of the axe is identical. It was quite common in the Shang period for different animal masks to appear on a single object, especially a bronze or bone object.[3] Shang.

Published: Alfred Salmony, *Carved Jade of Ancient China* (Berkeley, 1938), pl.VIII–4; Sueji Umehara, *Inkyo* (Tokyo, 1964), p.33.

[1] The shape of this axe resembles that of the small, square bronze axes used both in China and Siberia. See B. Karlgren, 'Some Weapons and Tools of the Yin Dynasty,' *BMFEA* 17 (1945), pls.5:28–34 and 34:192.
[2] The *lei-wen* designs for the eyes on this piece are slightly unusual and indicate the versatility of Shang artists.
[3] W.C. White, *Bone Culture of Ancient China*

(Toronto, 1945), pl.XLIII–LVII; S. Umehara, *Inkyo* (Tokyo, 1964), illus.38, 47.

## 13 TRAPEZOIDAL CEREMONIAL AXE

**Dark grey jade with black and white clouds.**
**Length $9\frac{1}{4}$ in; width $4\frac{3}{4}$ in; thickness $\frac{7}{16}$ in.**
**Bequest of Alfred F. Pillsbury, 50.46.311**

Stone axes were long used by the people of Neolithic China. This trapezoidal axe head has a beveled surface and terminates in a convex blade. The narrower end of the axe is damaged somewhat at one corner. Two very small biconical perforations, neither of which is well finished, have been drilled near the narrower end and were used to attach the axe to a shaft.[1] The smaller of these two asymmetrically spaced perforations is placed very close to the side edge of the axe in an unusual and awkward position. Since the narrower end is thinner than the rest of the axe, it is possible that this edge was inserted into the shaft, a practice which was common in other Neolithic civilizations.[2] The great beauty of the jade and the extremely smooth and highly polished surface of the axe would suggest that it was used for ceremonial or burial purposes. Similar stone axes have been excavated at Yin-hsü sites.[3] Shang.

Published: Arden Gallery, *3000 Years of Chinese Jade* (New York, 1939), p.58, No.30; Sueji Umehara, *Shina kogyoku zuroku* (Kyoto, 1955), pl.XXIV.

[1] Li Chi, 'Yin-hsü yu-jen shih-ch'i t'u-shuo,' *BIHP* 23 (1952), 523–620. The author states that perforated sharp-edged stone tools are slightly later in development.
[2] Li Chi, 'Chi Hsiao-t'un ch'u-t'u chih ch'ing-tung ch'i,' *KKHP*, 1949, no.4, pp.1–70 and illus.29:a1–a23.
[3] Li Chi, 'Yin-hsü yu-jen shih-ch'i t'u-shuo,' *BIHP* 23 (1952), 523; J.G. Andersson, 'Prehistory of the Chinese,' *BMFEA* 15 (1943), 261–270; *Kao-ku*, 1963, no.6, p.308 and 1972, no.5, p.8. Similar jade specimens are preserved in the Royal Ontario Museum, Toronto, and the A.W. Bahr collection in the Field Museum of Natural History, Chicago.

## 14 FLAT *CHI* AXE

**Mottled grey-green jade with traces of red pigment.**
**Length $6\frac{15}{16}$ in; width $4\frac{7}{8}$ in; thickness $\frac{3}{8}$ in.**
**Bequest of Alfred F. Pillsbury, 50.46.377**

*Chi* is the term used to describe any short, wide, trapezoidal axe with projecting teeth or flanges on the two sides. The teeth were originally used to facilitate fastening the axe to the handle. However, the flanges on this axe are a purely

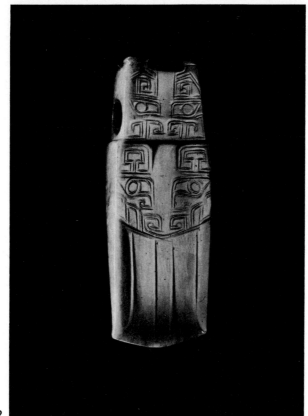

12

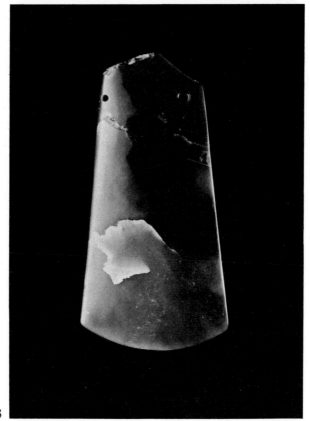

13

decorative element referred to as *chi* teeth, a term also used to describe similar flanged teeth found on other objects made of jade and bronze. This *chi* axe is very flat and has a slightly convex, sharpened blade on one end. The smooth surface of the axe has no decoration. Three perforations have been drilled from one side in a triangular pattern to facilitate fastening the axe to a shaft. Most likely the two were attached at an angle ⌐ .[1] Similar *chi* axes have been excavated from the late Shang sites at Anyang,[2] although most of the excavated axes have only a single central perforation for the attachment of a shaft. The *chi* axe does not seem to have existed in the Neolithic period and is a rather sophisticated tool, indicating the advanced development of the society which used it.[3] Shang.

Published: Joan Hartman, *Chinese Jade Through the Centuries* (New York, 1968), p.13, no.3; *The Minneapolis Institute of Arts Bulletin* 39, no.18 (1950), 88.

[1] Na Chih-liang, *Yü-ch'i t'ung-shih*, vol.1 (Hong Kong, 1964), 156, illus.86.
[2] Li Chi, 'Yin-hsü yu-jen shih-ch'i t'u-shuo,' *BIHP* 23 (1952), 523–619 and pl.8:A93; J.G. Andersson, 'Prehistory of the Chinese,' *BMFEA* 15 (1943), 252–255 and 261–270.
[3] Li Chi, *op. cit.*, pp.223, 614.

## 15 CEREMONIAL MINIATURE *CHI* AXE

**Mottled tan jade (darker at handle); stem of bronze; patinated band decoration of inlaid turquoise and crystal between the handle and blade body; traces of red pigment.**
**Length 7 in; width 2⅛ in; thickness ¼ in.**
**Bequest of Alfred F. Pillsbury, 50.46.269**

This miniature *chi* axe is composed of three parts: the jade blade, bronze handle sleeve, and jade handle. The blade has an elongated trapezoidal shape, with flanged teeth projecting from its two long sides, and is similar to axes excavated from Yin-hsü.[1] A central perforation is located near the top of the plain blade.

The handle of this axe inserts into a bronze sleeve, the band of which is decorated with inlaid turquoise and crystal in a rendering of a large, rectangular eye with curved lines on either side, a design commonly seen on Shang bone carvings.[2] The jade handle is wide and long and *en face* depicts an animal mask with double-line, slanted, rectangular eyes and two large horns. The mask resembles a jade mask excavated from Anyang.[3] The long sides of the handle are also flanged. Surmounting the base of the handle is a tiger in profile with the large head, large ear, and curled tail characteristic of the Shang style.[4]

It should be noted that the jades used for the blade and handle are of different color and texture, and the carving techniques in both are also quite different. While the handle is definitely Shang, the blade was perhaps made at a slightly later date. The composition as a whole is probably a later juxtaposition not intended by the original artist.

[1] Li Chi, 'Yin-hsü yu-jen shih-ch'i t'u-shuo,' *BIHP* 23 (1952), pl.8.
[2] S. Umehara, *Inkyo* (Tokyo, 1964), pl.46; W.C. White, *Bone Culture of Ancient China* (Toronto, 1945).
[3] S. Umehara, *Shina kogyoku zuroku* (Kyoto, 1955), pl.70; S.H. Hansford, *Chinese Carved Jades* (London, 1968), pl.8:a.
[4] S.H. Hansford, *op. cit.*, pl.4; S. Umehara, *Inkyo* (Tokyo, 1964), pl.143.

## 16 CEREMONIAL BRONZE AND JADE *KO* BLADE

**Green jade with brown markings; bronze with green crystal-like inlay.**
**Length 10¾ in; width 1 13/16 in; thickness ⅛ in.**
**Bequest of Alfred F. Pillsbury, 50.46.15**

Unlike the plain jade *ko*, the bronze and jade *ko* was not a practical weapon, being used only for ceremonial displays, stage performances, and burials. The artist's primary concern was for aesthetic excellence rather than practicality; hence the workmanship was elaborate and the materials precious. This ceremonial blade is one of the best examples of an early *objet d'art* in China. The Minneapolis Institute of Arts Collection contains three bronze and jade *ko*. Similar types were excavated from the well-known late Shang site at Anyang, substantiating the dating as well as the significance of the pieces in this collection.[1]

The stylized bird motif on the hilt is popular on Shang pieces. The plain bronze area between the hilt and blade functioned to fasten the *ko* to a spear,[2] and the two perforations on the blade possibly were used for attaching additional decorative tassels in order to further enhance the aesthetic appeal of the piece. The green crystal-like inlay, which is often mistaken for turquoise, is probably glass. Shang.

[1] Li Chi, 'Chi Hsiao-t'un ch'u-t'u chih ch'ing-tung ch'i,' *KKHP*, 1949, no.4, pp.38–54.
[2] *Ibid.*, p.40; Li Chi, 'Yü pei ch'u-t'u ch'ing-t'ung kou-ping fen-lei t'u-chieh,' *BIHP* 22 (1950), 1–18.

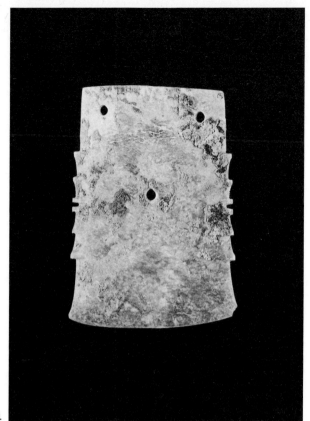

14

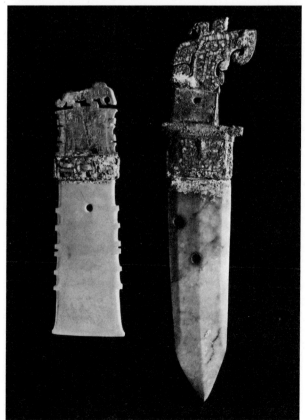

15,16

## 17 CEREMONIAL *KO* DAGGER

**Grey-green jade with white striations; bronze handle with green crystal-like inlay; highly patinated.**
**Length 9¼ in; width 3 in; thickness 3/16 in.**
**Bequest of Alfred F. Pillsbury, 50.46.123**

Similar to the ceremonial *ko* blade No.16, this *ko* dagger has a jade blade and bronze handle and in technique, composition, and decoration is executed in the artistic convention of the Shang. The shortness of its jade blade in proportion to the length of the bronze hilt is slightly unusual. Shang.

## 18 CEREMONIAL *KO* DAGGER

**Opaque white jade blade; bronze handle, patinated and inlaid with green crystal chips.**
**Length 9 in; width 3½ in; thickness 3/16 in.**
**Bequest of Alfred F. Pillsbury, 50.45.124**

Similar to the two previous blades, this *ko* dagger is most unusually short. The shortness of the blade in relation to the length of the handle gives this piece an awkward appearance. The original, presumably longer blade may have been broken. Shang.

## 19 CEREMONIAL SPEAR HEAD

**Greyish white jade with variations of bluish and brown clouds; bronze, hollow handle with green crystal-like inlay; highly patinated handle.**
**Length 6⅝ in; width 2¼ in; thickness 7/32 in.**
**Bequest of Alfred F. Pillsbury, 50.46.268**

Composed of a spade-shaped jade blade, this spear head has a central ridge creating a beveled surface and a cylindrical, hollow bronze hafting socket. While the surface of the blade is plain, the surface of the bronze hafting socket is covered with green crystal-like inlay.

The spear head is a weapon that is best used in attacking the enemy in face-to-face combat. It is usually fastened to a long post or hafting socket, as this piece is, and always remains in an upright position after being fastened to its post.[1] Among the findings at Yin-hsü, bronze spear heads were common, whereas stone spear heads were rare and jade nonexistent.[2] Ironically, a large number of jade spear heads of unknown provenance have survived in museum and private collections.[3] In composition the jade spear head with bronze hafting socket was derived from bronze prototypes, although the bronze spear heads were used in battle, while the jade were used for ceremonial and burial purposes.

Published: Arden Gallery, *3000 Years of Chinese Jade* (New York, 1939), p.17, no.7 and illus., p.57; *Parnassus*, 11, no.2 (1939), 29.

[1]Li Chi, 'Yin-hsü yu-jen shih-ch'i t'u-shuo,' *BIHP* 23 (1952), 523–620; *idem*, 'Yü-pei ch'u-t'u ch'ing-t'ung kou-ping fen-lei t'u-chieh, *BIHP* 22 (1950), 1–19.
[2]*Ibid.*
[3]C.T. Loo, *Chinese Archaic Jades* (New York, 1950), pl.II, no.3.

## 20 *YÜAN* DISC

**Calcified jade with remnants of green clouds from the original color; traces of red pigment and earthlike substance.**
**Diameter 4⅞ in; inside diameter 2⅝ in; thickness ⅛ in.**
**Bequest of Alfred F. Pillsbury, 50.46.374**

According to an ancient Chinese classic, the *Êrh-ya*, discs with a large central perforation were called *yüan*. Although *pi, huan,* and *yüan* discs are usually flat, this *yüan* from The Minneapolis Institute of Arts Collection has a raised ridge around either side of the central perforation. A pattern of incised concentric rings echoes this raised ridge and decorates the surfaces of both sides of the disc. Because of the inner ridge, pieces similar to this have on occasion been wrongly labeled cup stands,[1] an identification which is not completely in error because of the Ch'ing Dynasty ceramic cup stands made in imitation of the ancient *yüan*.[2] It does pose, however, the question of why there are two types of *yüan*, one with a flat surface and one with a raised ridge.

In ancient times the *yüan* probably was a solid convex disc that was thrown as a weapon. Eventually the central perforation was cut out to facilitate carrying the disc when it was not in use,[3] and in time the *yüan* lost its convex shape and became solely a decorative object. When the disc became a bracelet, a smooth raised ridge that made the disc more comfortable to wear was added around the central perforation. This is evidenced not only by this *yüan* but also by a similar one excavated at the Shang site of Hsiao-t'un.[4] It has not been uncommon to find stone *yüan* on the arms of the deceased in excavated graves dating from as early as Neolithic times.[5]

Lo Chen-yü has suggested that *yüan* also served as ceremonial objects when subjects greeted the king, a function which he feels is reflected in the composition of the original Chinese character *yüan*.[6]

Another speculation on this matter has been put forth by Shih Chang-ju.[7] Because excavation records show that large numbers of *yüan* discs have been found in chariot pits, he has suggested that the roundness of the discs relates to their function as connecting pieces for several parts of the chariot.

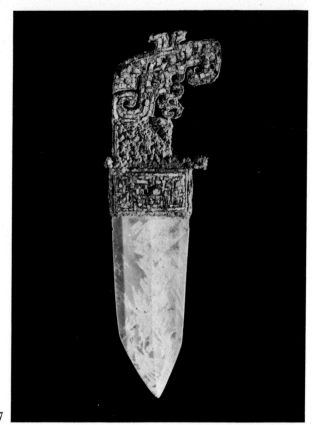

7

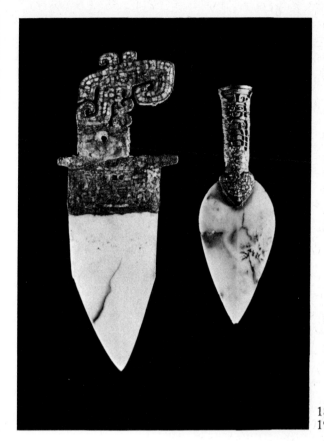

18
19

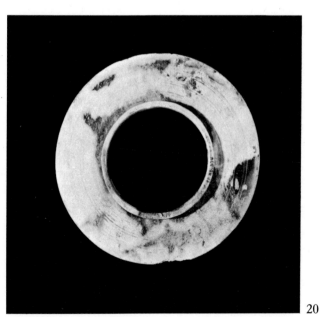

20

[1] A. Salmony, *Chinese Jade Through the Wei Dynasty* (New York, 1963), pp.45, 49; pl.vi:4.

[2] An actual Ching Dynasty cup stand in the National Palace Museum in Taiwan that can be used for comparison is reproduced in *Illustrated Catalogue of Chinese Government Exhibition for the International Exhibition of Chinese Art in London*, vol.2 (London, 1936), pl.86.

[3] Na Chih-liang, *Yü-ch'i t'ung-shih*, vol.1 (Hong Kong, 1964), 60–61.

[4] Shih Chang-ju, 'Hsiao-t'un Yin-tai Ping-tsu chi-chih chi ch'i yu-kuan hsien-hsiang', *BIHP*, Special Issue, vol.4, part 2 (1960), 783.

[5] *Wen-wu*, 1972, no.5, p.25.

[6] Lo Chen-yü, 'Shih-yüan,' *Yung-fen hsiang-jen kao chia; Yün-ch'uang man-kao* (Tientsin, 1918). Reprinted in *Lo Hsüeh-t'ang hsien-shêng ch'üan-chi* (Taipei, 1968), p.2.

[7] Shih Chang-ju, *op. cit.*

## 21 HUMAN-FIGURE PENDANT

**Pale green translucent jade; traces of earthlike substance.**
**Height 2¾ in; width 1 7/16 in.**
**Bequest of Alfred F. Pillsbury, 50.46.328**

Shang craftsmen frequently solved the problem of representing the human figure by depicting it in a half-squatting, half-sitting position, as was done in this pendant of a crouching man.[1] Incised double lines create a large, stylized eye near the top of the head and decorate the wing-like coiffure, the body, and the limbs of the figure. Despite these lines, the various parts of the body cannot be identified with any certainty. A cross inside a circle, a design often found on objects from the Shang period, appears near the pendant's lower edge.

There are four perforations in this piece,[2] the largest of which was drilled from front to back just below the figure's waist. Because this perforation is too large in relation to the size of the figure to have been a pendant hole and because a pendant would not require the shallow, vertical groove in the center of the underside, it would seem fairly certain that this figure was once a fitted ornament, attached to another object through this large perforation. Three additional perforations are located on the back of the figure along the central groove. A vertical bore hole drilled from the top of the head to the back of the neck connects two perforations, while a third one at the base of the figure is connected by another bore hole to the large perforation at the waist. Were anything threaded vertically through the perforations on the underside, the figure could not have been attached to another object through the perforation at the waist. It would seem apparent, therefore, that the three perforations in the back were added at a later date to convert the fitting into a pendant and probably were consciously adapted to the groove line already existing on the fitting. Although both sides of this piece are decorated in the same manner, the front is quite rounded, while the back is flat, a further indication that the piece was not originally created as a pendant. Even at this early date pendants usually appeared the same from either side.

In ancient times the position of a suspended pendant was seemingly of little concern. For example, a jade deer pendant from the former C. T. Loo collection has a perforation in the chest, and rabbit pendants from the same collection have perforations in the head or in the foot,[3] a consequence of these locations being that the pendants hang in a position which is quite awkward. Similarly, this piece, if suspended from the large perforation at the figure's waist, would have hung upside-down, which suggests that the three perforations were added at a much later date to make the pendant hang more attractively. Shang.

[1] Li Chi, 'Kuei-tsuo tun-chü yü chi-chü,' *BIHP* 24 (1953), 283–301.

[2] Liang Ssu-yung and Kao Ch'ü-hsün, *Hou Chia Chuang*, vol.2, *1001 M* (Taipei, 1962), illus.219:10.

[3] P. Pelliot, *Jades archaïques de Chine appartenant à M. C.T. Loo* (Paris, 1925), pls.30–31.

## 22 DRAGON PENDANT

**Calcified ivory jade mottled with blue-green clouds; traces of red pigment.**
**Length 2⅛ in; width ⅞ in; thickness ⅛ in.**
**Bequest of Alfred F. Pillsbury, 50.46.248**

In this flat pendant the dragon is shown in silhouette with a large head, slanted, rectangular eye, bottled horn, large tail and single foot, a typical Shang presentation of the subject. Both design and execution are simple. Similar examples were excavated from the Shang sites of Anyang[1] and Ta-ssu-k'ung-ts'un.[2]

There are three Shang pendants depicting the dragon and its variants in The Minneapolis Institute of Arts Collection, Nos.22, 23, and 24. No.23 has similar features, and No.24 again shows the dragon in silhouette. On the basis of composition and execution, No.24, being more formalized and lacking the very archaic naïveté of the former two, can be dated the end of Shang.

Both the identification and genesis of the dragon are still speculative. Fragmentary references to the animal are found in ancient literature, and it has been variously suggested that the dragon resembles the salamander, the horse, and the serpent.[3] Throughout the history of China the dragon has been looked upon as a divine and fantastic animal and in its totemic role has commanded authority and respect.

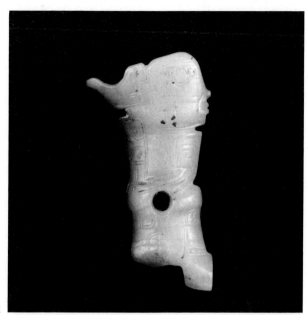

21

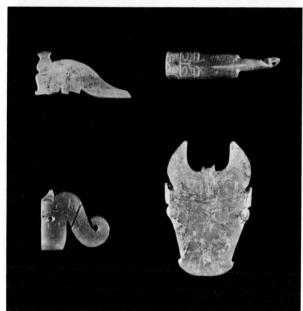

22–5

Representations of the dragon have been found in early pictographic writing,[4] although with a single foot, as shown here, the design is often mistakenly labeled a *k'uei* design, or *k'uei-wen*.[5]

[1]S. Umehara, *Shina kogyoku zuroku* (Kyoto, 1955), pl.69.
[2]*KKHP*, 1955, no.9, pp.52–57; *Wen-wu*, 1972, no.8, pp.17–25.
[3]Na Chih-liang, *Yü-ch'i t'ung-shih*, vol.2 (Taipei, 1970), 95–96.
[4]See introduction, p.14.
[5]Na Chih-liang, *op. cit.*, pp.102–103. According to the *Shuo-wen*, a *k'uei* animal is a single-footed dragon. Actually when a dragon is depicted with a single foot, it only indicates that the animal is footed and does not rigidly suggest a *k'uei* design, it being questionable if there is such an animal as a *k'uei*; after all, there are no one-footed animals.

## 23 DRAGON PENDANT

**Pale greyish green jade; traces of earthlike substance.**
**Length $2\frac{3}{8}$ in; width $\frac{9}{16}$ in; thickness $\frac{11}{32}$ in.**
**Bequest of Alfred F. Pillsbury, 50.46.256**

Seen from above, this crouching dragon in the round has identical features on both sides. The animal's bottled horns, rectangular eyes, large mouth and two feet are in relief, and its shoulder and haunch are effectively conveyed by a simple groove line. The extending tail curves into a convenient pendant hole, and a second perforation is drilled through the lower lip of the creature. Although this animal strongly resembles a tiger, and in its expression and execution is similar to a tiger pendant in the Royal Ontario Museum collection,[1] the bottled horns identify it as a dragon.

[1]D. Dohrenwend, *Chinese Jades in the Royal Ontario Museum* (Toronto, 1971), p.60 (first piece from the left).

## 24 DRAGON PENDANT

**Translucent olive-green jade; traces of red pigment.**
**Height $1\frac{1}{2}$ in; width $1\frac{7}{16}$ in; thickness $\frac{3}{4}$ in.**
**Bequest of Alfred F. Pillsbury, 50.46.350**

Depicted on a flat pendant, the large, rectangular head, straight-lined sides, and *S*-curved tail of this dragon in profile yield an abstract and compact design. Viewed from the side, the dragon resembles a semi-human face in profile. A bore hole drilled diagonally from two directions is located behind the eye on the back of the pendant. Delicate and well-executed *lei-wen* designs in thread-line

relief cover the surfaces of both sides, creating a surface decor that is characteristic of Shang jade carvings (Nos.34, 40, and 41).

Published: Alfred Salmony, *Carved Jade of Ancient China* (Berkeley, 1938), pl.XI:7.

## 25 BULL-HEAD PENDANT

**Grey-blue jade with calcification; traces of red pigment and earthlike substance.**
**Height $2\frac{3}{4}$ in; width $1\frac{13}{16}$ in; thickness $\frac{9}{32}$ in.**
**Bequest of Alfred F. Pillsbury, 50.46.267**

During the Shang and Chou periods the bull-head motif was popularly used in relief decoration and in three-dimensional statuettes.[1] The bull shown here has both the familiar *mu-lei-wen* eyes and the slightly stylized diamond pattern rendered in thread-line relief on the horns. A non-functional column which was originally between the two horns has been broken off, with only the base remaining. The slightly convex underside of the pendant is undecorated. A biconical perforation runs from the lower lip through to the backside. The simplicity and the almost crude appearance of this pendant diminish neither the great majesty of the animal's head nor the sure technique of the ancient craftsman. This piece is, indeed, one of the best of its kind. Shang.

Published: Alfred Salmony, *Carved Jade of Ancient China* (Berkeley, 1938), pl.XV:1.

[1]Chêng Tê-k'un, 'Seven Yin Sculptures from Anyang,' *Archives: Chinese Art Society of America* 2 (1947), 6–10; *Wen-wu*, 1965, no.12, p.37.

## 26 FISH PENDANT

**Highly calcified ivory jade, *chi-ku-pai* ('as white as chicken bone'); traces of red pigment and earthlike substance.**
**Chord $3\frac{1}{2}$ in; width $\frac{3}{4}$ in; thickness $\frac{11}{32}$ in.**
**Bequest of Alfred F. Pillsbury, 50.46.245**

Fishing was the most common means of obtaining food in ancient China, and it is, therefore, not surprising that the depiction of the fish was one of the most popular decorative motifs in the Shang period. As early as prehistoric times fish were shown on pottery objects,[1] and individual representations of fish made of jade or other materials have often been found in Shang tombs.[2] The semi-circular or crescent shape was a favorite of Shang craftsmen and was used for such varied motifs as birds, dragons, and stylized seated figures,[3] as well as for fish. The fish pendant shown here is a semi-circular band with raised edges

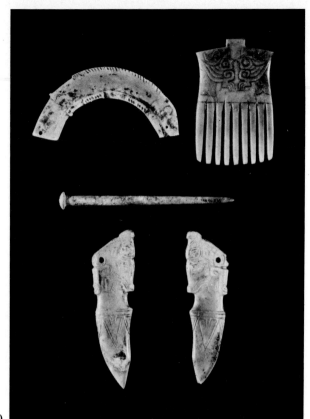

26–30

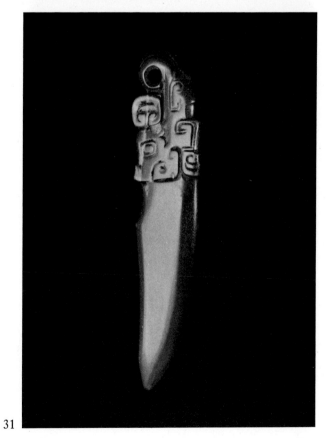

31

to represent the ventral fin on both sides of the piece along the belly of the fish. A minimum of incised detail is used to abstractly indicate the eyes and dorsal fin. Biconical perforations are located at the mouth and at the edge of the tail. A very similar fish pendant has been excavated at Hui Hsien in Honan, further evidence of the great importance of this pendant.[3] Shang.

[1]Chêng Tê-k'un, *Chinese Archaeology, Supplement to Volume One: New Light on Prehistoric China* (Cambridge, 1960), figs.10, 11.
[2]*KKHP*, 1955, no.9, pp.25–90; *Wen-wu*, 1972, no.8, p.17.
[3]*Kao-ku*, 1965, no.5, p.255 and illus.10:5.

## 27 COMB

**Calcified grey-green jade; traces of red pigment.**
**Length 3 in; width $1\frac{7}{8}$ in; thickness $\frac{7}{32}$ in.**
**Bequest of Alfred F. Pillsbury, 50.46.365**

Combs in ancient China not only served a functional purpose but also were worn as decorative hair ornaments. A comb as elegant and as delicately incised as this comb most likely would have been such an ornament. The nine teeth of this small comb are separated from the ornate handle by an incised line. The rectangular handle with slightly concave side edges has a flattened knob at the top with a horizontal perforation through it, suggesting that the comb also could have been worn as a pendant. The handle is incised with a pair of stylized birds with long, striated crests and tails, facing one another in profile, a motif that is identical on both front and back.

The jade combs excavated from the Shang site at Anyang have a small, flattened, rectangular knob on top, often with incised animal decoration,[1] and usually are additionally decorated with stylized birds and animals.[2] The presence of these two features, the flattened, rectangular knob on the top of the comb and the stylized birds on the handle,[3] relates this comb to the excavated pieces. Shang.

Published: Alfred Salmony, *Carved Jade of Ancient China* (Berkeley, 1938), pl.XVI: *The Minneapolis Institute of Arts Bulletin* 31, no.33 (1942), 113; Joan Hartman, *Chinese Jade Through the Centuries* (New York, 1968), p.14, no.6.

[1]S. Umehara, *Inkyo* (Tokyo, 1964), p.85.
[2]*Ibid.*, p.84, ill.36:2–4.
[3]Shih Chang-ju, 'Yin-tai t'ou-shih chü-lih,' *BIHP* 28 (1957), 611–670.

## 28 HAIRPIN

**Mottled grey-green jade.**
**Length $4\frac{1}{8}$ in; thickness $\frac{3}{16}$ in.**
**Bequest of Alfred F. Pillsbury, 50.46.336**

The jade hairpin shown heré is similar in form to a modern straight pin. The pin has a plain, round cap and no surface decoration. Hairpins made of bone or jade were used quite commonly in the Shang period. Unlike the simple cap of this piece, however, the heads of the hairpins often were elaborately carved.[1] Nevertheless, several such hairpins of both simple and ornate design have been excavated from Shang sites near Peking, Anyang, and Chi-nan.[2] Shang.

[1]Shih Chang-ju, 'Yin-tai t'ou-shih chü-lih,' *BIHP* 28 (1957), 611.
[2]*Ibid.*, illus.I:5. This narrow, elongated pin with a simple cap is similar to The Minneapolis Institute of Arts pin. Examples of bone hairpins can be seen in *Kao-ku*, 1963, no.3, p.117 and illus.6; *Wen-wu*, 1958, no.12, p.31; *Wen-wu*, 1959, no.11, p.8 and illus.37–38.

## 29 *MI* BOW TIP

**Calcified ivory jade, *chi-ku-pai* ('as white as chicken bone'); traces of red pigment and earthlike substance; woven texture on the underside.**
**Height $3\frac{5}{8}$ in; width 1 in; thickness $\frac{5}{32}$ in.**
**Bequest of Alfred F. Pillsbury, 50.46.257**

## 30 *MI* BOW TIP

**Highly calcified jade, ivory-colored, *chi-ku-pai* ('as white as chicken bone'); traces of red pigment and earthlike substance.**
**Height $3\frac{3}{16}$ in; width 1 in; thickness $\frac{1}{8}$ in.**
**Bequest of Alfred F. Pillsbury, 50.46.258**

These two plaques (Nos.29 and 30) are identical in size and decor, and if put together, back to back, match perfectly and become a single bow tip similar to No.31. It is most likely that these two pieces are parts of an original bow tip, especially since the fronts of both are carved with great care while the backs appear to be hurriedly done. The so-called *mi* bow tip, a small tusk-shaped object, usually inserted edgewise at either end of the bow to secure the bow string, was identified by Shih Chang-ju in his study of weapon sets excavated from Anyang.[1] This animal design, with its bottled horns, *mu-lei-wen* eye in thread-line relief, and geometric open-triangle design is depicted in the characteristic Shang style.

Published: Alfred Salmony, *Carved Jade of Ancient China* (Berkeley, 1938), pl.XII: 6–7; *The Minneapolis Institute of Arts Bulletin* 31, no.33 (1942), 117; C. T. Loo, *Chinese Archaic Jades* (New York, 1950), pl.XXIII:1, 3.

[1]Shih Chang-ju, 'Hsiao-t'un yin-tai tê ch'êng-t'ao ping-ch'i,' *BIHP* 22 (1950), 35–39.

## 31 *MI* BOW TIP

**Translucent grey-green jade with traces of earthlike substance.**
**Length $3\frac{1}{2}$ in; width $\frac{3}{4}$ in; thickness $\frac{3}{8}$ in.**
**Bequest of Alfred F. Pillsbury, 50.46.323**

This tusk-shaped object is similar to the Shang *mi* bow tip studied by Shih Chang-ju.[1] The upper portion of the piece is embellished with a compact animal motif which possibly could be identified as a profile view of a dragon executed in the Shang manner. Thread lines in high relief outline the broad jaws, rectangular eyes, single foot, and stylized *C*-shaped ears. A tail curls into a perforation above the dragon's head. Shang.

Published: Alfred Salmony, *Carved Jade of Ancient China* (Berkeley, 1938), pl.XII:5.

[1]Shih Chang-ju, 'Hsiao-t'un yin-tai tê ch'êng-t'ao ping-ch'i,' *BIHP* 22 (1950), 19–79 and illus.11.

## 32 HUMAN-HEAD FINIAL

**Mottled white jade; traces of claylike substance.**
**Length $1\frac{15}{16}$ in; width $1\frac{1}{16}$ in; thickness $\frac{9}{32}$ in.**
**Bequest of Alfred F. Pillsbury, 50.46.259**

Eloquently demonstrating the Shang portrayal of man, this finial depicts a human of decidedly distorted and unrealistic proportions whose facial features are defined by the popular *lei-wen* spiral pattern. The unnatural pose, arbitrary proportions and abstract surface patterns clearly illustrate the decorative function of Shang jade carvings. Shang.

Published: Alfred Salmony, *Carved Jade of Ancient China* (Berkeley, 1938), pl.IX:3; Shih Chang-ju, 'Yin-tai t'ou-shih chü-lih,' *BIHP* 28 (1957), illus.14:1.

## 33 ANIMAL-FACE APPLIQUÉ

**Calcified green jade; traces of earthlike substance on the back.**
**Length $2\frac{1}{4}$ in; width 2 in; thickness $\frac{15}{32}$ in.**
**Bequest of Alfred F. Pillsbury, 50.46.266**

This slightly convex appliqué is in the form of an animal mask with large curled horns similar to those of a sheep or goat. The outline of the horns is broken by a series of large rectangular teeth, and both the ears and lower side jaws project beyond the outline of the face. Incised double lines delineate a *t'ao-t'ieh* type of animal face with *mu-lei-wen* eyes, stylized nose, and comma pattern on the horns. A pair of biconical perforations has been drilled at the two sides of the lower jaw, and a second pair at the curl of each horn was never finished. Both sides of this piece are identical; however, the carving on the back side is much simpler and not so skilfully executed. This mask appliqué is quite similar to pieces excavated at Hsiao-t'un in Anyang, indicating that this piece was perhaps at one time a decorative ornament for the handle of an arrow case.[1] Shang.

[1]Shih Chang-ju, 'Hsiao-t'un yin-tai tê ch'êng-t'ao ping-ch'i,' *BIHP* 22 (1950), 21–22 and illus.32:2–4.

## 34 ANIMAL-FACE APPLIQUÉ

**Calcified tan jade with traces of red pigment.**
**Length $1\frac{1}{4}$ in; width $2\frac{1}{16}$ in; thickness $\frac{3}{16}$ in.**
**Bequest of Alfred F. Pillsbury, 50.46.265**

During the Shang period there was a tremendous variety in the animal-face motifs used as decorative elements. Masks such as this plaque appliqué, now frequently referred to as *t'ao-t'ieh*, oftentimes had specific characteristics that made it possible to identify the mask as a representation of a particular animal, such as a horned ox, a tiger, or a deer. In time, however, *t'ao-t'ieh* masks gradually became more stylized and could no longer be related to any realistic animal. C.T. Loo most curiously identified this mask as a pair of deer in profile.[1] It is perhaps best simply to call this piece an animal face, without imposing any specific identification on it.

In addition to the three-horned antlers, the mask has a flanged outline and wide, hooked side jaws that create a rhythmic and decorative silhouette. Thread lines in relief define the jaw and large nostrils of the creature as well as the bottled horns. A conical perforation has been drilled in the center of the lower jaw. The back side of the plaque is plain, indicating that the piece was applied to another object as decoration.

The stylized animal-face motif, as well as the thread-line relief, serves to date this piece to the Shang period. Among related motifs are the bronze chariot decor (M102) from Hsiao-t'un, Anyang, in which the horns of the animal are in the shape of a five-pointed star, and another piece (M40) from the same site in

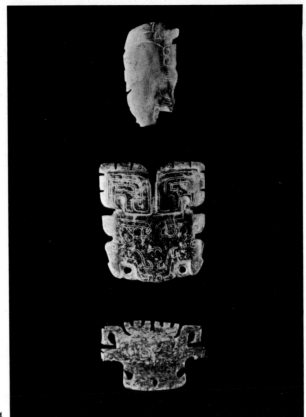

32–4

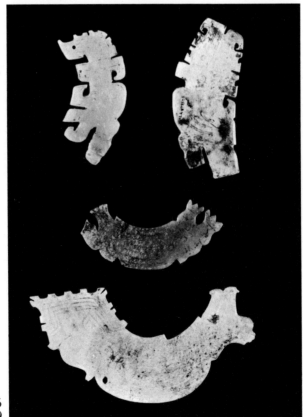

35–6
38–9

which the animal's horns form two stylized birds.[1]

Published: Arden Gallery, *3000 Years of Chinese Jade* (New York, 1939), illus.56; C. T. Loo, *Chinese Archaic Jades* (New York, 1950), pl.XXIII:2; Sueji Umehara, *Shina kogyoku zuroku* (Kyoto, 1955), pl.LXX.

[1]C.T. Loo, *Chinese Archaic Jades* (New York, 1950), pl.XXIII:2. Curiously, the author identifies this mask as a *t'ao-t'ieh* as well as two deer in profile.

## 35 BIRD PLAQUE

**Partially calcified pale green jade; traces of earthlike substance.**
**Length 3 in; width $1\frac{11}{16}$ in; thickness $\frac{1}{4}$ in.**
**Bequest of Alfred F. Pillsbury, 50.46.225**

A profile depiction of a stylized bird, this plaque is among the finest of the pieces dating from the Shang period. The flanged outline of the piece accentuates the bird's large crest and its hook-shaped beak and wings. Thread lines define the circular eye and decorate the surfaces on both sides of the plaque with a chevron pattern on the beak, cowrie shells at the neck, and *C*- and *T*-shaped curves on the crest and wings. The bird's foot is crudely finished and has a well-marked cut line to facilitate its use as a fitting. A conical perforation at the tip of the crest indicates that this piece could also have been worn as a pendant.
   The composition of this bird is closely related to that of the jade bird plaque excavated at Yin-hsü.[1] The decorative patterns on the excavated bird are slightly different from those on this piece; however, similar *C*-shaped linear curves, indicating the wings, appear on the abdomens of both birds. *C*-shaped curves are a decorative motif often found on Shang objects, including the carved artifacts from Anyang.[2] Other ornamental fragments excavated at Anyang are similar in articulation and decorative design to the flanged beak, wings, tail, and crest of this plaque. This bird, therefore, is very characteristic of the Shang style in its composition, its decorative patterns, and its thread-line surface designs. It is, moreover, a distinguished example of Shang craftsmanship. Shang.

[1]Liang Ssu-yung and Kao Ch'ü-hsün, *Hou Chia Chuang*, vol.2, *HPKM 1001* (Taipei, 1962), illus.117:15.
[2]*Ibid.*, illus.94:3A, 96, 128:6, 130:16, 157:12.

## 36 BIRD PLAQUE

**Highly calcified grey-green jade; traces of red pigment and earthlike substance.**
**Length $3\frac{1}{2}$ in; width $1\frac{3}{8}$ in; thickness $\frac{7}{32}$ in.**
**Bequest of Alfred F. Pillsbury, 50.46.274**

This plaque of a stylized standing bird seen in profile is similar in style and quality to the previous piece. The bird stands on a straight-bottomed base which has been partially broken off. Flanges outline and accentuate the projecting, blunted beak, the curved wing, and the large, upright crest. Thread lines in relief create *C*- and *T*-shaped decorative patterns which are the same on both sides of the plaque. An unfinished perforation was begun at the edge of the bird's foot.
   The flanged and curvilinear articulation of the outline of this plaque strongly resembles that of many of the fragmentary fitting parts excavated at Yin-hsü.[1] The rather elegant bifurcated crest seen on this bird is a feature most commonly found in the bird motifs decorating *ko* daggers.
   Thread-line carving was a technique widely used in the Shang period. The thread-line patterns on this plaque are executed with great skill and create beautiful surface decorations that enhance the aesthetic quality of the entire piece. It is regrettable that this exquisite plaque has been so greatly damaged by breakage and calcification. Shang.

[1]Liang Ssu-yung and Kao Ch'ü-hsün, *Hou Chia Chuang*, vol.2, *HPKM 1001* (Taipei, 1962), illus.156:9. Also see No.35 in this catalogue.

## 37 BIRD FINIAL

**Pale green translucent jade; traces of red pigment and earthlike substance.**
**Length $3\frac{5}{8}$ in; width $2\frac{1}{4}$ in; thickness $\frac{7}{32}$ in.**
**Bequest of Alfred F. Pillsbury, 50.46.224**

A finial in the shape of an inverted capital letter *L*, this unusual piece represents a highly abstract birdlike animal. One side of the finial forms a concave lunar curve. The outlines of the other two sides are serrated by a series of irregularly spaced, curvilinear spirals that create a highly decorative silhouette, yet make it difficult to decipher the features of this fantastic bird with any satisfaction. Thread lines in low relief form the bird's large circular eye and *lei-wen* designs which, in combination with striations, decorate the surface of the piece and possibly represent the wings and crest of the bird. The loose composition and the juxtapositioning of decorative motifs evident in this piece, however, can only suggest a very fanciful bird. The execution of the thread-line decoration on this finial is the same as that on the previous two bird plaques (Nos.35, 36).

A small, projecting column at the base of this piece indicates that it was to be fitted into another object and was probably used as a finial. The prominent curved beak and large stylized crest of this imaginary bird strongly resemble the bird motifs often found on the handles of bronze or jade *ko* daggers; therefore, it is likely that this finial was used to decorate bronze weapons or knives. Shang.

Published: Arden Gallery, *3000 Years of Chinese Jade* (New York, 1939), p.71, no.144. Sueji Umehara, *Shina kogyoku zuroku* (Kyoto, 1955), pl.xxii:2.

## 38 BIRD PLAQUE (FITTING)

**Mottled tan jade; traces of red pigment.**
**Length 3¼ in; width 15/16 in; thickness⅛ in.**
**Bequest of Alfred F. Pillsbury, 50.46.272**

This flat, *huang*-shaped plaque takes the form of an unusual, stylized birdlike animal. The creature is seen in profile and, although it has the wing and tail designs characteristic of Shang birds, its head is not that of a bird. The animal has a blunted beak, a short, curved tail, and a pair of bottled horns in place of a crest. A relief carving technique has been used to highlight the features of the animal as well as the circular *lei-wen* and striation designs that decorate its surface. The foot has been broken, but it may once have been used to fit the plaque into another object.

There are three other *huang*-shaped pieces in The Minneapolis Institute of Arts Collection which also show a birdlike figure with a head similar to the one on this plaque. The animal on the piece that follows is very similar to this one, except for the plumed crest that replaces the bottled horns. Nos.103 and 104 are semicircular pendants that have a head at each end, but it is difficult to discern whether the pair of heads on either piece is that of a man or of a bird.

Alfred Salmony illustrates four pieces similar to those in this collection in his book *Carved Jade of Ancient China*.[1] One of the pieces, which Salmony calls a 'Deity', closely resembles this plaque, although Salmony's figure has both a human head and a human body.[2] It would seem apparent, however, that this piece in The Minneapolis Institute of Arts Collection represents a being with a human head and a bird body. Such creatures existed in ancient myths, and in the *Shan-hai-ch'in* (Hills and Rivers Classic) both gods and human-headed figures with bird bodies are described.[3] Accordingly, this plaque must depict a mythological god that was part man and part bird. In ancient times pendants and plaques were used not only as decorative ornaments but as talismans to protect the wearer from evil and bad fortune. Thus this figure of a mythological

god was most likely used for such a purpose, the powerful horns serving as an added indication of its protective capabilities. Shang.

[1] A. Salmony, *Carved Jade of Ancient China* (Berkeley, 1938), pls.x:1; xviii:1, 2; xx:3.
[2] *Ibid.*, pls.x:1; xx:3.
[3] *Shan-hai-ch'in*, vol.6, p.36 and vol.7, p.43. A translation of this reference is given in F. Waterbury, *Early Chinese Symbols and Literature: Vestiges and Speculations, with Particular Reference to the Ritual Bronzes of the Shang Dynasty* (New York, 1942), p.120.

## 39 BIRD PLAQUE

**Calcified jade which now appears opaque ivory; traces of red pigment.**
**Length 5¼ in; width 1⅞ in; thickness ⅛ in.**
**Bequest of Alfred F. Pillsbury, 50.46.270**

Another mythological deity with a human head and bird body, this flat *huang*-shaped plaque is similar both in composition and design to the previous piece. The stylized figure is seen in profile, and its flanged silhouette accentuates the large crest, the blunted beak, and the double-petalled, plumed tail. The extra tail-like section was used to fit the plaque into another object. Engraved linear *lei-wen* designs and variations on a *C*-comma pattern further stylize the animal and provide an overall surface decoration. A conical perforation is located at the top of the crest. Both sides of the piece are identical.

The head ornament of this deity is in the shape of a stylized plume. The serrated outer section of the headdress may well represent a hair ornament. This stylized plume motif became the conventionalized Shang manner of depicting both human hair and birds' crests. Further examples of the use of this convention in this collection are seen in the birds' plumes on the handle of the small Shang comb, No.27, the crest of the stylized bird, No.35, and the headdress of the figurine, No.32. In his book. *Carved Jade of Ancient China*, Alfred Salmony also illustrates two deity figures with horizontally arched, striated *S*-curve designs to represent hair.[1] Shang.

[1] A. Salmony, *Carved Jade of Ancient China* (Berkeley, 1938), illus.xx:2,3.

Published: *The Minneapolis Institute of Arts Bulletin* 31, no.33 (1942), 116.

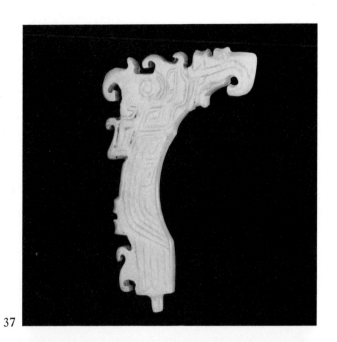

37

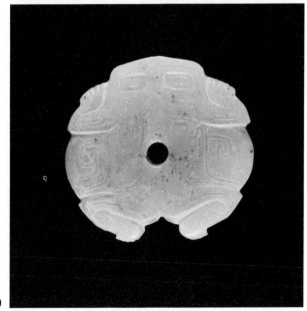

40

## 40 TOAD INLAY

**Light green translucent jade; traces of earthlike substance.**
**Diameter 2 in; thickness $\frac{15}{16}$ in.**
**Bequest of Alfred F. Pillsbury, 50.46.273**

A slightly concave, high-relief disc in the form of a crouching toad, this piece is remarkable for the great beauty of its workmanship. The toad is depicted as if seen from above, and all four of its legs are visible within the outline of the expanded circular belly. Thread lines creating a spiral *lei-wen* pattern represent the toad's two large eyes and provide a decorative design on its back. A central perforation has been drilled vertically through the piece from both sides. The underside of the animal is plain except for an incised fitting ring around the circumference of the disc and two slanted bore holes, one at the mouth and one at the tail. A bore hole has been drilled horizontally from the center of the mouth to the middle of the underside.

This toad inlay is related to the carved toad decoration on a stone architectural stand excavated at Hou Chia Chuang.[1] The shape of the inlay and the decorative pattern on the toad's back are also quite similar to those of another stone toad from Hou Chia Chuang, although the excavated toad is oval-shaped rather than round.[2] Shang.

Published: Alfred Salmony, *Carved Jade of Ancient China* (Berkeley, 1938), pl.xix:5.

[1]Liang Ssu-yung and Kao Ch'ü-hsün, *Hou Chia Chuang*, vol.2, *HPKM 1001* (Taipei, 1962), illus.82.
[2]*Ibid.*, illus.94:3A.

## 41 HANDLE

**Highly calcified ivory jade with blue clouds; traces of red pigment and earthlike substance.**
**Length $4\frac{3}{8}$ in; width $1\frac{5}{8}$ in; thickness $\frac{15}{32}$ in.**
**Bequest of Alfred F. Pillsbury, 50.46.263**

This ornate handle fitting takes the form of a crouching dragon seen in profile. Thread lines on both sides of the piece define a *mu-lei-wen* eye, bottled horns, a long, angular, striated tail, and a single claw. The strongly flanged outline of the handle, slightly thinner than the rest of the piece, is a feature characteristic of many Shang artifacts.[1] A single perforation for attaching the handle has been drilled from one side at the stem of the fitting. The composition of this dragon is quite similar to that of a decorative motif on a jade *chüeh* excavated at Shan-tung,[2] although the striated lines which form the body of the dragon are absent on the *chüeh*. Shang.

Published: Alfred Salmony, *Carved Jade of Ancient China* (Berkeley, 1938), pl.xiii:3; *The Minneapolis Institute of Arts Bulletin* 31, no.33 (1942), 114.

[1]Chêng Tê-k'un, *Archaeology in China*, vol.2, *Shang China* (Cambridge, 1960), p.120; Liang Ssu-yung and Kao Ch'ü-hsün, *Hou Chia Chuang*, vol.2, *HPKM 1001* (Taipei, 1962).
[2]*Wen-wu*, 1972, no.8, p.17.

## 42 HANDLE

**Dark green jade; traces of earthlike substance.**
**Length 5 in; width $2\frac{3}{8}$ in; thickness $\frac{25}{32}$ in.**
**Bequest of Alfred F. Pillsbury, 50.46. 277**

Although appearing heavy and clumsy, this handle is similar to the previous piece in composition and carving technique. Differences lie in its greater width and thickness, shorter handle stem carved with striated lines for gripping, and dragon design. This dragon is also in a crouching position but has ears rather than horns, *lei-wen* patterning decorating the body, rather than striations, and a lower lip which curves upward rather than downward. A biconical perforation, which is also decorated with incised striations, is found at the stem of the fitting. Shang.

Published: Alfred Salmony, *Carved Jade of Ancient China* (Berkeley, 1938), pl.xiii:2.

## 43 *YA-CHANG* SCEPTER

**Mottled brown jade with light and dark clouds.**
**Length $16\frac{1}{8}$ in; width $4\frac{1}{4}$ in; thickness $\frac{3}{8}$ in.**
**Bequest of Alfred F. Pillsbury, 50.46.313**

This long scepter with its trapezoidal blade corresponds to Wu Ta-ch'eng's description of the Chou period *ya-chang* ceremonial scepter.[1] A *chang*, defined in the *Shuo-wen* as 'half of a *kuei* tablet,' was an object with a diagonal blade, and a *ya-chang* was a *chang* with teeth in the area between the blade and the handle, like those on the piece shown here.[2] The Minneapolis Institute of Arts *ya-chang*, however, differs slightly from Wu's illustration in that it has two protruding teeth rather than a single one. Particularly in the Chou period, *ya-chang* scepters were used in the administration of military posts and the mobilization of troops.

The shapes of this scepter and No.11 are very similar, but the series of elaborate stylized teeth on the axe has become a single pair of very simple teeth on the scepter. Instead of ending with the concave blade of the axe, the *ya-chang* ends with a convex, curved cutting

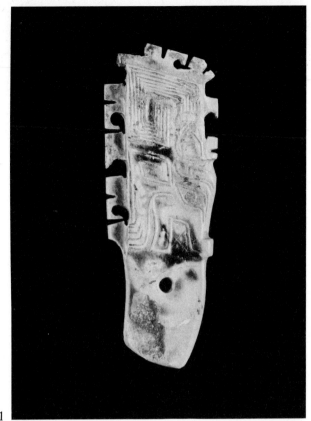

41

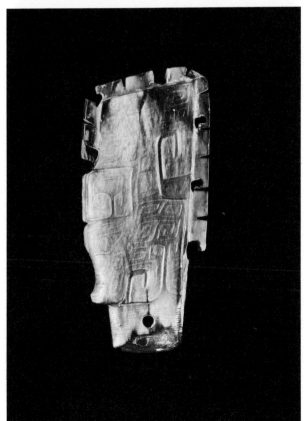

42

edge with a sharp tip. These differences evidence the varying functions of the two objects: the decorative axe was used only in ceremonies and burials; the unembellished scepter was an administrative symbol reflecting the dignity of the authority it represented.

The blade of this *ya-chang* is beveled on one side only, and a crescent-shaped groove line is cut along the blade body. The hilt is slanted along the bottom and chipped at one corner. A conical perforation occurs in the stem of the hilt, parallel to the projecting teeth on the sides. Early Western Chou.

[1] Wu Ta-ch'eng, *Ku-yü t'u-k'ao* (modern reprint edited by Na Chih-liang, Taipei, 1971), pp.21, 22; Na Chih-liang, *Yü-ch'i t'ung-shih*, vol.1 (Hong Kong, 1964), 20–22.
[2] *Ibid*. Other comparative materials are: *Wen-wu*, 1966, no.1, p.58; R. S. Jenyns, *Chinese Archaic Jades in the British Museum* (London, 1951), pl.xiv, left; D. Dohrenwend, *Chinese Jades in the Royal Ontario Museum* (Toronto, 1971), p.46, center.

## 44 CEREMONIAL *KO* DAGGER

**Ivory/tan jade.**
**Length 10 in; width 2 in; thickness $\frac{1}{8}$ in.**
**Bequest of Alfred F. Pillsbury, 50.46.383**

The gentle curve of this slender dagger's long, diagonally slanted tang, as well as the fine, lustrous quality of the jade itself, makes this piece one of great elegance and beauty. The arrowhead tip of the blade is thin and sharp, and the band of lighter colored jade across the area of the tang surrounding the perforation perhaps indicates that the *ko* at one time was tied or otherwise fastened to a handle.

In the evolution of the *ko* dagger, the length of the tang tended to increase. This is particularly characteristic of the bronze *ko* with a *hu* necking,[1] which most probably was a direct influence on the form of this jade *ko*. Bronze *ko* with fully developed *hu* neckings do not antedate the Chou period and, consequently, long-handled daggers do not occur in the excavated material from the Shang site of Yin-hsü.[2] Thus, this jade *ko* could be attributed most reasonably to the Early Western Chou period.

[1] Li Chi, 'Yü-pei ch'u-t'u ch'ing-t'ung kou-ping fen-lei t'u-chieh,' *BIHP* 22 (1950), 1–19.
[2] Li Chi, 'Yin-hsü yu-jen shih-ch'i t'u-shuo,' *BIHP* 23 (1952), 523–620.

## 45 *HU* TRAPEZOIDAL CEREMONIAL BLADE

**Mottled brown-black jade spotted with yellow sparkles and clouds.**
**Length 16$\frac{1}{2}$ in; width 3$\frac{7}{8}$ in; thickness $\frac{3}{8}$ in.**
**Bequest of Alfred F. Pillsbury, 50.46.381**

## 46 *HU* TRAPEZOIDAL CEREMONIAL BLADE

**Brown-black jade spotted with yellow sparkles and clouds.**
**Length 15$\frac{7}{8}$ in; width 3$\frac{3}{4}$ in; thickness $\frac{3}{16}$ in.**
**Bequest of Alfred F. Pillsbury,  50.46.379**

In form the *hu* is reminiscent of ancient stone implements, more particularly, of elongated cutting tools.[1] During the Chou period the *hu* became a ceremonial emblem and was worn hanging from the waist as a girdle ornament.[2] Three types of *hu* blades are mentioned in the *Chou-li: t'ing* and *ta-kuei*, *hu* blades with straight, parallel short ends, a type used exclusively by the emperor; *t'u*, *hu* blades with straight, non-parallel short ends, a type used by feudal princes; and *hu* (the label for this type is the same as the generic term), trapezoidal *hu* blades with short ends which slant outward diagonally.

Despite the detailed descriptions in early literature of the *hu* blade, the surviving examples reveal many variations in size, shape, and number and placement of perforations.[4] It is likely that *hu* blades were used regularly as decorative ceremonial objects by aristocrats and commoners alike and were not made in compliance with rigid specifications.

Of the two *hu* illustrated here, No.45 is a simple, plain blade with a beveled cutting edge along one long side and three conical perforations parallel to and near the long side of the blade opposite the cutting edge. The two short sides flare outward slightly, adding length to the cutting blade. No.46 is similar to No.45, having a convex, beveled edge on one long side, three perforations, and short ends which flare out slightly. Early Western Chou.

[1] A detailed discussion of the *hu* is presented in Na Chih-liang, *Yü-ch'i t'ung-shih*, vol.1 (Hong Kong, 1964), 11–13. A discussion of stone prototypes is presented in Li Chi, 'Yin-hsü yu-jen shih-ch'i t'u-shuo,' *BIHP* 23 (1952), 523–620.
[2] Na, *op. cit.*, pp.11–13, Li Chi, *op. cit.*, pp. 523–620; Wu Ta-ch'eng, *Ku-yü t'u-k'ao* (modern reprint edited by Na Chih-liang, Taipei, 1971), pp.18–19.
[3] Na, *op. cit.*, pp.11–13.
[4] *Wen-wu*, 1972, no.4, illus.7–14 and p.29.

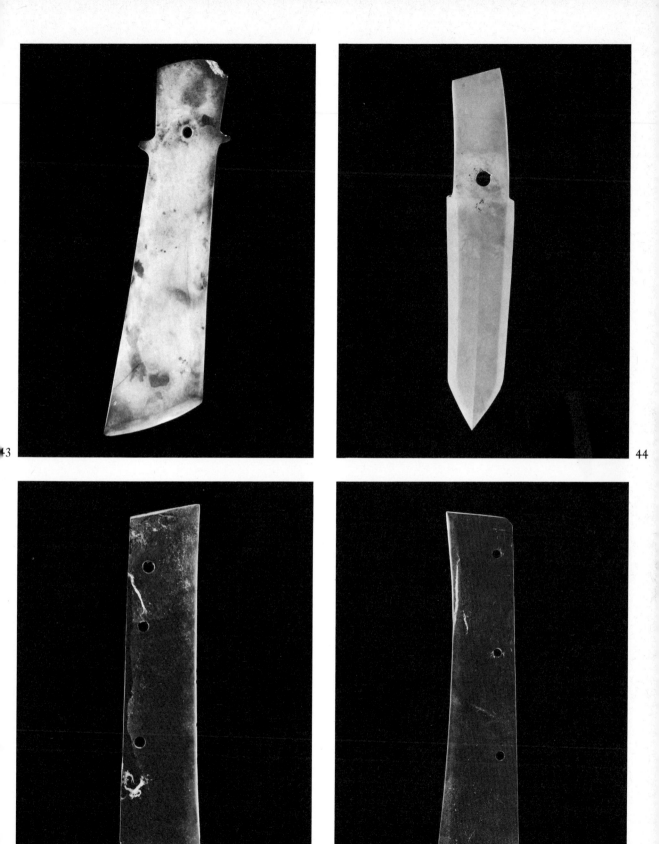

43

44

5

46

## 47 *HU* TRAPEZOIDAL CEREMONIAL BLADE

**Black jade.**
**Length 20⅜ in; width 2 11/16 in; thickness 1/16 in.**
**Bequest of Alfred F. Pillsbury, 50.46.398**

This extremely long, thin blade with finely beveled surface has four conical perforations placed in a straight line parallel to and opposite the blade edge.

This is the longest *hu* in The Minneapolis Institute of Arts Collection. Its blade length corresponds closely to that of the Imperial *hu* recorded in the 'Yü-tsao' section of the *Chou-li*,[1] and, indeed, this *hu* may have been used by the emperors in the Chou Dynasty, making this a rare and precious piece. Early Western Chou.

[1] Na Chih-liang, *Yü-ch'i t'ung-shih*, vol.1 (Hong Kong, 1964), 12. The study of early Chinese measurement is discussed in *Wen-wu*, 1957, no.3, p.25.

## 48 *HU* TRAPEZOIDAL BLADE

**Marble-grey jade with grey-black veins and ochre clouds.**
**Length 12 in; width 2 7/16 in; thickness 11/32 in.**
**Bequest of Alfred F. Pillsbury, 50.46.382**

This *hu* differs from the previous three in two respects. There is an articulated recession at one end of the blade where the jade is thinner, which suggests that the blade was designed to be affixed to a handle, and there are only three perforations, unlike the examples illustrated by Wu Ta-ch'eng, which all had four.[1] The pronounced indentation at one side of the *hu*, near its end, suggests that this *hu* was modeled after a stone cutting tool with a handle. In comparison with the three previous *hu*, the composition is less severe, illustrating an artistic freedom which points to the likelihood of its having been a rather commonplace object. Early Western Chou.

[1] Wu Ta-ch'eng, *Ku-yü t'u-k'ao* (modern reprint edited by Na Chih-liang, Taipei, 1971), illus.17.

## 49 *HU* TRAPEZOIDAL BLADE

**Mottled black jade, spotted with yellow sparkles.**
**Length 17 1/16 in; width 3 9/16 in; thickness 9/32 in**
**Bequest of Alfred F. Pillsbury, 50.46.309**

Having basically the same shape as the previous *hu*, this piece, however, has a pair of small, projecting, lunar-shaped bands at one end. Each band is composed of two small,

projecting teeth, adding a decorative element and distinguishing this blade from the severe, plain ceremonial blades. Early Western Chou.

Published: Arden Gallery, *3000 Years of Chinese Jade* (New York, 1939), p.56, no.21.

## 50 *HU* TRAPEZOIDAL CEREMONIAL BLADE

**Olive-green jade with brown on reverse side.**
**Length 11¾ in; width 3⅛ in; thickness 5/32 in.**
**Bequest of Alfred F. Pillsbury, 50.46.376**

Rather than having two short ends which flare gently outward to give a longer cutting edge, this *hu* has two short ends of different lengths, each flaring outward at a different angle and in opposite directions, resulting in a cutting edge which is shorter than the top edge. Also, the perforations are placed in unconventional positions. It is likely that this *hu* was reworked and its original form modified. The straight edges of the two short ends and the bilaterally central position of the large perforation suggest that the object was originally a *ta-kuei*.[1] Early Western Chou.

[1] Na Chih-liang, *Yü-ch'i t'ung-shih*, vol.1 (Hong Kong, 1964), 11–12; also, No.45 in this catalogue.

## 51 *PI* DISC

**Mottled green jade with brown marks; damaged along the edge.**
**Diameter 11⅜ in; diameter of inner circle 2¼ in; thickness 5/32 in.**
**Bequest of Alfred F. Pillsbury, 50.46.378**

From the Chou through the Han Dynasties, the *pi* disc was a popular and widely used ceremonial object on both religious and secular occasions. In accordance with the belief that Heaven was round and Earth was square, *pi* discs were used in imperial services for the worship of Heaven; they were used, especially *k'u-pi*, or *pi* discs adorned with grain patterns, as emblems of rank by officialdom; and they were exchanged as tokens of friendship.

According to the *Êrh-ya*, perforated discs fall into three categories: *pi*, discs with a perforation one-half the width of the jade band; *huan*, discs with a perforation the same width as the jade band; and *yüan*, discs with a perforation twice the width of the jade band.[1] Discs with these exact proportions, however, are seldom found.

Although jade *huan* and *yüan* discs are both commonly excavated from Shang sites, the *pi* discs that were excavated from Hsiao-t'un were made of stone. Those of jade seem not to

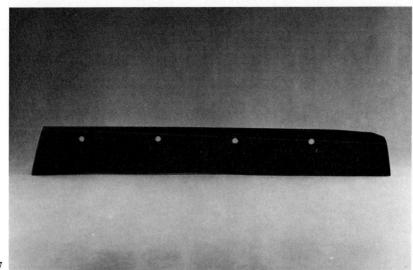

47

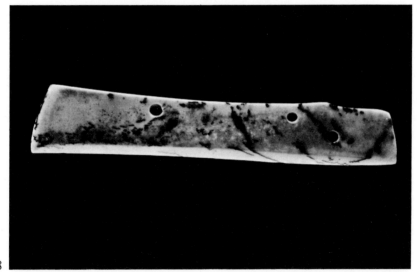

48

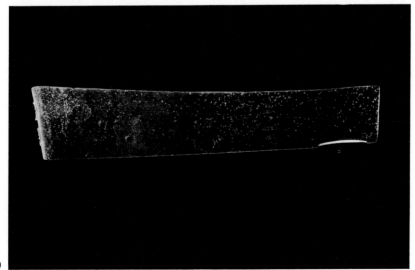

49

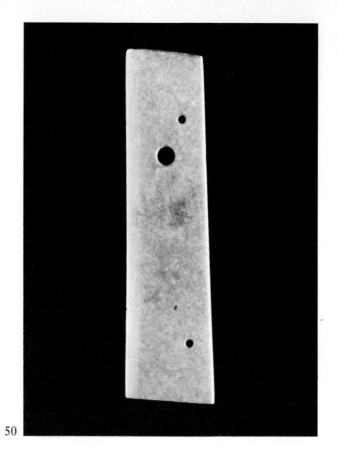

50

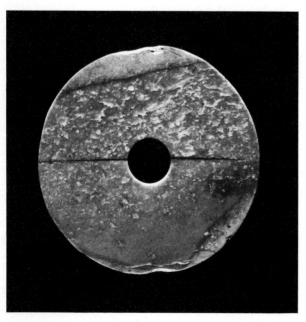

51

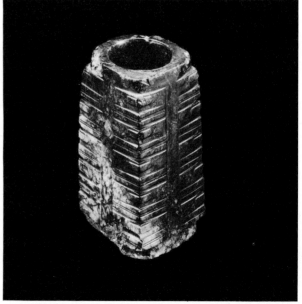

52

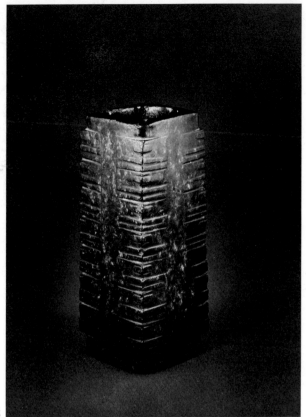

53

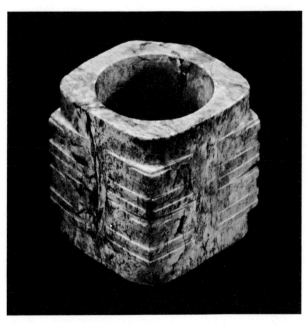

54

have become popular until the Chou period.[2]

Of the three *pi* discs in The Minneapolis Institute of Arts Collection, Nos.51, 149, and 150, this plain disc with its imperfectly round form and rough, unfinished edges reveals a certain naïveness and clumsiness in the craftsmanship and is the earliest of the three. Visible cutting marks on either of its sides indicate that sawing took place simultaneously from both sides of the disc. Although its plainness makes dating on the basis of style difficult, the very simplicity of the disc lends an unpretentious, almost archaic feeling, making it impossible to date it later than Early Western Chou. Early Western Chou.

Published: *The Minneapolis Institute of Arts Bulletin* 31, no.33 (1942), 115.

[1]A more detailed discussion of *pi* discs is presented in Na Chih-liang, *Yü-ch'i t'ung-shih*, vol.1 (Hong Kong, 1964), 17–20 and 57–61.
[2]Shih Chang-ju, 'Hsiao-t'un Yin-tai Ping-tsu chi-chih chi ch'i yu-kuan,' *BIHP*, Special Issue, vol.4, part 2 (1960), 793 and illus.7:1, 2.

## 52 *TS'UNG*

**Dark greyish-green jade.**
**Height 5⅜ in; diameter 2½ in; thickness 23/32 in**
**Bequest of Alfred F. Pillsbury, 50.46.303**

This truncated tube has slightly pyramidal exterior surfaces and short ring collars protruding from both the top and bottom. Incised channels divide the outer surface into five sections vertically and four sections around the perimeter.

During the Chou Dynasty, when rituals and emblems were established and standardized, the *ts'ung* had two functions. It was used as a symbol of Earth in worship ceremonies and as an emblem of rank by empresses and women of high station.[1]

There are numerous modern hypotheses about the origin of the form of the *ts'ung*. It has been considered a derivative of both the ancient Chinese chimney and the small *lê* bead[2] and more commonly has been considered a representation of an ancient fertility symbol.[3] Despite these speculations, a *ts'ung* like this was the result of a long process of development and modification and by the Chou period had become a standardized ceremonial object.[4] Early Western Chou.

[1]Na Chih-liang, *Yü-ch'i t'ung-shih*, vol.1 (Hong Kong, 1964), 23–27.
[2]*Ibid.*, p.24.
[3]E. Erkes, 'Some Remarks on Karlgren's Fecundity Symbols in Ancient China,' *BMFEA* 3 (1931), 63–68; B. Karlgren, 'Some Fecundity Symbols in Ancient China,' *BMFEA* 2 (1930), 1–67; Ling Shu-sheng,

'Chung-kuo ku-tai shên-chu yü yin-yan hsing-chih ch'ung-pai,' *Bulletin of the Institute of Ethnology* 8 (1959), 1–46.
[4]Similar objects, although more simplified than this *ts'ung*, have been excavated from Shang tombs and are reported in *Wen-wu*, 1972, no.4, pp.62–64; *KKHP*, 1955, no.9, pl.18:3; *KKHP*, 1972, no.1, p.59 and illus.12:3.

## 53 *TS'UNG*

**Mottled dark green jade.**
**Height 6⅞ in; diameter 2¾ in; thickness ⅞ in.**
**Bequest of Alfred F. Pillsbury, 50.46.302**

Similar to the previous *ts'ung*, this piece, however, has straight vertical sides and an incised ribbon and circle design decorating each of its four corners, an arrangement of decor that is comparable to that of a *lê* bead.[1] Early Western Chou.

[1]Na Chih-liang, *Yü-ch'i t'ung-shih*, vol.1 (Hong Kong, 1964), 24; No.52 in this catalogue.

## 54 *TS'UNG*

**Mottled pale ochre jade.**
**Height, 3 in; diameter 2¾ in; thickness ⅞ in.**
**Bequest of Alfred F. Pillsbury, 50.46.304**

Similar in both form and decoration to the previous two pieces, this short *ts'ung*[1] has an incised ribbon design that divides the perimeter of its four exterior surfaces into two sections. Early Western Chou.

[1]From its length this *ts'ung* can be classified as a *tsu-ts'ung*, a symbol of imperial power during the Chou period. Na Chih-liang, *Yü-ch'i t'ung-shih*, vol.1 (Hong Kong, 1964), 25–26.

## 55 SEATED-FIGURINE PENDANT

**Translucent white jade with opaque calcification.**
**Height 1 in; width ½ in; thickness ⅝ in.**
**Bequest of Alfred F. Pillsbury, 50.46.261**

Though miniature in scale, the solid, cylindrical shape of this figure seated with its hands on its knees makes it deceptively monumental in appearance. The nose, mouth, and *mu-lei-wen* eyes are defined by incised lines, as is the overall double *lei-wen* pattern on the surface. The hair, which is pulled tightly off the face, is composed of narrow striations. A biconical pendant hole is located at the back of the head.

Both in technique and quality this piece compares with the famous Shang seated figure

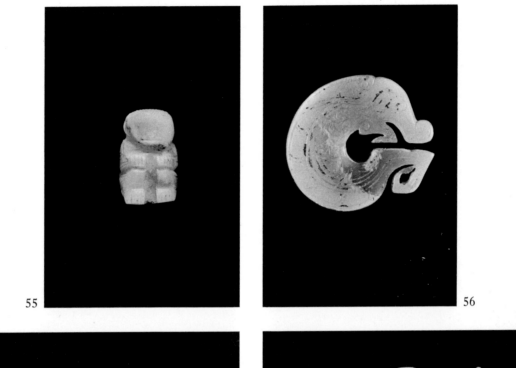

55

56

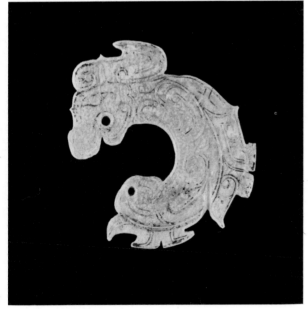

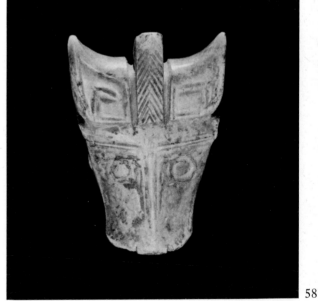

7

58

in the Ch'en Jen-dao collection.[1] The Minneapolis Institute of Arts figurine, however, differs in both pose and expression, perhaps reflecting the slightly later date and the less restricted conventions of the Early Western Chou. Early Western Chou.

[1] Chen Jen-dao, *Chin-k'uei lun-ku ch'u-chi* (Hong Kong, 1952), pl.1:1–5. This piece is also illustrated in Chêng Tê-k'un, *Archaeology in China*, vol.2, *Shang China* (Cambridge, 1960), pl.XII and p.272. Additional comparative material is found in C.T. Loo, *Chinese Archaic Jades* (New York, 1950), pl.XVII:5.

## 56 DRAGON PENDANT

**Translucent white-grey jade; traces of earthlike substance.**
**Length $1\frac{5}{8}$ in; width $1\frac{3}{8}$ in; thickness $\frac{5}{16}$ in.**
**Bequest of Alfred F. Pillsbury, 50.46.241**

Curled into a nearly circular form, this pendant portrays a dragon with a large upper lip, a short, hooked lower lip, and a tail that curves outward to form a convenient pendant hole. The engraved, stylized eye in *mu-lei-wen*, the triangular horn, the cowrie-shell design and the body striations are all rendered identically on both sides. A small bore hole is located above the dragon's head on one side of the pendant. Early Western Chou.

Published: Alfred Salmony, *Carved Jade of Ancient China* (Berkeley, 1938), pl.XXII:2.

## 57 DRAGON PENDANT

**White jade; traces of red pigment.**
**Length $2\frac{1}{4}$ in; width 2 in; thickness $\frac{1}{16}$ in.**
**Bequest of Alfred F. Pillsbury, 50.46.233**

The stylized dragon that decorates this semi-circular pendant is adorned with a *mu-lei-wen* eye, a cowrie-shell design on the unusual hooked horn, a spiral design on the flanges, and a complex double-line spiral pattern covering the surface. The pendant has a beveled surface and two biconical perforations, one between the jaws of the mouth, the other near the tip of the tail.

Although the technical execution of this piece resembles Shang workmanship, the large upper lip and small, short lower lip are characteristic of the Chou depiction of the dragon. Early Western Chou.

Published: Osvald Sirén, *Histoire des arts anciens de la Chine*, vol.1 (Paris, 1929), pl.74, bottom row; Arden Gallery, *3000 Years of Chinese Jade* (New York, 1939), p.71, no.123.

## 58 BULL-HEAD PENDANT

**Grey-green jade; traces of red pigment and calcification.**
**Height $2\frac{1}{2}$ in; width $2\frac{1}{8}$ in; thickness $\frac{7}{16}$ in.**
**Bequest of Alfred F. Pillsbury, 50.46.244**

The unpretentious simplicity of this pendant is reminiscent of similar pieces from earlier periods; however in contrast to the earlier pieces the facial expression on this bull has become extremely naturalistic. The bore hole at the lower lip of the animal has been drilled through to the back side; consequently, if this piece were worn as a pendant, the face of the bull would hang upside down. Thread lines in relief define the facial features and the stylized pattern on the horns. A vertical, rectangular column decorated with a chevron pattern is located between the two horns. Although this column may be a hatlike ornament, it has been suggested that the form and the decoration of animal masks such as this, and particularly of the column between the horns, were adapted from similar motifs on bronze vessels.[1] Because of technical limitations in casting, early bronze vessels usually had flanges, often placed at the center of an *en face* animal motif. Such flanges between the ears or horns of an animal eventually became an integral part of the entire decorative motif and were retained long after they were no longer structurally necessary. The jade lapidary who carved this pendant simply imitated the animal motif exactly as it appeared on bronze objects, reflecting in doing so the dominant position of bronzes in the art of the period. A very similar piece excavated at Feng-hsi substantiates the dating of this piece to Early Western Chou.[2] Early Western Chou.

Published: Arden Gallery, *3000 Years of Chinese Jade* (New York, 1939), p.22 and pl.65:1.

[1] T'an Tan-ch'ung, 'T'ao-t'ieh wen te kou-ch'eng,' *BIHP*, Special Issue, vol.4, part 1 (1960), 275–278.
[2] Wang Po-hung *et al.*, *Feng-hsi fa-chüeh pao-kao*, Institute of Archaeology Monograph Series D, no.12 (Peking, 1962), p.126 and illus.207:1.

## 59 BUFFALO PENDANT

**Mottled ivory-grey jade; traces of red pigment.**
**Length 2 in; height 1 in; thickness $\frac{7}{16}$ in.**
**Bequest of Alfred F. Pillsbury, 50.46.385**

This small pendant carved in the round is an extremely vivid portrayal of a young buffalo balking and resisting attempts to be pulled forward. The most essential and characteristic features of the animal have been captured with a minimum of detail, great understanding, and

charming naturalism. The incised eyes of the buffalo are the only surface details. A perforation has been drilled between the lips and through the lower jaw. Similar figures of jade have been unearthed at a Western Chou tomb in Chang-chia-p'o, Feng-hsi.[1] Early Western Chou.

[1]Wang Po-hung et al., Feng-hsi fa-chüeh pao-kao, Institute of Archaeology Monograph Series D, no.12 (Peking, 1962), p.126 and pl.85:11.

## 60 OX PENDANT

**Highly calcified, opaque white jade with little remnant of the original green color; traces of earthlike substance.**
**Length $1\frac{3}{4}$ in. height 1 in; thickness $\frac{5}{8}$ in.**
**Bequest of Alfred F. Pillsbury, 50.46.330**

This delightful pendant of a young ox carved in the round is similar in both its naturalism and its lively expression to the preceding figure of a young buffalo (No.59). The only surface decorations are the slanted, rectangular eyes and the C-spiral design on the horns. A biconical perforation runs from the mouth to the back of the lower jaw. Early Western Chou.

## 61 BIRD PENDANT

**Completely calcified jade, opaque ivory except for spots of the original translucent color; traces of red pigment.**
**Length $4\frac{7}{16}$ in; height $1\frac{1}{4}$ in; thickness $\frac{5}{32}$ in.**
**Bequest of Alfred F. Pillsbury, 50.46.237**

The elegant and graceful silhouette of this pendant outlines the form of a seated, stylized bird with a long sweeping tail. The bird has an incised round eye and diagonally striated wing feathers behind the claw, a design that is identical on both sides of the pendant. The narrow and relatively sharp tip of the bird's bifurcated tail echoes the form of a hsi, or knot opener. A small perforation is located at the front of the bird's chest.

The shape of this pendant is similar to that of a bird excavated at the Early Western Chou site of Feng-hsi.[1] Although the bird from Feng-hsi has no surface decoration, the incised lines on other excavated pieces from the same site reveal a carving technique closely related to that on this pendant.[2] Early Western Chou.

[1]Wang Po-hung et al., Feng-hsi fa-chüeh pao-kao, Institute of Archaeology Monograph Series D, no.12 (Peking, 1962), illus.85:9.
[2]Ibid., illus.85:5, 13.

## 62 BIRD PENDANT

**Translucent grey-brown jade with calcification on one side; traces of red pigment and earthlike substance.**
**Length $3\frac{3}{4}$ in; height $1\frac{3}{8}$ in; thickness $\frac{3}{16}$ in.**
**Bequest of Alfred F. Pillsbury, 50.46.229**

The stylized, seated bird seen in profile, similar to the one on the flat pendant shown here, was a motif frequently used by the Western Chou lapidary. Curvilinear spirals and striations decorate the surface on both sides of this piece and define the bird's round eye, wing, and long, bifurcated tail. Despite the fluidity and grace of this incised decor, the imposition of a semi-circular, or huang, shape on the overall form of the pendant makes the bird appear somewhat awkward. Conical perforations for stringing have been drilled in the bird's chest and tail.

## 63 BIRD PENDANT

**Calcified ivory jade; traces of red pigment.**
**Height $1\frac{11}{16}$ in; width $\frac{13}{16}$ in; thickness $\frac{3}{16}$ in.**
**Bequest of Alfred F. Pillsbury, 50.46.260**

This pendant is related to the previous pendant in its style and craftsmanship, although since it was not carved to conform to a huang shape, it lacks the stiffness characterizing the former pendant. The bird has a large winglike crest and a wide, relatively short tail that curves sharply downward, ending in a bifurcated fin. A narrow, striated fin directly behind the bird's foot perhaps indicates that the bird is a type of waterfowl. A large biconical perforation is located in the chest. Early Western Chou.

## 64 BIRD PENDANT

**Partially calcified, translucent light green jade; traces of red pigment and earthlike substance.**
**Length $3\frac{1}{8}$ in; height 2 in; thickness $\frac{5}{32}$ in.**
**Bequest of Alfred F. Pillsbury, 50.46.250**

Another flat pendant of a stylized, seated bird comparable in composition and execution to the two previous pendants (Nos.62 and 63), this piece differs from them in the complexity of its incised decor. Spiral lei-wen designs decorate the body of the bird, while simpler lines describe the large eye, wide, blunted beak, and sweeping crest. The sloping tail is bifurcated and finlike, and there is a narrow, striated fin behind the bird's leg. The protruding area above the bird's foot has no anatomic explanation and is a feature uncommon in ancient Chinese representations of birds. A biconical perforation is located in the

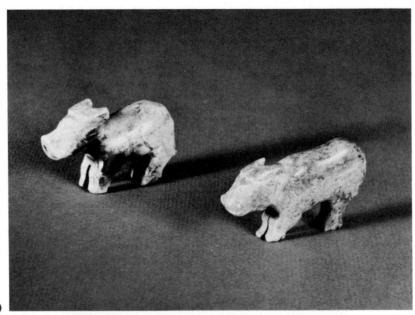

59,60

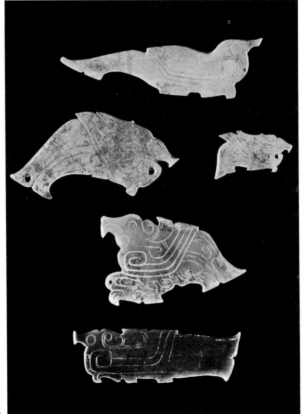

61–5

78

66

67

protuberance above the claw. Early Western Chou.

## 65 BIRD PENDANT

**Translucent deep green jade with brown clouds; traces of earthlike substance.**
**Height $3\frac{5}{8}$ in; width $1\frac{1}{8}$ in; thickness $\frac{1}{8}$ in.**
**Bequest of Alfred F. Pillsbury, 50.46.240**

While similar in execution to the preceding pieces, the stylized bird in this pendant appears to have been created in accordance with a well-defined artistic convention and is, consequently, far more precise in articulation and formalized in expression than the birds on the foregoing pendants. This bird has a long, rectangular shape and is distinguished by a blunt beak, long, bifurcated tail, and two small, striated fins behind the leg joint. A small perforation appears at the edge of the chest. The elegant simplicity and the formalized appearance of this bird are also seen in No.61. Early Western Chou.

## 66 BIRD PENDANT

**Partially calcified, mottled yellow-green jade; traces of red pigment.**
**Height $3\frac{1}{2}$ in; width $1\frac{1}{4}$ in; thickness $\frac{1}{8}$ in.**
**Bequest of Alfred F. Pillsbury, 50.46.342**

This unusual depiction of a stylized, standing bird, both in its physical appearance and its sense of elegance, resembles a motif found on Early Chou bronze vessels.[1] The bird, which may represent a peacock, has a narrow beak, a round eye carved in relief, and a prominent, truncated crest. The long, curved neck is attached to a large, awkwardly shaped wing and body section incised with spiral designs. The bird's feet are not shown, and the bifurcated tail-like appendage upon which the bird appears to stand ends in a sharpened flare. Both sides of the pendant are identical. Early Western Chou.

[1] S. Umehara, *Inkyo* (Tokyo, 1964), pl.80:1.

## 67 BIRD PENDANT

**Translucent white jade with lightly calcified underside; traces of red pigment.**
**Length $1\frac{7}{8}$ in; width $1\frac{1}{4}$ in; thickness $\frac{3}{16}$ in.**
**Bequest of Alfred F. Pillsbury, 50.46.236**

Similar in appearance to bird pendants unearthed at the well-known Early Chou sites of Feng-hsi[1] and Ta-ssu-k'ung-ts'un,[2] this flat pendant is closely related to the excavated pieces in its composition and execution. The bird's head has a large, round eye and a hooked beak. A carving technique frequently seen on Shang pieces was used to execute the spiral C-pattern and the striations that decorate the wing and curve along the plume and tail. A small perforation has been drilled at the edge of the chest. A woven texture is found on the underside of the pendant in the area near the beak. Early Western Chou.

[1] Wang Po-hung *et al.*, *Feng-hsi fa-chüeh pao-kao*, Institute of Archaeology Monograph Series D, no.12 (Peking, 1962), illus.85:9.
[2] *KKHP*, 1955, no.9, p.53 and illus.21; S. H. Hansford, *Chinese Carved Jades* (London, 1968), pl.12.

## 68 BIRD PENDANT

**Highly calcified jade with little remnant of the original grey-green color.**
**Length $3\frac{5}{16}$ in; height 2 in; thickness $\frac{7}{32}$ in.**
**Bequest of Alfred F. Pillsbury, 50.46.344**

A jaunty, stylized bird seen in profile decorates this unusual plaque-pendant. Because of the imposition of a *huang* shape on the piece,[1] the composition of the bird seems somewhat awkward, particularly the elongated body section and the wide, stiffly arched tail. Curvilinear striations and C-spiral designs decorate both sides of the pendant, and these, together with the bird's large, round eye and sprightly crest, create a lively representation of the animal and also testify to the sophisticated skill of the Chou craftsman. There are four perforations in the pendant, a small one in the chest and larger ones in the curl of the tail, the curl of the crest, and the lower curve of the beak. Early Western Chou.

[1] A line running from the broad, blunt beak, along the chest and underside of the bird, to the curled section of the tail would roughly define a semi-circle.

## 69 BIRD PENDANT

**Partially calcified light green jade; traces of red pigment and earthlike substance.**
**Length $2\frac{1}{2}$ in; height $1\frac{1}{4}$ in; thickness $\frac{1}{16}$ in.**
**Bequest of Alfred F. Pillsbury, 50.46.226**

Stylistically this extremely elegant pendant has a close affinity to bird pendants excavated at Ta-ssu-k'ung-ts'un, Anyang, in 1953.[1] These profile depictions of seated birds clearly derive from the same artistic background and conventions, sharing the characteristics of blunt beaks that curve downward to form a hook, stylized crests that are swept back in rhythmic *lei-wen* curls, and wide, sloping, flared tails. The single spiral and four upward-angled striations that define the wing of this bird

68

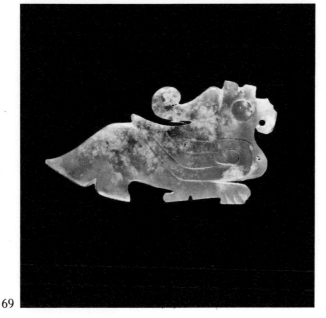

69

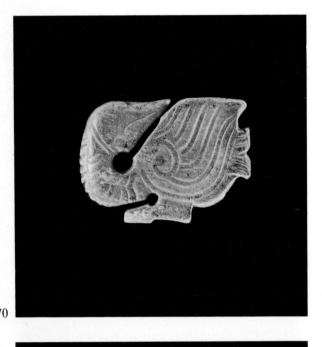

70

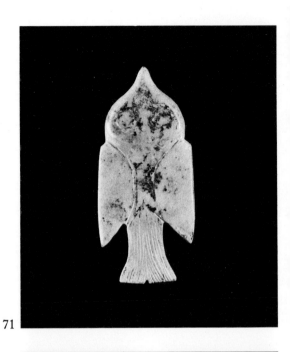

71

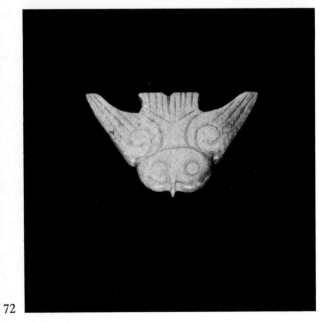

72

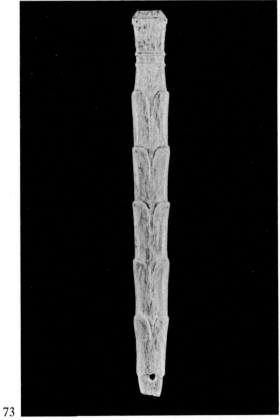

73

provide the only incised surface decoration. Two conical perforations, a small one in the chest, a larger one in the hook of the beak, indicate by their positions the sole use of this piece as a pendant. Some breakage is evident on the bird's beak. Early Western Chou.

Published: Osvald Sirén, *Histoire des arts anciens de la Chine*, vol.1 (Paris, 1929), p.74, middle row; Alfred Salmony, *Carved Jade of Ancient China* (Berkeley, 1938), pl.xviii:4.

[1] *KKHP*, 1955, no.9, p.53, illus.21; S. H. Hansford, *Chinese Carved Jades* (London, 1968), pl.12:12.

## 70 BIRD PENDANT

**Calcified ivory jade; traces of red pigment. Length 1$\frac{3}{4}$ in; height 1$\frac{1}{4}$ in; thickness $\frac{9}{32}$ in. Bequest of Alfred F. Pillsbury, 50.46.369**

Cleverly designed, this pendant shows a bird, probably a goose, with its head turned backward over its body. Perhaps because of this composition, the bird's head and neck seem rather large in proportion to the size of the body. Thread lines in relief create chevron patterns on the wide neck and curvilinear striations and a circular spiral on the wing and short, bifurcated tail. Although the use of thread lines was characteristic of the Shang period, the striations on the wing appear mechanical, and the chevron design on the neck is unknown on Shang pieces, indicating that this pendant is most likely a product of the early Western Chou. Two circular perforations with slot extensions, one at the turn of the bird's neck, separating the head from the back, and one at the base of the leg joint separating the neck from the foot, are skillfully placed so that they serve a compositional purpose as well as provide a means of attaching pendant tassels. Early Western Chou.

Published: Alfred Salmoney, *Carved Jade of Ancient China* (Berkeley, 1938), pl.xxv:8; *The Minneapolis Institute of Arts Bulletin* 31, no.33 (1942), 117; C. T. Loo, *Chinese Archaic Jades* (New York, 1950), pl.xxiii:7; Joan Hartman, *Chinese Jade Through the Centuries* (New York, 1968), p.17, pl.12.

## 71 BIRD PENDANT

**Calcified ivory jade; traces of red pigment. Length 2$\frac{1}{4}$ in; width 1 in; thickness $\frac{3}{8}$ in. Bequest of Alfred F. Pillsbury, 50.46.238**

This depiction of a stylized bird differs from the preceding bird pendants in that the creature is seen from above rather than in profile. The bird has large, round eyes; wings that are set

off from the body by simple, incised lines; and a narrow, swallowlike, scored tail. The peculiar shape of the bird's head is a feature that also appears in No.86 in The Minneapolis Institute of Arts Collection, as well as in similar birds from at least three other collections.[1] The underside of the pendant is plain with the exception of biconical perforations for stringing at the tip of the beak. Early Western Chou.

Published: C.T. Loo, *Chinese Archaic Jades* (New York, 1950), pl.xxiii:4.

[1] René-Yvon Lefèbvre d'Argencé, *Chinese Jades in the Avery Brundage Collection* (San Francisco, 1972), pl.vii; Elizabeth Lyons, *Mr. and Mrs. Ivan B. Hart Collection: Archaic Chinese Jades* (Northampton, Massachusetts, 1963), pl.xxix; A. Salmony, *Archaic Chinese Jades from the Edward and Louise B. Sonnenschein Collection* (Chicago, 1952), pl.xlvi: 1–3, 5.

## 72 BIRD PENDANT

**Partially calcified, mottled yellow-green jade; traces of red pigment. Length 1$\frac{7}{8}$ in; height 1$\frac{1}{8}$ in; thickness $\frac{7}{32}$ in. Bequest of Alfred F. Pillsbury, 50.46.343**

Another piece viewed from above, this triangular-shaped pendant shows a charming little bird with its wings spread as if in flight. The bird, which resembles a swallow with a short tail, has round eyes carved in low relief and a surface decor of simple striations and spirals composed of deep, relatively wide-cut lines. The form of the piece is skillfully tapered and subtly refined and a small, inconspicuous perforation has been drilled through the beak. Early Western Chou.

## 73 HANDLE

**Highly calcified grey-green jade; traces of red pigment and earthlike substance. Length 7 in; width $\frac{5}{8}$ in; thickness $\frac{3}{8}$ in. Bequest of Alfred F. Pillsbury, 50.46.228**

Five pairs of finely modeled petals carved in relief decorate the body of this grey-green, oblong handle. Two ridges encircle the narrower top section, and the lower end terminates with a tapered arrow curve through which a small perforation has been drilled for attaching the handle to another object. In both style and workmanship, this piece has a close affinity to The Minneapolis Institute of Arts *ts'ung* belonging to the same chronological period (No.54). Early Western Chou.

## 74 ARROWHEAD

**Calcified opaque white jade with brown and blue marks.**
**Length $2\frac{3}{4}$ in; width $1\frac{5}{8}$ in; thickness $\frac{5}{32}$ in.**
**Bequest of Alfred F. Pillsbury, 50.46.348**

Although similar in appearance to the bronze arrowheads that were used as weapons, this jade arrowhead was intended solely as a funerary object. The jade arrowhead has a broad, rounded tip rather than the sharp, pointed tip of the bronze arrowhead and, therefore, could not have served a functional purpose. The arrowhead's smooth, undecorated surface is broken only by a central ridge that runs from the shaft to the tip. Both sides of the piece are identical. Late Western Chou.

## 75 *KO* DAGGER PENDANT

**Ivory jade; traces of earthlike substance.**
**Length $2\frac{15}{16}$ in; width $\frac{15}{16}$ in; thickness $\frac{1}{4}$ in.**
**Bequest of Alfred F. Pillsbury, 50.46.264**

Although this piece has the characteristic shape of a *ko* dagger, its miniature size is indicative of its use as a decorative pendant. The straight base of the tang and the narrow, pointed tip of the blade are derived from bronze *ko*; however, to facilitate the use of the piece as a pendant, the tang of this dagger was made considerably shorter than that of its prototypes. A decorative band consisting of three sets of incised parallel lines and a pair of criss-cross patterns occurs in the area between the blade and the tang. A small perforation for stringing has been drilled from both sides at the top of this patterned area. Although miniature *ko* similar to this one were among the jades found at both Hsin-ts'un[1] and Feng-hsi,[2] this pendant surpasses the excavated pieces in elegance as well as artistic quality. Late Western Chou.

Published: Paul Pelliot, *Jades archaïques de Chine appartenant à M. C. T. Loo* (Paris, 1925), pl.VIII:7.

[1] Kuo Pao-chün, *Hsün-hsien Hsin-ts'un*, Institute of Archaeology Monograph Series B, no.13 (Peking, 1964), pl.101:7.
[2] Wang Po-hung *et al.*, *Feng-hsi fa-chüeh pao-kao*, Institute of Archaeology Monograph Series D, no.12 (Peking, 1962), pl.86:6.

## 76 STANDING FIGURE

**Translucent green jade; traces of earthlike substance.**
**Length $2\frac{3}{8}$ in; width $1\frac{3}{16}$ in; thickness $\frac{9}{16}$ in.**
**Bequest of Alfred F. Pillsbury, 50.46.246**

The solemnity of the dress of this small, standing figure characterizes the description of Chou garments in the ancient classic, the *Chou-li*.[1] This figure, apparently a male, is clothed in a square-necked robe with a long skirt, a wide sash that wraps around the waist, and long ties that fall in an axe shape from the waist. Incised lines indicate the folds of the skirt, the cuffs of the sleeves, and the collar of the robe. The striated hair of the figure is combed to the back of the head and brought out to the sides to form a rectangular, hatlike shape. Facial features are executed in low relief; detail features are only summarily defined. The convex front and flat back of this piece suggest that it was used as a fitting ornament rather than as a statuette. There are four rather crude, unfinished perforations, one above each ear and one below each shoulder. The base of the figure is broken, and a crack line extends down the left side of the figure from the jaw to the base. Late Western Chou.

Published: Paul Pelliot, *Jades archaïques de Chine appartenant à M. C.T. Loo* (Paris, 1925), pl.XLI:7; Alfred Salmony, *Carved Jade of Ancient China* (Berkeley, 1938), pl.XXI:9.

[1] M. Hayashi, 'The Dress and Head Ornament of the Statue of Man Made of Nephrite in the Western Chou Period,' *Shirin*, 1972, no.2, pp.1–38 (text in Japanese).

## 77 DRAGON PENDANT

**Calcified yellowish green jade with grey-brown and brown clouds accentuating the upper horizontal silhouette.**
**Length 3 in; height $1\frac{5}{16}$ in; thickness $\frac{5}{32}$ in.**
**Bequest of Alfred F. Pillsbury, 50.46.231**

Exhibiting remnants of Shang composition, this dragon is depicted in profile with a large head, short body, bottled horn, single foot, and diamond-shaped eye; yet the rendering of the simple *lei-wen* spiral design, using a shallow, sloping cut to broaden the incised lines, is similar to the execution and artistic expression of several Chou bird pendants in The Minneapolis Institute of Arts Collection, Nos.64, 67, and 84, and the sharply tapered edge is executed in the same manner as that of the bull-head plaque, No.92, characteristic of the Chou technique.

The extra appendage behind the foreleg has no apparent function and raises the question of whether it is indeed a foot. Western Chou.

Published: Paul Pelliot, *Jades archaïques de Chine appartenant à M. C.T. Loo* (Paris, 1925), pl.XXV:7.

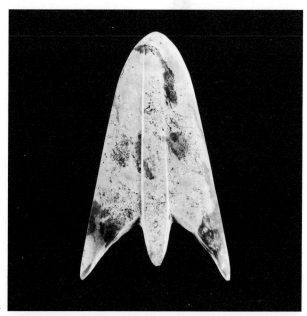

74

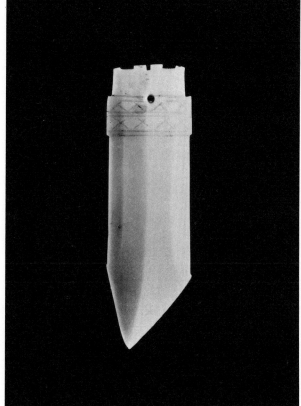

75

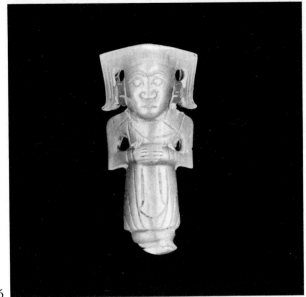

76

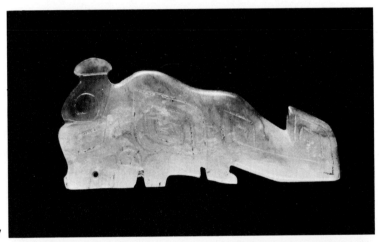

77

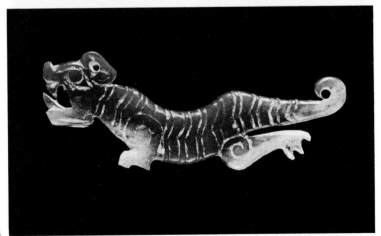

78

## 78 TIGER PENDANT

**Translucent green jade; traces of earthlike substance.**
**Length $3\frac{1}{4}$ in; height $\frac{7}{8}$ in; thickness $\frac{3}{16}$ in.**
**Bequest of Alfred F. Pillsbury, 50.46.252**

This lively pendant shows a magnificent stylized tiger with legs spread and back arched in a ferocious and powerful leap. Although the high degree of stylization in this pendant tends to obscure the natural tiger likeness, the overall spirit of the piece vividly conveys the tiger's ferocity and agility. The animal's large head has *mu-lei-wen* eyes and a snarling, open mouth with two long fangs. Prominent wavy striations decorate the tiger's slightly curved body, and stylized comma spirals mark the joints of the short front paws and the long rear legs. The claw-like feet, particularly evident on the back legs, are rarely seen in works of this period. The curl of the animal's tail creates one pendant hole and a second hole is located in the middle of the ear. Both sides of the piece are identical.

The shape of this pendant is similar to those of two other pieces in The Minneapolis Institute of Arts Collection, a tiger pendant (No.79) and a composite animal pendant (No.80), dating from the same period. All three of these pendants are executed in a manner common to the Late Western Chou or Early Eastern Chou periods.

The *mu-lei-wen* eyes, the nearly equal size of the upper and lower jaws, and the open mouth with protruding fangs characterizing this tiger pendant are common features in Late Shang and Western Chou representations of the tiger. In marked contrast to this, tigers in the following Eastern Chou period are usually shown with plume-like ears and large axe-shaped lower jaws.[1] Late Western Chou.

Published: Alfred Salmony, *Carved Jade of Ancient China* (Berkeley, 1938), pl.XXII:1.

[1]A. Salmony, *Carved Jade of Ancient China* (Berkeley, 1938), pls.LII:1 and XLVII:1, 7.

## 79 TIGER PENDANT

**Partially calcified, translucent green jade; traces of earthlike substance.**
**Length $3\frac{7}{8}$ in; width 1 in; thickness $\frac{5}{32}$ in.**
**Bequest of Alfred F. Pillsbury, 50.46.251**

The semi-circular shape of this pendant is reminiscent of the *huang* form frequently used by jade lapidaries in the Shang period. The pendant shows a crouching tiger with its body and long tail curved upward in a rhythmic arc. A deep wedge-shaped cut rends the tiger's neck, and a minimum number of incised lines indicate its large eye, mouth, ear, and paws. Both sides of the pendant are identical. The curl of the tiger's tail creates one pendant hole, and a second, a small conical perforation, is located between the tiger's lips. Repaired damage is visible at the middle of the tail.

Although the body of this tiger has a much greater curve, the pendant is stylistically related to the previous tiger pendant (No.78), particularly in the execution of the head. The mouths of both tigers are executed in a manner common to objects from both the Shang and Western Chou periods.

The simplicity of the carving and the unpretentious naturalism of this tiger pendant are similar in quality to that of the buffalo-head appliqué (No.92), which constitutes, along with this piece, an outstanding example of the great beauty and fine craftsmanship of the jades from the Chou period. Late Western Chou.

Published: Stanley Charles Nott, *Chinese Jade Throughout the Ages* (New York, 1937), pl.XIX:2.

## 80 ANIMAL PENDANT

**Highly calcified, opaque ivory jade; little remnant of the original green color; traces of red pigment.**
**Length $3\frac{3}{4}$ in; width $1\frac{1}{16}$ in; thickness $\frac{1}{4}$ in.**
**Bequest of Alfred F. Pillsbury, 50.46.357**

Although executed with the same simplicity and precision as the previous two tiger pendants (Nos.78 and 79), the imaginary animal motif of this *huang*-shaped pendant is unique and was perhaps derived from the descriptions of fantastic animals in early Chinese folk tales. The creature, shown in a crouching position, has a bird beak, a tiger body, and a fish tail. The large blunt beak is decorated with a chevron pattern; a *lei-wen* design outlines the eye; and a small spiral appears within the triangular shape of the stylized horn. The curled tip of the animal's wide tail creates a hook. The extra blade-like part of the tail may well have been adapted from a *hsi* ('knot opener') or used for fitting the pendant into another object. There is a biconical perforation in the front paw and a second unfinished one slightly behind it. Both sides of the pendant are identical. Late Western Chou.

Published: Stanley Charles Nott, *Chinese Jade Throughout the Ages* (New York, 1937), pl.XIX:1.

79

80

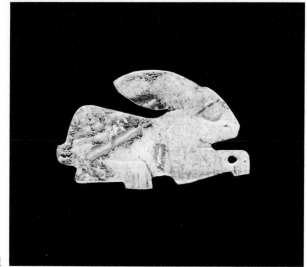

81

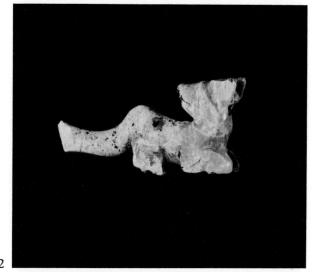

82

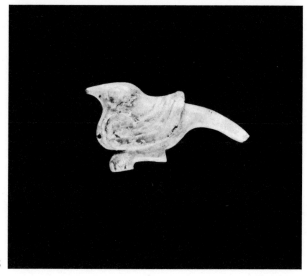

83

## 81 HARE PENDANT

**Highly calcified, opaque tan jade.**
**Length $2\frac{1}{16}$ in; height $1\frac{1}{2}$ in; thickness $\frac{3}{32}$ in.**
**Bequest of Alfred F. Pillsbury, 50.46.370**

Decorative ornaments representing the hare were quite common in the Western Chou period. The thin, flat pendant illustrated here shows a crouching hare in silhouette. A circular eye in low relief and short striations on the two paws are the only surface details, although the hare has an unusually large ear, an example of a technique often used in this period to give particular emphasis to one of the animal's unique characteristics. Despite the exaggerated and almost abstract shape of the ear and the minimal use of interior details, the artist has created a convincing and naturalistic representation of a hare. A conical perforation is located in the front paw. Both sides of the pendant are identical. Similar pieces have been excavated from the site of Hsin-ts'un in Honan,[1] providing the date of Late Western Chou or Early Warring States for this pendant. Late Western Chou.

[1] Kuo Pao-chün, *Hsün-hsien Hsin-ts'un*, Institute of Archaeology Monograph Series B, no.13 (Peking, 1964), p.64 and illus.CII:7, 8.

## 82 DOG PENDANT

**Calcified, translucent yellow jade; traces of red pigment and earthlike substance.**
**Length 2 in; height $\frac{7}{8}$ in; thickness $\frac{11}{32}$ in.**
**Bequest of Alfred F. Pillsbury, 50.46.333**

The liveliness of this animated, crouching dog carved in the round, like that of the ox surmounting the *hsi* (No.90), is achieved by the animal's gesture rather than through the use of surface decoration. The dog's head is turned and its ears are erect in an unpretentiously realistic manner; only the mouth and eyes are indicated with simple, incised lines. A pendant hole is located between the dog's ears at the back of the head. The blade at the end of the long, wide tail is similar to those often found on the tails of Shang fish and was derived most likely from the *hsi* pendant, the pointed tip of the *hsi* having been transformed in this instance into a blade. Late Western Chou.

## 83 BIRD PENDANT

**Pale grey-green jade, partially calcified.**
**Length $1\frac{3}{4}$ in; height $\frac{7}{8}$ in; thickness $\frac{3}{16}$ in.**
**Bequest of Alfred F. Pillsbury, 50.46.341**

A simply but exquisitely executed representation of a seated bird with a long, sloping tail, this pendant is carved in the round and conveys a sense of solidity and volume belying its miniature size. The bird's wings are decorated with a circular spiral design and upward-angled striations. A small biconical perforation for stringing is drilled through the front of the chest. Similar pendants have been excavated at Hsin-ts'un, Feng-hsi, and Ta-ssu-k'ung-ts'un.[1] Late Western Chou.

[1] Kuo Pao-chün, *Hsün-hsien Hsin-ts'un*, Institute of Archaeology Monograph Series B, no.13 (Peking, 1964), p.72; S. H. Hansford, *Chinese Carved Jades* (London, 1968), pl.12; Wang Po-hung *et al.*, *Feng-hsi fa-chüeh pao-kao*, Institute of Archaeology Monograph Series D, no.12 (Peking, 1962), illus.85:7.

## 84 BIRD PENDANT

**Pale ivory/grey jade, highly calcified.**
**Length 2 in; height 1 in; thickness $\frac{1}{2}$ in.**
**Bequest of Alfred F. Pillsbury, 50.46.247**

The bird pendant shown here is carved in the round, and the large eye is worked in low relief. The lower section of the blunt beak curves under to form a pendant hole, and a small perforation is located on the underside, between the legs. The bird's long tail is split at the end like that of a swallow. Three upward-angled striations in relief decorate the wings and provide the only incised surface ornamentation.

Despite the vivid overall naturalism of the bird on this pendant, its features, notably the large blunt beak, are a remnant of the Shang period and are commonly seen in birds decorating the handles of Shang *ko* daggers. The execution of this piece is comparable to that of both the previous pendant (No.83) and the buffalo-head appliqué (No.92), dating to the Chou period. Late Western Chou.

## 85 BIRD PENDANT

**Slightly calcified, translucent light green jade.**
**Length $1\frac{1}{2}$ in; height $1\frac{3}{8}$ in; thickness $\frac{3}{16}$ in.**
**Bequest of Alfred F. Pillsbury, 50.46.346**

Although lacking the elegance of the seated birds of the previous pendants, this profile figure of a duck is shown in a simple, extremely

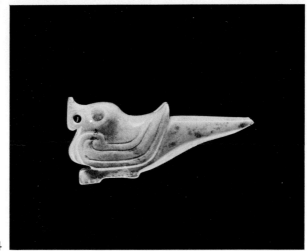

84

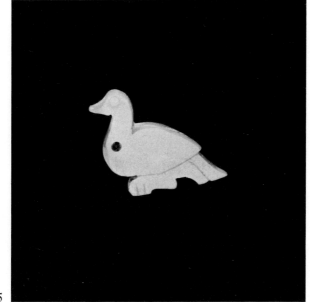

85

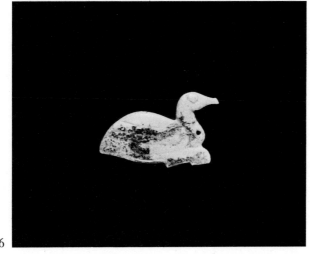

86

87

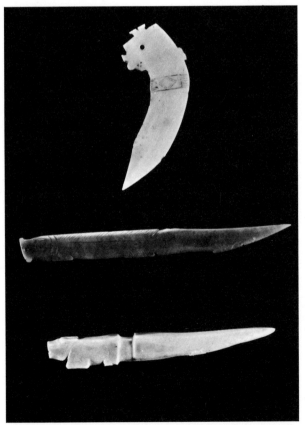

88–90

naturalistic manner. Here the Chou artist has captured not the specific likeness of the bird, but its essence; the low wings, broad body, thick neck, and large beak charmingly depict the duck's characteristic ungainliness. With the exception of the incised round eye, there is no use of descriptive surface detail, evidence not only of the artist's ability but also of his acute observation of nature. A biconical perforation for stringing is located in the bird's chest. Late Western Chou.

## 86 BIRD PENDANT

**Highly calcified jade with deep yellow-green clouds, remnants of the original color; traces of red pigment and earthlike substance.**
**Length 1¼ in; height 1 in; thickness $\frac{5}{32}$ in.**
**Bequest of Alfred F. Pillsbury, 50.46.227**

This pendant again represents a seated bird shown in profile, which, from its long neck and the shape of its head and body, can be identified as a wild goose. The Chinese, believing that mated pairs of geese remain faithful to one another for life, have always had a great fondness for the wild goose and long viewed the bird as a symbol of fidelity. It was not uncommon for a man to present his bride, at the time of their marriage, with a replica of a wild goose, often in the form of a pendant, signifying their hopes for a long and harmonious life together. Jade pendants of wild geese have also often been found among mortuary objects, a further demonstration of how highly the Chinese esteemed the bird.

The carving technique employed on this piece is similar to that on the bird pendant (No.83), particularly in the execution of the round eye and the striations and curvilinear C-spiral patterns on the wing. Comparable in its elegant simplicity to the hare pendant in this collection (No.81), the Chou craftsman has again minimized the surface detail and has relied on the expressiveness of the pendant's form to characterize the bird. A biconical perforation for stringing is located at the base of the neck. Late Western Chou.

## 87 CICADA PENDANT

**Tan jade; traces of earthlike substance.**
**Length 2½ in; width 1 in; thickness $\frac{3}{16}$ in.**
**Bequest of Alfred F. Pillsbury, 50.46.239**

Although closely resembling the cicada design found on bronze vessels from the Shang period, this stylized cicada pendant has two clawed feet distinguishing it from the popular Shang motif. The swallow-like shape of the cicada's

head and the decor are remindful of two bird pendants (Nos.71 and 72) from the Early Western Chou and make it likely that this pendant also dates from that period. The slightly convex upper surface of the piece is patterned with spiral *lei-wen* and triangle designs in unevenly and clumsily executed thread-line relief. The decor on the top part of the cicada's body is dissociated from that on the lower portion, suggesting that a later hand reworked this antique jade pendant without completely obliterating the original character of the surface pattern. The underside of the piece is undecorated. A small, conical perforation is located nearly between the cicada's large, bulging eyes. Early Western Chou.

Published: Alfred Salmony, *Carved Jade of Ancient China* (Berkeley, 1938), pl.XXVI:1.

## 88 BIRD PENDANT IN THE FORM OF A *KO* DAGGER

**Calcified ivory jade; traces of red pigment.**
**Length 2¹³⁄₁₆ in; width 1¼ in; thickness $\frac{3}{32}$ in.**
**Bequest of Alfred F. Pillsbury, 50.46.332**

Although this miniature *ko* dagger is similar to No.75, its long, pointed tip also suggests a *hsi*, or knot opener. The abstract bird motif that decorates the handle possibly is a direct adaptation of the distinctive, bird-headed bronze handles affixed to jade dagger blades in the Shang period (see Nos.16, 17, and 18); however, the decorative band of incised striations with the large, central diamond is related compositionally to decorative patterns found on objects excavated at the Western Chou sites of Hsin-ts'un[1] and Feng-hsi.[2] Although such elements occur in ornamental patterns on Shang pieces, the preciousness of the pendant, combined with its superb craftsmanship, reflects the refined artistic preferences of the latter part of the Western Chou. Late Western Chou.

[1] Kuo Pao-chün, *Hsün-hsien Hsin-ts'un*, Institute of Archaeology Monograph Series B, no.13 (Peking, 1964), illus.101:4.
[2] Wang Po-hung *et al.*, *Feng-hsi fa-chüeh pao-kao*, Institute of Archaeology Monograph Series D, no.12 (Peking, 1962), illus.86:4, 6.

## 89 *HSI* FISH PENDANT

**Green jade; traces of earthlike substance.**
**Length 4¾ in; width ⅜ in; thickness $\frac{3}{16}$ in.**
**Bequest of Alfred F. Pillsbury, 50.46.361**

This narrow pendant represents an elongated fish. One side of its triangular tail has become

the cutting edge of the *hsi*[1] and narrows to a pointed tip. Incised striations create a long dorsal and small ventral fin. A perforation has been drilled at the center of the slightly splayed snout. The exquisite and refined craftsmanship apparent in this pendant is comparable to that of the fish pendant excavated at the Late Western Chou site of Hsin-ts'un.[2] Late Western Chou.

[1]A discussion of the *hsi* pendant is presented in Na Chih-liang, *Yü-ch'i t'ung-shih*, vol.1 (Hong Kong, 1964), 67–68 and the Introduction to this catalogue.
[2]Kuo Pao-chün, *Hsün-hsien Hsin-ts'un*, Institute of Archaeology Monograph Series B, no.13 (Peking, 1964), pl.103:1.

## 90 *HSI* PENDANT

**Oyster white jade.**
**Length 4 in; thickness $\frac{13}{32}$ in.**
**Bequest of Alfred F. Pillsbury, 50.46.242**

This cylindrical tusk-shaped *hsi* pendant is surmounted by a buffalo carved in the round. A narrow concave band separates the buffalo from the lower end of the *hsi*. Although the carving is extremely shallow and economical, the buffalo likeness is both natural and lively and creates a vivid impression of vigor similar to that seen in the plaque silhouette of a hare in this collection (No.81). The technique of using broad, short, shallow cuts, such as those on the sides of the buffalo's legs, is similar to that used on the buffalo-head appliqué (No.92). Late Western Chou.

Published: *The Minneapolis Institute of Arts Bulletin* 31, no.33 (1942), 117.

## 91 HUMAN-FACE ORNAMENT

**Calcified tan/grey jade.**
**Height $3\frac{1}{4}$ in; width $2\frac{1}{8}$ in; thickness $\frac{3}{16}$ in.**
**Bequest of Alfred F. Pillsbury, 50.46.230**

This slightly convex plaque with straight bottom and circular top depicts a stylized human face with striated hair, large eyes in relief, and nose and mouth of relief bands; the back side is plain except for four pairs of bore holes indicating the piece's function as a plaque. Salmony illustrates four similar depictions of the human face.[1] The relief composition of this particular piece is very shallowly carved, a technique popular in Shang and Chou times (see nos.27, 52, 53 and 54 in this collection); however, the composition itself is rigid and conventionalized, having neither the naïveté and unpretentiousness of Shang design nor the liveliness and fluency of the Eastern Chou compositions. The piece, therefore, can be placed in the Late Western Chou period. Late Western Chou.

[1]A. Salmony, *Carved Jade of Ancient China* (Berkeley, 1938), pl.xxviii, 1, 3, 4, 5.

## 92 BUFFALO-HEAD APPLIQUÉ

**Translucent white jade with light brown clouds; traces of red pigment.**
**Height $1\frac{7}{16}$ in; width $2\frac{1}{8}$ in; thickness $\frac{3}{16}$ in.**
**Bequest of Alfred F. Pillsbury, 50.46.232**

This appliqué has the form of a frontal view of a buffalo head with two large, curved horns and projecting, grooved ears. A few simple, incised lines serve to define the *mu-lei-wen* eyes and the nose of the animal, the simplicity of the features adding to the beauty of the piece. A sense of three-dimensionality is achieved by the subtle rounding of the edges of the mask, particularly at the ears and horns. The reverse side of the piece is not decorated. A biconical perforation is situated at the position of the nostril. A similar appliqué, dated to the period of Late Western Chou or Early Eastern Chou, has been excavated at Hsin-ts'un.[1] Late Western Chou.

[1]Kuo Pao-chün, *Hsün-hsien Hsin-ts'un*, Institute of Archaeology Monograph Series B, no.13 (Peking, 1964), p.64 and illus.102:1.

## 93 CEREMONIAL *KO* DAGGER

**Tan jade with ivory-white markings.**
**Length $8\frac{5}{16}$ in; width 1 in; thickness $\frac{1}{8}$ in.**
**Bequest of Alfred F. Pillsbury, 50.46.375**

Objects retaining the original features of the *ko* dagger, but with a more simplified shape similar to that of the blade shown here, were very popular beginning in the Early Eastern Chou period.[1] This *ko* is plain except for the subtle groove line that separates the blade body from the hilt. The long blade is extremely thin, and a central ridge and two side ridges create a slightly beveled surface. A single biconical perforation has been drilled at the stem of the hilt. The thinness of this *ko* is indicative of its non-functional use. Such daggers have often been found in groups as burial or ceremonial objects.[2] Early Eastern Chou.

[1]*Kao-ku*, 1963, no.10, p.536; *Kao-ku*, 1965, no.7, p.339; Lin Shou-chin *et al.*, *Shang-ts'un-ling Kuo-kuo mu-ti*, Institute of Archaeology Monograph Series D, no.10 (Peking, 1959), illus.xxi: 8–10, xxx: 1–9.
[2]*Wen-wu*, 1972, no.4, p.29 and pl.7:17.

91

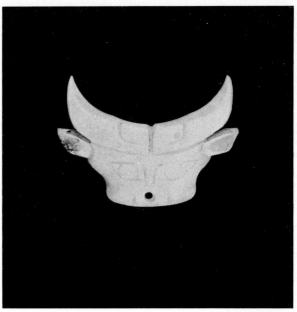

92

93

95

## 94 CEREMONIAL *KO* DAGGER

**Marbled black jade.**
**Length $7\frac{1}{4}$ in; width 1 in; thickness $\frac{5}{32}$ in.**
**Bequest of Alfred F. Pillsbury, 50.46.358**

Similar stylistically to No.93, this *ko* dagger
dates from slightly later in the Chou period.
The simple, straight form of the blade is
interrupted only by a slight curve between the
handle and the blade body. The surface of the
piece is smooth and without decoration. There
is a small perforation at the center of the
handle. Late Eastern Chou.

## 95 *CHI-HUAN* DISC WITH NOTCHES

**Pale green translucent jade with light**
**brown clouds.**
**Diameter $6\frac{3}{8}$ in; width 2 in; thickness $\frac{3}{16}$ in.**
**Bequest of Alfred F. Pillsbury, 50.46.299**

The rim of this flat, thin disc is divided into
three sections by three projecting notches with
series of four small serrations between each
notch. The surface is plain. The use of
serration on the *huan* was originally derived
from that on the *chi* axe ('serrated axe' or
'battle axe').[1] While the serration on earlier
axes functioned to secure the lashing of the
blade to the handle, the serration of later
ceremonial axes was purely decorative.[2]

Wu Ta-ch'eng, a Ch'ing Dynasty jade
scholar, believed that this type of perforated
disc with notches, the *hsüan-chi* was an
armillary sphere, a rotating part of a ritual
astronomical instrument.[3] But among the
numerous similar discs that survive, many are
decorated and lack uniformity in size and
shape; in this they fail to conform to the
conventional characteristics of ritual objects –
uniformity and simplicity. It is possible that
these perforated discs were worn as bracelets
and were purely secular decorative objects. In
addition to the numerous surviving *chi-huan*
in museums,[4] a disc comparable to this disc
has been excavated at Hsin-ts'un and is datable
to the Early Eastern Chou.[5] Early Eastern
Chou.

[1]Na Chih-liang, 'The *Ch'i-Pi* or Battle-Axe
*Pi* Disc,' *The National Palace Museum Bulletin*,
1966, no.5, pp.1–7, and 1967, no.6, pp.9–10.
See also No.14.
[2]*Ibid.*
[3]Wu Ta-ch'eng, *Ku-yü t'u-k'ao* (modern reprint
edited by Na Chih-liang, Taipei, 1971), illus.17.
[4]The Dr and Mrs Max Loehr collection; the
A.W. Bahr collection, Field Museum of
Natural History, Chicago; and the British
Museum collection.
[5]Kuo Pao-chün, *Hsün-hsien Hsin-ts'un*,
Institute of Archaeology Monograph Series B,
no.13 (Peking, 1964), p.65 and pl.50:10.

## 96 BEAR PENDANT

**Mottled pale yellow jade; traces of red**
**pigment and earthlike substance.**
**Height $1\frac{1}{4}$ in; width $\frac{15}{16}$ in.**
**Bequest of Alfred F. Pillsbury, 50.46.324**

Despite its lack of specific detail, this small,
stocky bear, carved in the round, has a surprising
degree of naturalism and is reminiscent of the
stone bear unearthed at Ho Chia Chuang.[1] The
carving strokes are clearly evident on the
uneven surface of the piece, perhaps reflecting
the influence of wood carving.[2] Early Eastern
Chou.

[1]Liang Ssu-yung and Kao Ch'ü-hsün, *Hou Chia
Chuang*, vol.2, *HPKM 1001* (Taipei, 1962),
illus.87.
[2]*Ch'u wen-wu chan-lan t'u-lu* (Peking, 1954),
pl.23:39.

## 97 OVAL TUBE

**Mottled green jade with white clouds.**
**Length $5\frac{7}{8}$ in; diameter $3\frac{3}{4}$ in; thickness**
**$\frac{5}{32}$ in.**
**Bequest of Alfred F. Pillsbury, 50.46.305**

This piece, a thin tube with one oval end and
one horseshoe-shaped end, is similar to objects
in only a few other collections.[1] Although
various suggestions have been made concerning
its function, none has been conclusive.
René-Yvon Lefèbvre d'Argencé refers to a
similar piece in the Avery Brundage collection
as a hair ornament,[2] in spite of the fact that
there is no perforation for inserting a hair pin to
fasten the tube securely. A similar tube in the
Bahr collection has been labeled a sacrificial
grain scoop by Stanley Charles Nott,[3] although
the open-ended shape would prove impractical
for this purpose. It is also possible that the tube
served as a ceremonial cuff bracelet.

The dating of the piece is both controversial
and difficult since its exact function is unknown
and since it has no surface decor. Proposed
dates have ranged from the Chou[4] and Warring
States period to the Han.[5] The tube may be
attributed tentatively to the Early Eastern
Chou, although a more correct dating will
require much research and examination of
field material. Early Eastern Chou.

[1]The Avery Brundage collection in the M.H.
DeYoung Memorial Museum, San Francisco;
the A.W. Bahr collection in the Field Museum
of Natural History, Chicago; the C.J. Hamlin
collection in the Buffalo Museum of Science,
Buffalo, New York; and the Winthrop
collection in the Fogg Museum of Art, Harvard
University, Cambridge, Massachusetts, have
similar pieces.
[2]René-Yvon Lefèbvre d'Argencé, *Ancient*

*Chinese Jades in the Avery Brundage Collection*
(San Francisco, 1971), pl.xviii.
[3]Stanley Charles Nott, *Chinese Jade Throughout the Ages* (New York, 1937), pl.xv:2.
[4]Arden Gallery, *3000 Years of Chinese Jade* (New York, 1939), pl.67:83.
[5]d'Argencé, *op. cit.*, pl.xviii.

## 98 *HSI-PI* DISC

**Translucent egg-shell grey jade with brown markings on the edge.**
**Diameter $2\frac{7}{8}$ in; inner diameter 1 in; thickness $\frac{1}{4}$ in.**
**Bequest of Alfred F. Pillsbury, 50.46.345**

Although this small *pi* disc has the proportions of a *huan*, with band and perforation of equal width, similar small discs, which were probably worn as pendants, are known as *hsi-pi*,[1] the generic term for small *pi, huan,* and *yüan* pendants. A comparable disc was excavated at Hui Hsien,[2] and there are numerous similar *hsi-pi* in museum collections. Of the five in The Minneapolis Institute of Arts Collection, three with grain pattern decoration are datable to the Eastern Chou (Nos.98, 99 and 100). The remaining two (Nos.160 and 161) are slightly oval in shape and date from the Han period. Late Eastern Chou.

[1]Na Chih-liang, *Yü-ch'i t'ung-shih*, vol.1 (Hong Kong, 1964), 87.
[2]Hsia Nai *et al.*, *Hui-hsien fa-chüeh pao-kao*, Archaeological Field Reports, no.1 (Peking, 1956), illus.78:20, 26.

## 99 *HUAN* DISC

**Pale egg-shell jade; traces of dried clay or lacquer.**
**Diameter $5\frac{3}{8}$ in; diameter of hole $1\frac{7}{8}$ in; thickness $\frac{1}{8}$ in.**
**Bequest of Alfred F. Pillsbury, 50.46.314**

Incised concentric lines enframe the spiral grain decor field of this *huan* disc. The spiral grain design has a nipple boss in light relief at the center. The long spiral tail encircling the boss lends this piece an affinity to lapidary works excavated at Shou Hsien, one of the most important Warring States sites.[1] Calcification has obliterated the decor pattern on the reverse side. Late Eastern Chou.

[1]O. Karlbeck, 'Selected Objects from Ancient Shou Chou,' *BMFEA* 27 (1955), pl.57:5; *Wen-wu*, 1956, no.5, pl.29:3; Hsia Nai *et al.*, *Hui-hsien fa-chüeh pao-kao*, Archaeological Field Reports, no.1 (Peking, 1956), illus. 76:20, 26.

## 100 *HSI-PI* DISC

**Tannish brown jade with dark brown clouds; partially calcified.**
**Diameter $2\frac{1}{8}$ in; inner diameter $\frac{7}{8}$ in; thickness $\frac{5}{32}$ in.**
**Bequest of Alfred F. Pillsbury, 50.46.287**

Triangular-shaped openwork extending from the rim of this small pendant disc suggests a serpentine animal with a large, incised *mu-lei-wen* eye. The inner and outer rims of the disc are slightly raised and enframe a decor field that is covered with a spiral-grain design. Both sides of the disc are identical.

Openwork carving extending from the outer rim of the disc was long developed by the Warring States period, a notable example of the form being the stunning Nelson-Atkins piece from the Warring States territory of Chin-ts'un.[1] An increase in the popularity of the form during the Han Dynasty can be posited from the number of such discs excavated from various Han sites.[2] Intricate openwork carving on a disc as small as this reflects both the artist's ability to manipulate the design and the decorative nature of the Han lapidary art. Han.

[1]*Handbook of the Collections in the William Rockhill Nelson Gallery of Art and Mary Atkins Museum of Fine Arts*, vol.2, *Art of the Orient* (Kansas City, Missouri, 1973), pp.22–23.
[2]*Wen-wu*, 1964, no.12, pl.2:4; *Kao-ku*, 1972, no.1, p.8; A. Salmony, *Carved Jade of Ancient China* (Berkeley, 1938), pl.xxxvii:2, 4.

## 101 *CHÜEH* DISC WITH SLIT OPENING

**Translucent white jade with calcified markings.**
**Diameter $1\frac{13}{16}$ in; diameter of hole $\frac{7}{16}$ in; thickness $\frac{3}{32}$ in.**
**Bequest of Alfred F. Pillsbury, 50.46.337**

Traditionally there have been three primary opinions on the uses of *chüeh* in ancient China. Since the objects are frequently found in pairs near the ears of skeletons in excavated burial sites,[1] it has been hypothesized that the discs were worn as ear ornaments in some yet unknown manner (because of the narrowness of the slit opening, *chüeh* could not have been attached directly to the ears; but possibly were placed on them similar to the way in which cicada-shaped funerary objects were inserted into the mouths of the dead).

A second use of *chüeh* is suggested by the old Chinese saying, 'A man of decision wears a *chüeh*.' The saying is derived from a legend in which the moment of an important decision was accompanied by the fondling of a *chüeh* pendant. In this legend the association between arriving at a decision and wearing a

98

100

*chüeh* as a pendant doubtlessly is related to the fact that the word *chüeh*, meaning 'pendant',' is pronounced the same as the word *chüeh*, meaning 'to decide.'[2]

And finally, *chüeh* considerably larger than those used as ear ornaments or pendants were given as administrative emblems and as symbols of disfavor to officials leaving Court. According to the writings of Kuan Yüng, when a *huan* disc was presented to an official with an assignment away from Court, the *huan* was a message to him that he should return again to Court; when a *chüeh* was presented to an official thus departing, it was a notice to him that he was not to come back.[3] This symbolism is reflected in the pronunciations of these two words: the word *huan* denotes both 'circular bracelet' and 'to come back,' while *chüeh* means 'a disc with a slit,' 'to decide,' and 'do not return.'

The *chüeh* shown here, judging from its small size, was probably used either as an ear ornament or as a pendant. The disc has no surface decoration, and the slit is wider at either end than it is in the center of the band. Numerous similar *chüeh* have been excavated from various Eastern Chou sites and serve to date this piece to that period.[4] Late Eastern Chou.

[1]*Kao-ku*, 1963, no.10, p.536; *Kao-ku*, 1963, no.5, p.229; *Kao-ku*, 1965, no.7, p.339; Na Chih-liang, *Yü-ch'i t'ung-shih*, vol.1 (Hong Kong, 1964), 88–89.
[2]Na Chih-liang, *op. cit.*, pp.88–89.
[3]*Ibid.*, p.87.
[4]*Ibid.*, pp.61–62.

## 102 *CHÜEH* DISC WITH SLIT OPENING

**Green jade with brown clouds and dark green moss; partially calcified on the back. Diameter 2 $\frac{3}{16}$ in; diameter of hole $\frac{7}{16}$ in; thickness $\frac{3}{32}$ in.**
**Bequest of Alfred F. Pillsbury, 50.46.271**

Although *chüeh* are frequently found near the ears of skeletons in burial sites, the fact that this disc is decorated on only one side indicates that it was probably an appliqué decoration rather than an ear ornament and that it perhaps was used in a manner similar to that of the two *chüeh* that were found attached as ornaments in a composite belthook excavated at Ku-wei-ts'un, Hui Hsien.[1] Four incised dragon heads in a comma and striation pattern decorate this *chüeh*, a motif that also occurs on a *chüeh* excavated at Shang-ts'un-ling[2] and a 'plaque ornament' found at Shou Hsien.[3] Late Eastern Chou.

[1]S.H. Hansford, *Chinese Carved Jades* (London, 1968), pl.31.
[2]Lin Shou-chin *et al.*, *Shang-ts'un-ling Kuo-kuo*

*mu-ti*, Institute of Archaeology Monograph Series D, no.10 (Peking, 1959), p.52 and illus.XLII:1, XXVI:1.
[3]Yü Shih-chi *et al.*, *Shou-hsien Ts'ai-hou mu ch'u-t'u i-wu*, Institute of Archaeology Monograph Series B, no.5 (Peking, 1956), illus.104:1–4.

## 103 *HUANG* CRESCENT-SHAPED PENDANT

**Ivory-grey jade, highly encrusted on the reverse side; traces of red pigment.**
**Length 3 $\frac{13}{32}$ in; width $\frac{3}{4}$ in; thickness $\frac{1}{4}$ in.**
**Bequest of Alfred F. Pillsbury, 50.46.243**

Two human heads in profile, one at either end of this *huang*, or arched pendant, top interlocking, serpentine bodies described by spiral bands. The hair style, composed of striations incised on a band that extends from each end of the pendant, arches to form an openwork square, thereby providing convenient pendant holes. Facial features are indicated by extremely delicate incising, the *mu-lei-wen* eye being the most prominent feature. Delicate, narrow thread-line designs decorate the surface. Calcification has obliterated the design on the reverse side.

Although *huang* with figural motifs were a part of the Shang tradition, the human figure was always portrayed so that the different parts of the body were recognizable. During the Chou period the artistic emphasis turned toward more purely decorative designs, and human figures were depicted with greater imagination. In this pendant the highly imaginative and stylized human profile and the interlocking serpentine body suggest a fantastic deity-like identity of the kind described in early legends.

Technically and artistically this piece implies a competent and sophisticated workmanship that can well be compared with the famous dragon pendants from the Warring States site of Chin-ts'un.[1] The fluent, delicate incisions and narrow thread lines of the surface decor are characteristic of Late Chou carvings. Late Eastern Chou.

Published: Arden Gallery, *3000 Years of Chinese Jade* (New York, 1939), p.72 and pl.130.

[1]A. Salmony, *Carved Jade of Ancient China* (Berkeley, 1938), pl.XL:2, 4 and XLI:2.

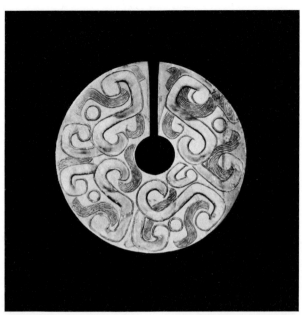

102

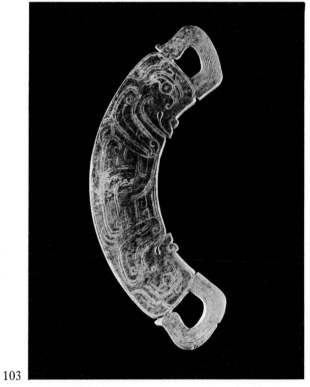

103

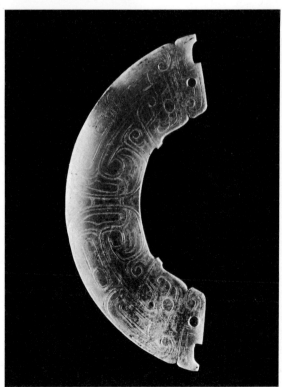

104

## 104 *HUANG* CRESCENT-SHAPED PENDANT

**Pale green tanslucent jade, partially calcified; traces of red pigment.**
**Length $3\frac{1}{2}$ in; width $1\frac{1}{8}$ in; thickness $\frac{7}{32}$ in.**
**Bequest of Alfred F. Pillsbury, 50.46.253**

Each end of this *huang* terminates in a fantastic human head in profile, with a highly stylized, incised *mu-lei-wen* eye and curvilinear designs marking other features. Short, serpentine bodies that end in a hook meet at the center of the *huang* without interlocking. A biconical perforation is located at each end of the pendant.

The human heads and serpentine bodies on this *huang* resemble those of the previous piece, as does the excellent carving; yet compositionally the design is less compact, with the bodies only meeting at the center of the piece, rather than interlocking. The stylized, *S*-shaped headdress or hair style is reminiscent of the Shang depictions of stylized bird crests.[1] Late Eastern Chou.

[1]See Nos.27, 32, and 39 in this catalogue and A. Salmony, *Carved Jade of Ancient China* (Berkeley, 1938), illus.xx:2, 3.

## 105 *YUAN-LÊ* COLUMNAR BEAD

**Mottled marble-yellow jade.**
**Length $2\frac{15}{16}$ in; diameter $\frac{7}{8}$ in; thickness $\frac{1}{4}$ in.**
**Bequest of Alfred F. Pillsbury, 50.46.363**

Natural objects such as bones and feathers were used as pendants or other decorative accessories at a very early time. Bone, which provides a natural perforation, was easily adapted for use as a bead or pendant. Eventually jade or metal beads, similar to that illustrated here, replaced bone beads.

The cloud-spiral pattern covering the surface of this bead is a pattern common to the works of the Warring States craftsmen. Similar beads were found at Chin-ts'un, Loyang.[1] Late Eastern Chou.

[1]The Chin-ts'un findings have long been dispersed in various museum collections. Beads from Chin-ts'un are illustrated in W.C. White, *Tombs of Old Lo-yang* (Shanghai, 1934), pl.cxxviii:332a, b. The best examples of beads from this site are now in the Freer Gallery of Art in Washington, D.C., and the Fogg Museum of Art in Cambridge, Massachusetts.

## 106 BEAD

**Tan calcified jade.**
**Length $3\frac{3}{16}$ in; width $\frac{11}{16}$ in; thickness $\frac{7}{32}$ in.**
**Bequest of Alfred F. Pillsbury, 50.46.292**

The rhythmic outline of this narrow, flattened bead is created by four rectangular notches cut into either of its long sides. A channel in low relief decorated with incised criss-cross and *S*-spiral designs bisects the bead longitudinally. The remainder of the surface of the bead is decorated with an incised and low relief spiral-cloud pattern. Both sides of the bead are identical, although one side is worn. A skilfully drilled perforation runs the entire length of the bead.

Although this bead is flattened and plaquelike, it may represent a development of the tubular bead pendant of earlier times. Stylistically the bead is related to the beads found at Liu-li-ko,[1] and its exquisite, refined workmanship echoes the Late Eastern Chou or Warring States lapidary work from Chin-ts'un.[2] Late Eastern Chou.

Published: C.T. Loo, *Chinese Archaic Jades* (New York, 1950), pl.liii:7.

[1]Kuo Pao-chün, *Shan-piao-chen yü Liu-li-ko*, Institute of Archaeology Monograph Series B, no.11 (Peking, 1959), pl.110 and p.60.
[2]W.C. White, *Tombs of Old Lo-yang* (Shanghai, 1934), pl.cxxxiii:326a.

## 107 BELT HOOK

**Ivory jade; traces of earthlike substance.**
**Length $4\frac{1}{8}$ in; width $\frac{1}{2}$ in; thickness $\frac{5}{16}$ in.**
**Bequest of Alfred F. Pillsbury, 50.46.388**

Longitudinal fluting gives this slender, arched belt hook a grooved surface. The arched curve of the hook forms an *S*-shaped silhouette that terminates with a dragon head at the hook end. A rectangular stud projects from the underside of the belt hook.

Belt hooks in this style, made of bronze or jade, appeared during the Warring States period and then attained an immediate popularity, perhaps because of changes in Chinese fashion.[1] Similar jade belt hooks were found at Ta-ssu-k'ung-ts'un[2] and similar bronze pieces at Erh-li-kang in Cheng-chou,[3] Liu-li-ko in Hui Hsien, and Shan-piao-chen in Chi Hsien.[4] Of the three belt hooks in The Minneapolis Institute of Arts Collection, this piece has the simplest decor; No.108, which is badly damaged, has a more complex design; and No.163, which is the most elaborate, has a dragon head depicted in the Han fashion. Late Eastern Chou.

[1]Kao Chü-hsün, 'Chan-kuo mu-nei tai-ko

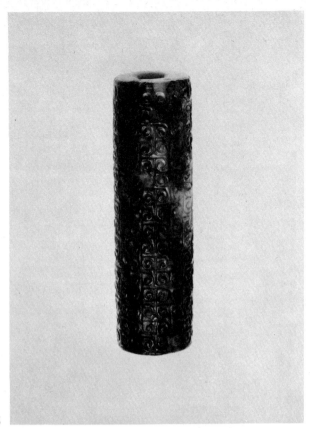

105

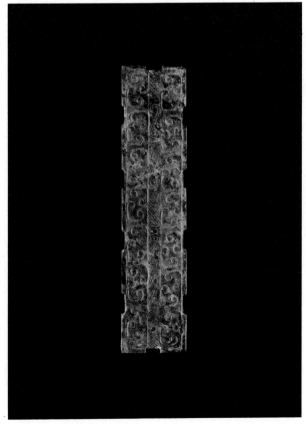

106

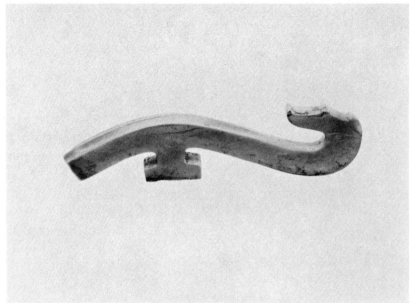

107

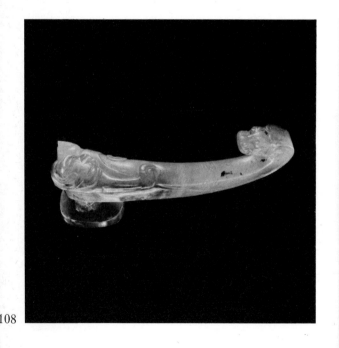

108

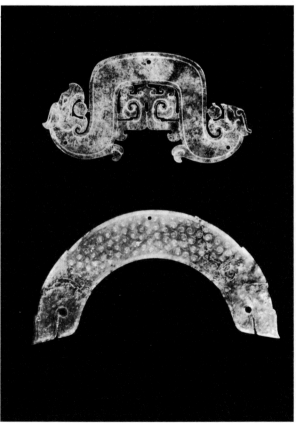

109,110

yung-tu te tui-t'sê,' *BIHP* 23 (1952), 489–510;
B. Karlgren, 'New Studies on Chinese
Bronzes,' *BMFEA* 9 (1937), fn.10; O. Sirén,
*Histoire des arts anciens de la Chine*, vol.1 (Paris,
1929), 62–63.
[2]Kao Chü-hsün, *op. cit.*
[3]Honan Wenhuachü, *Cheng-chou Erh-li-kang*,
Institute of Archaeology Monograph Series D,
no.7 (Peking, 1959).
[4]Kuo Pao-chün, *Shan-piao-chen yü Liu-li-ko*,
Institute of Archaeology Monograph Series B,
no.11 (Peking, 1959).

## 108 BELT HOOK

**Translucent tan jade.**
**Length $2\frac{5}{8}$ in; height $\frac{3}{4}$ in; thickness $\frac{9}{32}$ in.**
**Bequest of Alfred F. Pillsbury, 50.46.290**

This curved belt hook terminates with a
naturalistic dragon head at the hook end and is
further decorated with an incised triangle
design on the hook, a barely visible dragon
design on the wider, damaged end, and an
incised petal design on the buckle stub.

Belt hooks in this style are commonly found
lying at the waist or slightly lower on skeletons
in tombs from the Warring States period.
Late Eastern Chou.[1]

[1]Kao Chü-hsün, 'Chan-kuo mu-nei tai-ko
yung-tu te tui-t'sê,' *BIHP* 23 (1952), 489–510.

## 109 *HÊNG* GIRDLE-PENDANT HEADPIECE

**Mottled grey jade; breakage at one end.**
**Length 5 in; width $2\frac{1}{2}$ in; thickness $\frac{5}{16}$ in.**
**Bequest of Alfred F. Pillsbury, 50.46.234**

A stylized tiger head with ball in mouth
decorates each end of this *W*-shaped pendant.
An incised criss-cross pattern decorates the
flanking wings and the spiral variations in
openwork that fill the arch between the animal
bodies; nipple bosses in low relief cover the
surface of the arch. A small perforation in the
neck of each tiger, a slightly larger perforation
in the center of the arch, and an elongated
opening in the center of the openwork provide
pendant holes.

Two types of girdle pendants were worn in
China, one by commoners and the other by
aristocrats. While the pendants used by
commoners were varied in shape and style,
those worn by aristocrats were of a
conventionalized composition that indicated
social position.[1] In fact, the social position,
gracefulness, and pace of the wearer were all
announced by the tinkling of the pendants
suspended from his girdle.[2]

In a formal girdle-pendant composition, the
*hêng*, or headpiece, usually has four

perforations: a center perforation used to
attach the piece to the girdle and three
additional perforations, one on either side and
one at the lower center, used to suspend
additional jade ornaments.[3]

Similar *hêng* have been excavated at
Hsin-yang in Honan.[4] Late Eastern Chou.

Published: *The Minneapolis Institute of Arts
Bulletin* 39, no.18 (1950), 88.

[1]Na Chih-liang, *Yü-ch'i t'ung-shih*, vol.1 (Hong
Kong, 1964), 94–98.
[2]*Ibid.*, p.98.
[3]Kuo Pao-chün, 'Ku-yü Hsin-chuen,' *BIHP* 20
(1948), 1–46 and illus.6.
[4]*Wen-wu*, 1957, no.9, pp.21–22.

## 110 *HÊNG* GIRDLE-PENDANT HEADPIECE

**Mottled brown-green jade.**
**Chord $5\frac{7}{8}$ in; width $1\frac{1}{8}$ in; thickness $\frac{3}{16}$ in.**
**Bequest of Alfred F. Pillsbury, 50.46.286**

The three symmetrically-placed perforations
of this *huang*-shaped pendant indicate that it
could have been used as a *hêng*, or headpiece of
a composite girdle-pendant.

The fine carving and elegant composition
of this piece are comparable to that of the
*huang* pendant in the Royal Ontario Museum
collection[1] and the *huang* pendant excavated
from Hui Hsien.[2] Late Eastern Chou.

[1]D. Dohrenwend, *Chinese Jades in the Royal
Ontario Museum* (Toronto, 1971), p.76.
[2]Hsia Nai *et al.*, *Hui-hsien fa-chüeh pao-kao*,
Archaeological Field Reports, no.1 (Peking,
1956), pl.54:6 and p.227, fig.35:5.

## 111 *HÊNG* GIRDLE-PENDANT HEADPIECE

**Translucent white jade.**
**Length $4\frac{3}{8}$ in; width $\frac{9}{16}$ in; thickness $\frac{3}{16}$ in.**
**Bequest of Alfred F. Pillsbury, 50.46.356**

A stylized dragon head of extremely refined
incised linear design decorates each end of this
band-shaped pendant. Comma-grain pattern
covers the surface of the slightly curved band;
both sides are identical. Three perforations are
symmetrically positioned, one at either end of
the pendant and one at the center.

Although *hêng* is a generic term for pendants
of various shapes that were used as headpieces
in girdle-pendant compositions, this particular
piece conforms closely to Wu Ta-ch'eng's
definition of the *hêng*; 'Flat as a piece of
horizontal plank [wooden board], with two side
ends that curve downward slightly and have
perforations for attaching a pair of *huan*.'[1]

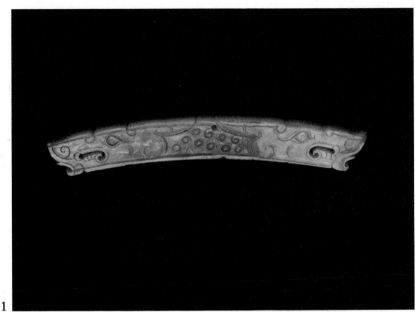

111

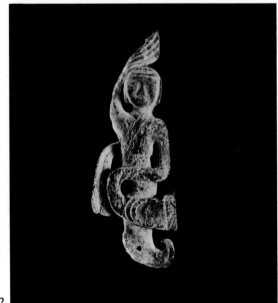

112

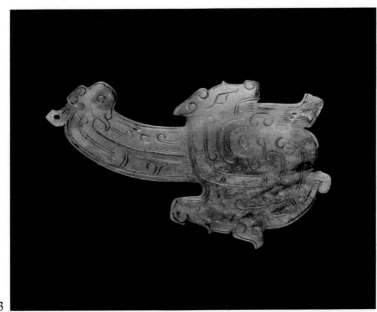

113

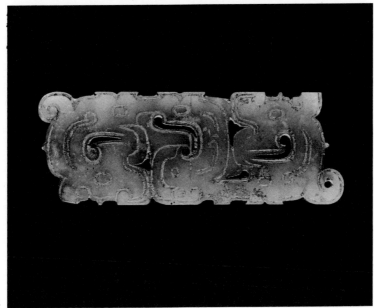

114

Although the design on this piece differs from that on the previous piece (No.110), both *hêng* belong to the same tradition, this pendant representing a type that was popular during the Warring States and Early Western Chou periods.[2] Late Eastern Chou.

[1]Wu Ta-ch'eng, *Ku-yü t'u-k'ao* (modern reprint edited by Na Chih-liang, Taipei, 1971), illus.17.
[2]*Wen-wu*, 1973, no.4, p.33, illus.39.

## 112 PENDANT OF A DANCER

**Calcified ivory jade.**
**Height 2½ in; width $\frac{15}{16}$ in; thickness $\frac{5}{16}$ in.**
**Bequest of Alfred F. Pillsbury, 50.46.281**

The ample, swinging sleeves and flowing sash of this dancing figure, as well as the position of the figure's arms, one raised behind the head and the other crossed in front of the waist, capture the graceful movements of a dance. Facial features are depicted with incision and shallow relief carving. The dancer's legs terminate in a fish tail through which a pendant hole has been drilled.

This figure immediately calls to mind the well-known figurine from Chin-ts'un, Loyang, part of a necklace composition that is now in the Freer Gallery of Art.[1] Late Eastern Chou.

[1]S.H. Hansford, *Chinese Carved Jades* (London, 1968), pl.34.

## 113 DRAGON PENDANT

**White jade with pale brown mottling; traces of earthlike substance and red pigment.**
**Length 3$\frac{5}{16}$ in; width 1$\frac{7}{8}$ in; thickness $\frac{3}{16}$ in.**
**Bequest of Alfred F. Pillsbury, 50.46.223**

Mythological deities were frequently described in the *Shan-hai-chin* (Hills and Rivers Classic) as fantastic composite animals having bird heads and dragon bodies. This double-headed dragon is depicted with two heads that face clockwise and a tail that extends from the body in a narrow band and then terminates in a bird head. A design resembling a human face is centered between the two interlocking curvilinear necks of the creature. Striations, *C*-comma spirals, and *lei-wen* designs in narrow thread line and delicate incision adorn the surface; both sides are identical. There is a small perforation at the tip of the tail, and a surface dent runs from one dragon head, along the lower edge of the tail, to the bird head.

Pictorially the composite animal motif occurred early in bronzes and reached its peak of popularity in Chinese art during the Warring States period. Late Eastern Chou.

Published: Arden Gallery, *3000 Years of Chinese Jade* (New York, 1939), p.30 and illus. 131.

## 114 DRAGON PENDANT

**Pale green translucent jade; traces of clay.**
**Length 3$\frac{5}{8}$ in; width 1$\frac{5}{16}$ in; thickness $\frac{5}{32}$ in.**
**Bequest of Alfred F. Pillsbury, 50.46.293**

Two dragon heads, each facing counter-clockwise, are carved in openwork in this flat, rectangular pendant. Incised parallel lines in the area between the two heads suggest a stylized bird and give added surface detail. The dragons' eyes are marked by small incised circles. A biconical perforation is situated at the mane of the dragon, and another, which remains unfinished, is positioned diagonally opposite it.

Similar rectangular pendants, also representing double-headed, serpentine animals with band bodies in *S*-curves, were excavated from the Shang-ts'un-ling burial sites, although the Shang-ts'un-ling pendants display more pronounced openwork and less complex designs.[1]

[1]Lin Shou-chin *et al.*, *Shang-ts'un-ling Kuo-kuo mu-ti*, Institute of Archaeology Monograph Series D, no.10 (Peking, 1959), pl.XXIX:6.

## 115 DRAGON PENDANT

**Translucent grey jade.**
**Diameter 3$\frac{1}{4}$ in; width $\frac{5}{8}$ in; thickness $\frac{1}{4}$ in.**
**Bequest of Alfred F. Pillsbury, 50.46.364**

This bracelet-shaped pendant terminates with a stylized dragon head at one end and a bird head at the other. The body of the dragon is decorated with a rope pattern composed of grooved striations. A small biconical perforation is centrally located, and a restoration line is visible near the head of the bird.

The rope pattern was common to the vocabulary of the Warring States lapidary artist,[1] as was the dragon head with the large upper lip and curled lower lip.[2] Late Eastern Chou.

[1]Yü Shih-chi *et al.*, *Shou-hsien Ts'ai-hou mu ch'u-t'u i-wu*, Institute of Archaeology Monograph Series B, no.5 (Peking, 1956), pl.105:10, 11, 14; Kuo Pao-chün, *Shan-piao-chen yü Liu-li-ko*, Institute of Archaeology Monograph Series B, no.11 (Peking, 1957), pl.111:6; A. Salmony, *Chinese Jade Through the Wei Dynasty* (New York, 1963), p.167.
[2]*Wen-wu*, 1957, no.9, pp.22–23 and illus.19.

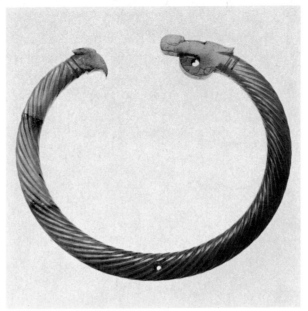

115

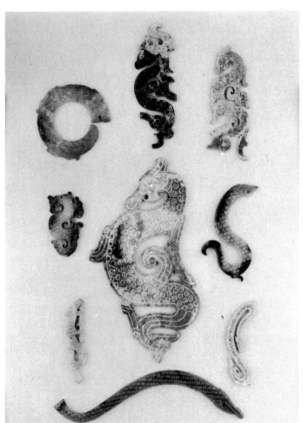

116–24

## 116 DRAGON PENDANT

**Pale tan jade; traces of red pigment.**
**Diameter 3¼ in; width ⅞ in; thickness 5/32 in.**
**Bequest of Alfred F. Pillsbury, 50.46.294**

A curled dragon and two smaller animals in profile are incised on this flat circular band with a slit opening. The surface of the pendant is covered with a striated rope pattern and spiral designs; both sides are identical. There are three perforations in the pendant, one between the lips of the dragon, one at the midpoint of the circular body, and a third between them, at the neck of the dragon, positionings that suggest that the pendant was used as a *hêng* in a girdle-pendant composition.

At first glance this complicated design appears to be a single dragon with two small, projecting animals on its back. Upon closer examination, it is apparent that there is a second dragon head executed in a thread-line spiral design immediately behind the first. The large protruding upper lip and short lower lip, the small, oblong double-line eye, the rope pattern executed in thread line, and the *lei-wen* variation spirals, referred to as the 'seaweed' pattern by Wu Ta-ch'eng, are all characteristic of the Warring States period.[1] The crouching tigerlike creatures interrupting the outline of the pendant recall a *huang* in the Winthrop collection.[2] Late Eastern Chou.

Published: Alfred Salmony, *Carved Jade of Ancient China* (Berkeley, 1938), pl.XLVI:5.

[1]Na Chih-liang, *Yü-ch'i t'ung-shih*, vol.2 (Taipei, 1970), 105–106; Wu Ta-ch'eng, *Ku-yü t'u-k'ao* (modern reprint by Na Chih-liang, Taipei, 1971), p.119; O. Karlbeck, 'Selected Objects from Ancient Shou Chou,' *BMFEA* 27 (1955), pl.59:1.
[2]A. Salmony, *Carved Jade of Ancient China* (Berkeley, 1938), pl.XXXIV:2.

## 117 DRAGON PENDANT

**Grey-green jade, partially calcified; traces of earthlike substance.**
**Length 5 5/16 in; width 1⅞ in; thickness 3/16 in.**
**Bequest of Alfred F. Pillsbury, 50.46.282**

The undulant, regardant dragon of this flat, double *S*-shaped pendant has an enframed body decorated with comma-grain pattern and curvilinear projections that suggest its extremities. A perforation is located at the center of the arched body. Both sides of the pendant are identical.

As the dragon pendants in The Minneapolis Institute of Arts Collection illustrate, the variances in the depiction of the dragon motif have been numerous; yet none have surpassed

the fluent manipulations of the Warring States craftsmen, renderings that declare the very decorative nature of the pendant and the subject matter through the sinuosity of the dragon's bodies, the curvilinear, projecting extremities, and the spiral-grain pattern surface decorations.[1] Late Eastern Chou.

[1]A similar piece is preserved in the Royal Ontario Museum and is illustrated in D. Dohrenwend, *Chinese Jades in the Royal Ontario Museum* (Toronto, 1971), p.7. Also, a comparable piece is illustrated in Kuo Pao-chün *Shan-piao-chen yü Liu-li-ko*, Institute of Archaeology Monograph Series B, no.11 (Peking, 1959), pl.113.

## 118 DRAGON PENDANT

**Pale green jade, calcified; traces of earthlike substance.**
**Length 5 in; width 1¾ in; thickness 5/32 in.**
**Bequest of Alfred F. Pillsbury, 50.46.283**

Another depiction of a characteristic Warring States dragon,[1] the double *S*-shaped, regardant dragon of this pendant has projecting, curvilinear extremities and an incised spiral *lei-wen* pattern decorating its body. Both sides are identical. A restoration mark repairing slight breakage at the tail is visible. Late Eastern Chou.

[1]*Ch'u wen-wu chan-lan t'u-lu* (Peking, 1954), pl.52. Although the piece illustrated here is a sword pommel, the dragon decorating the pommel also has an axe-shaped lower lip; comparative pieces can be seen in various museum collections (the Freer Gallery of Art, Washington, D.C.; the William Rockhill Nelson Gallery of Art, Kansas City, Missouri) and also amongst the excavated finds from the Warring States sites at Liu-li-ko.

## 119 DRAGON PENDANT

**Mottled pale yellow jade with brown markings.**
**Length 2¾ in; width 1 9/16 in; thickness ¼ in.**
**Bequest of Alfred F. Pillsbury, 50.46.372**

Having the form of a double-*S* that has been compactly curved into an overall rectangular shape, the regardant dragon of this pendant has an arched body, curled tail, and spirally projecting extremities. Both sides of the pendant are decorated with low relief grain pattern and fine criss-cross incisions that accent the curvilinear projections. There are three biconical perforations, two aligned vertically at the center of the arched body and a third located at the neck of the animal.

Stylistically this piece is similar to the

previous piece, No.118, and also compares with pendants excavated from the Eastern Chou sites at Fen-shui-ling[1] and Liu-li-ko.[2] Late Eastern Chou.

[1] *Kao-ku*, 1964, no.3, pp.111–137. This piece is also illustrated in S.H. Hansford, *Chinese Carved Jades* (London, 1968), pl.26:6.
[2] Kuo Pao-chün, *Shan-piao-chen yü Liu-li-ko*, Institute of Archaeology Monograph Series B, no.11 (Peking, 1959), pl.113:1.

## 120 DRAGON PENDANT

**Mottled green jade with black-brown markings, partially calcified; breakage at the center with a visible restoration line.**
**Length 8⅝ in; width 4 in; thickness 7/32 in.**
**Bequest of Alfred F. Pillsbury, 50.46.298**

Two animal heads, a dragon head and a bird head, decorate this arched, double *S*-curved pendant in openwork. The serpentine body of this two-headed creature is decorated with a spiral pattern and enframed by an incised band; linear incisions indicate the animals' features.

In character with Warring States dragon heads, the long top lip is curled upward and the lower lip is axe-shaped. The highly stylized bird head at the opposite end of the pendant has a sharp, hooked beak, a circular eye, and a crest with an incised *lei-wen* design. Composite animal designs, often fluently executed, are typical of the Warring States period. Numerous similar pendants have survived from ancient times[1] and others continue to be excavated from Warring States sites.[2] Late Eastern Chou.

[1] Similar pendants can be seen in the collections at the Fogg Museum of Art, Cambridge, Massachusetts; the Musée Guimet, Paris; and the Art Institute of Chicago, Chicago.
[2] The sites at Shang-tai-kuan, Hsin-yang, and Hui Hsien have all recently yielded comparable pieces, which have been reported in *Wen-wu*, 1954, no.8, pp.22–23; *Wen-wu*, 1957, no.9, pp.21–22 and illus.11; and *Ch'u wen-wu chan-lan t'u-lu* (Peking, 1954), pl.54–55.

## 121 DRAGON PENDANT

**Pale brown jade with brown clouds; breakage and restoration visible near the second perforation.**
**Length 4 in; width ⅝ in; thickness 7/32 in.**
**Bequest of Alfred F. Pillsbury, 50.46.295**

In a most fluent and carefree rendering, this serpentine dragon has a large upper lip, a short lower lip, and small, inconspicuous horns. A spiral-grain pattern covers the body of the dragon, and linear incisions indicate its features; both sides are identical. Two perforations, both

in the same half of the pendant, suggest that the pendant was used as a *hêng* headpiece in a girdle-pendant composition.

This piece, with the dragon shown in a serpentine silhouette, represents a variation of the dragon motif that was popular during the Warring States period. Similar dragon pendants have been excavated from Chin-ts'un[1] and Chang-tai-kuan in Hsin-yang,[2] both Warring States sites. Late Eastern Chou.

[1] Na Chih-liang, *Yü-ch'i t'ung-shih*, vol.2 (Taipei, 1970), p.105, fig.6B; S. Umehara, *Rakuyō Kinson kobo shūei* (Kyoto, 1937, rev. ed., 1943), illus.71–93; W.C. White, *Tombs of Old Lo-yang* (Shanghai, 1934), pl.cxxvi:311.
[2] *WWTKTL*, 1957, no.9, pp.21–22 and illus. 9–11.

## 122 DRAGON PENDANT

**White translucent jade; traces of mud and red pigment.**
**Length 3⅝ in; width ¾ in; thickness 3/16 in.**
**Bequest of Alfred F. Pillsbury, 50.46.284**

One of many excellent dragon compositions surviving from the Late Eastern Chou period, this serpentine dragon, with its elegant curvilinear appendages and tail, has an overall rectangular shape and is similar to dragon pendants excavated at Liu-li-ko.[1] Late Eastern Chou.

[1] Kuo Pao-chün, *Shan-piao-chen yü Liu-li-ko*, Institute of Archaeology Monograph Series B, no.11 (Peking, 1959), pl.113. It can also be compared with a piece from the collection of Chêng-Tê-k'un that is illustrated in S. H. Hansford, *Chinese Carved Jades* (London, 1968), pl.46.

## 123 DRAGON PENDANT

**Translucent green jade.**
**Length 8 7/16 in; width ¾ in; thickness 5/16 in.**
**Bequest of Alfred F. Pillsbury, 50.46.359**

Curved into a gentle *S*-shape, this pendant of a serpentine dragon with a bluntly cut tail is decorated with a spiral-grain pattern and a plain band that enframes the dragon's body. The mouth of the dragon is accentuated with a low relief band decorated with an incised rope pattern.

This simple composition resembles several dragon pendants unearthed at Chang-t'ai-kuan, Hsin-yang,[1] and based on this similarity may be assumed to have functioned as a headpiece in a girdle-pendant composition. Late Eastern Chou.

[1] *Wen-wu*, 1957, no.9, pp.21–22; S. H. Hansford,

Chinese Carved Jades (London, 1968), illus.29:d.
A smaller but similar serpentine dragon that
was used as a decorative inset in a belt hook is
illustrated in S. H. Hansford, *op. cit.*, illus.32:a.

[2]*Ibid.*
[3]M. Hayashi, 'Deities that Originated in the
Middle Shang Period,' *Tōhō Gakuhō* 41 (1970),
1–70 (text in Japanese).

## 124 DRAGON PENDANT

**Pale green jade.**
**Length 3 9/16 in; width 3/4 in; thickness 3/16 in.**
**Bequest of Alfred F. Pillsbury, 50.46.285**

This extremely narrow dragon pendant has a
flexible, serpentine body that curves into a
dramatic *S*-shape with the greatest ease and
fluidity. The sensuous, almost overly facile
sleekness of this serpentine dragon is balanced
by a delicate, curvilinear surface design;
incised comma-hooks and criss-crossed
incisions in a half-heart design decorate the
surface, their delicacy attesting to the very fine
craftsmanship of the pendant. The arched
shape and the centrally positioned pendant hole
suggest that this piece was a headpiece in a
girdle-pendant composition.

The pendant can be compared with the
famous necklace and pendant composition
thought to be from Chin-ts'un and now in the
Freer Gallery of Art.[1] Late Eastern Chou.

Published: Alfred Salmony, *Carved Jade of
Ancient China* (Berkeley, 1938), pl.XLI:1.

[1]A. Salmony, *Carved Jade of Ancient China*
(Berkeley, 1938), pl.LII.

## 125 DRAGON PENDANT

**Translucent pale green jade with marbled
black striations.**
**Height 2 3/4 in; width 2 1/16 in; thickness 3/16 in.**
**Bequest of Alfred F. Pillsbury, 50.46.373**

In this complex openwork carving the
serpentine dragon is rendered in an *S*-curve
with a bifurcated, spiral-hook tail and a
birdlike creature that intertwines with and
extends out from this tail. Incised spiral
designs mark the features of the animals, and
scallops, *lei-wen*, criss-crosses and rope striation
adorn the surface of the piece. The pendant
was made to be part of a more complex
composition,[1] although even on its own it is a
piece that reveals aesthetic elegance and
competent craftsmanship.

This intricate and complex design can best
be compared with a complete plaque
composition in the Art Institute of Chicago[2] and
Late Eastern Chou bronzes displaying similar
decorative motifs.[3] Late Eastern Chou.

[1]A. Salmony, *Archaic Chinese Jades from the
Edward and Louise B. Sonnenschein Collection*
(Chicago, 1952), pl.LXXX:6.

## 126 BIRD PENDANT

**Ivory jade ('as white as chicken bone').**
**Length 1 1/16 in; height 3/4 in; thickness 1/8 in.**
**Bequest of Alfred F. Pillsbury, 50.46.366**

In this small, curvilinear composition, the
double *S*-shaped body of a highly stylized,
regardant bird with a hooked beak and curved
crest interlocks with a decorative, openwork
spiral that echoes the lines of the bird's head
and creates a figure-eight design in the lower
half of the piece. A narrow, curved base adjoins
the composition at the bird's crest, the hump
of the bird's back, and the top of the
decorative spiral. Linear designs and facial
features are executed with incisions, and a
small perforation is located in the arch of the
bird's body.

Serpentine animal bodies interlaced with
decorative openwork occur in Warring States
and Han Dynasty jade carvings, wall paintings,
and bronzes. A similar bird pendant was
excavated from Hui Hsien.[1] Late Eastern
Chou.

[1]The Hui Hsien pendant can be seen in S.H.
Hansford, *Chinese Carved Jades* (London, 1968)
pl.36a; *Hsin Chung-kuo ti k'ao-ku shou-huo*,
Institute of Archaeology Monograph Series A,
no.6 (Peking, 1961); and Hsia Nai *et al.*,
*Hui-hsien fa-chüeh pao-kao*, Archaeological
Field Reports, no.1 (Peking, 1956). A similar
bird motif can be seen on two jade *pi* discs
illustrated in René-Yvon Lefèbvre d'Agencé,
*Ancient Chinese Jades in the Avery Brundage
Collection* (San Francisco, 1971), pl.XV, right;
and A. Salmony, *Carved Jade of Ancient China*
(Berkeley, 1938), pl.XXXIX.

## 127 FISH PENDANT

**Originally a white color, the jade is now
mottled grey with blue clouds; traces of
earthlike substance.**
**Length 3 1/2 in; width 1 in; thickness 3/16 in.**
**Bequest of Alfred F. Pillsbury, 50.46.249**

The fish in this pendant is curved in a *huang*
shape, or crescent shape, a pendant shape that
as early as the Shang Dynasty was popular with
Chinese lapidaries. Finely incised lines describe
the eyes, the gills, and the ventral and dorsal
fins; both sides are identical. A peculiar
footlike appendage that extends from the gill
probably has its origin in artistic inspiration
rather than anatomical observation. In
comparison with Shang fish pendants, this

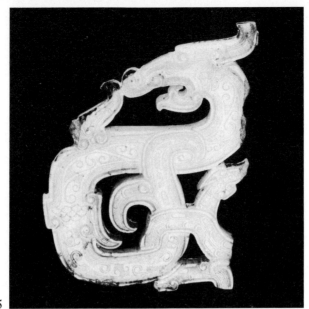

125

126

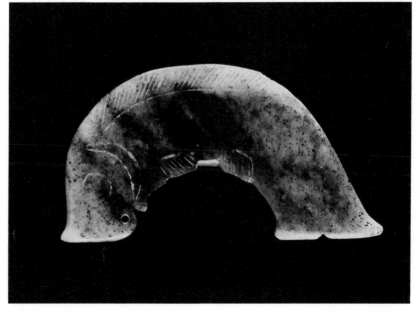

127

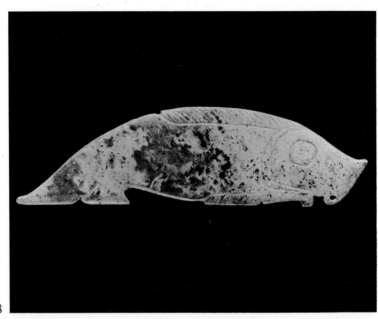

128

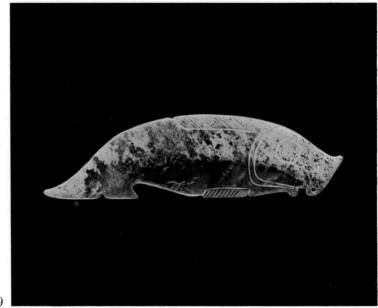

129

114

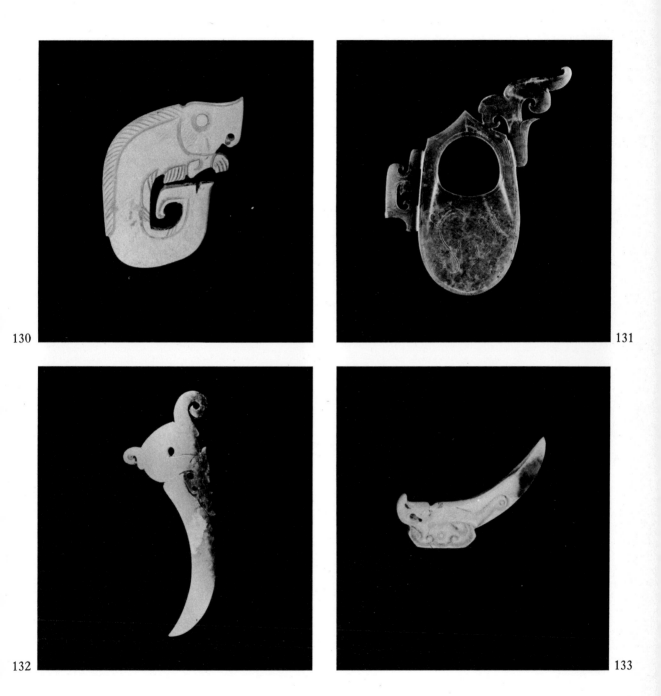

130

131

132

133

piece is more naturalistic and displays incisions that are more unified, shallower, and finer than those used by the Shang lapidaries.[1] Late Eastern Chou.

[1]See Liang Ssu-yung and Kao Ch'ü-hsün, *Hou Chia Chuang*, vol.2, *HPKM 1001* (Taipei, 1962), illus.xxxix:1–3 and No.27 in this catalogue for examples of Shang workmanship. See Kuo Pao-chün, *Hsün-hsien Hsin-ts'un*, Institute of Archaeology Monograph Series B, no.13 (Peking, 1964), illus.84 for an example of Late Eastern Chou workmanship.

## 128 FISH PENDANT

**Mottled yellow-grey jade, partially calcified; traces of red pigment.**
**Length 3¾ in; width 1 in; thickness ⅛ in.**
**Bequest of Alfred F. Pillsbury, 50.46.255**

## 129 FISH PENDANT

**Partially calcified light brown jade; traces of red pigment.**
**Length 3 3⁄16 in; width 1 in; thickness ⅛ in.**
**Bequest of Alfred F. Pillsbury, 50.46.254**

Each of these arched plaques depicts a fish in profile, with a blunted, large mouth; a split, sloping tail, one side of which extends to form a sharp blade edge that resembles a *hsi* tip; and eyes and fins that are indicated with simple, incised striations. Both sides are identical. A small biconical perforation is located in the lower lip of each fish.

The carving in this pair of pendants is comparable to, although more finely executed than that of the previous pendant (No.127). Late Eastern Chou.

## 130 FISH PENDANT

**White jade; traces of earthlike substance.**
**Length 1¾ in; width 1⅛ in; thickness 3⁄32 in.**
**Bequest of Alfred F. Pillsbury, 50.46.235**

Arched into a *lei-wen* spiral shape, this fish pendant has a slightly convex upperside and flat underside. The large, blunted mouth and claw below it, remnants of an ancient imagination, are also seen in the three previous pieces (Nos.127, 128, and 129), although not so fully articulated in the previous pieces as in this piece. The skillfully but mechanically executed striations that define the fins reveal careful draftsmanship similar to that of the previous three pieces. A biconical perforation is located in the lower lip of the fish. Late Eastern Chou.

## 131 PENDANT IN THE FORM OF AN ARCHER'S THUMB RING

**Partially calcified, translucent pale green jade with mottling.**
**Height 2⅓ in; width 2⅛ in; thickness 3⁄16 in.**
**Bequest of Alfred F. Pillsbury, 50.46.329**

Although similar to the actual archers' thumb rings that are made of leather or horn, this ring is flatter in form than its functional counterparts and was used solely as a decorative pendant.[1] Slanted bore holes are located in the triangular peak of the ring. Fluently executed curvilinear hook designs in openwork project from either side of the ring and together with the delicately incised cloud patterns on the surface of the ring reveal the exquisite workmanship that characterizes Eastern Chou jade carving. Comparable but less ornate archers' thumb rings have been excavated from several Warring States sites, including Loyang[2] and Shou Chou.[3]

Published: Sueji Umehara, *Shina kogyoku zuroku* (Kyoto, 1955), pl.LXXXIII.

[1]Na Chih-liang, *Yü-ch'i t'ung-shih*, vol.1 (Hong Kong, 1964), 65–66; A. Salmony, *Chinese Jade Through the Wei Dynasty* (New York, 1963), pp.26–28 and 188–189. A similar object, although without openwork carving, was called a 'chicken-heart pendant' by Wu Ta-ch'eng in his book *Ku-yü t'u-k'ao* (modern reprint edited by Na Chih-liang, Taipei, 1971), pp.4–5. C. T. Loo referred to similar objects as music picks in his book *Chinese Archaic Jades* (New York, 1950), pl.XLIX:1, 5, 6, 7, 8. Ch'ên Ta-nien referred to a similar object as a Taoist religious object.
[2]W.C. White, *Tombs of Old Lo-yang* (Shanghai, 1934), p.137 and pl.CXXXVIII: 337a–b and CXXXIX:337c.
[3]O. Karlbeck, 'Selected Objects from Ancient Shou Chou,' *BMFEA* 27 (1955), pl.62:7.

## 132 *HSI* DRAGON PENDANT

**Translucent white jade with brown markings; traces of earthlike substance.**
**Length 2½ in; width 1⅛ in; thickness ⅜ in.**
**Bequest of Alfred F. Pillsbury, 50.46.349**

This small, scimitar-shaped pendant is topped with a dragon body that is compacted into a flat, circular shape. The animal's tail is suggested by a hook that projects from behind its head, and its foot is suggested by a smaller hook opposite the tail. Sharp, intricate incisions mark the animal's facial features. A biconical perforation is located in the lower jaw of the animal.

Although this composition is simple, it reveals elegance, charm, and cleverness. The

fluid, curvilinear composition and the curls and hooks in openwork characterize Warring States artistic preferences.[1] Late Eastern Chou.

[1]Depictions of the dragon with a long, pointed upper lip and axe-shaped lower lip are typical of the Warring States and can be seen on the famous *pi* at the William Rockhill Nelson Gallery, Kansas City, Missouri; a necklace in the Freer Gallery of Art Collection, Washington, D.C. (reported to be from Chin-ts'un); a dragon-head pendant found at Shou Hsien, which is illustrated in O. Karlbeck, 'Selected Objects from Ancient Chou,' *BMFEA* 27 (1955), pl.62:1; and No.134 in this collection.

### 133 *HSI* PENDANT

**White translucent jade with marbled brown striations.**
**Length 2 in; width $\frac{7}{16}$ in; thickness $\frac{7}{16}$ in.**
**Bequest of Alfred F. Pillsbury, 50.46.331**

This pendant of an animal tusk is surmounted on one side by a relief plaque that is decorated with an exquisite portrayal of a deer in low relief and on the other side by a bird depicted in criss-cross incision and relief. The piece exhibits unique composition, excellent decor, and freely and competently executed linear designs. Han.

### 134 *HSI* TIGER PENDANT

**Translucent tan jade; traces of earthlike substance.**
**Length $4\frac{1}{8}$ in; width 1 in; thickness $\frac{3}{16}$ in.**
**Bequest of Alfred F. Pillsbury, 50.46.278**

By the Warring States period, the *hsi* knot-opener was used as a purely decorative pendant, although it retained the shape of the tusk.[1] This transition in function is readily apparent in the complicated, elaborate openwork design of this pendant: the lower part of the *hsi* has the shape of a scimitar with a split blade, and the top part displays the profile of a ferocious tiger. The tiger has sharp, hooked ears, a large mouth, and an axe-shaped lower lip and pointed upper lip. Scattered incised comma and floral designs adorn the surface; both sides are identical. A perforation is situated at the top of the pendant.

The fluid composition and excellent execution of this piece are also seen in several pieces excavated from Chin-ts'un.[1] Late Eastern Chou.

[1]S. Umehara, *Rakuyō Kinson kobo shūei* (Kyoto, 1937; rev. ed., 1943), pls.85:6 and 86:1, 7.

### 135 *HSI* TIGER PENDANT

**Partially translucent tan jade.**
**Length $3\frac{1}{4}$ in; width $1\frac{5}{8}$ in; thickness $\frac{5}{32}$ in.**
**Bequest of Alfred F. Pillsbury, 50.46.279**

This narrow, scimitar-shaped pendant is crowned with a stylized crouching tiger. The ferocious tiger is depicted in profile with an open mouth and lowered head. Curved hooks and spirals in openwork suggest the animal's extremities and further exaggerate its character. Incised criss-cross designs and striations adorn the surface. A perforation is located at the neck of the animal.

This pendant is similar stylistically to the previous piece and reveals the delicacy, intricacy and fluidity that characterize other Warring States designs. Similar pendants have been excavated at Chin-ts'un.[1] Late Eastern Chou.

Published: *The Minneapolis Institute of Arts Bulletin* 31, no.33 (1942), 118; Sueji Umehara, *Shina kogyoku zuroku* (Kyoto, 1955), pl.LXXXI:8.

[1]S. Umehara, *Rakuyō Kinson kobo shūei* (Kyoto, 1937; rev. ed., 1943), pl.86:1, 7.

### 136 *HSI* TIGER PENDANT

**Tan translucent jade, slightly calcified; traces of earthlike substance.**
**Length $4\frac{1}{2}$ in; width 1 in; thickness $\frac{1}{8}$ in.**
**Bequest of Alfred F. Pillsbury, 50.46.280**

This flat *hsi* pendant is topped with an elaborate openwork design composed of a tiger and an intertwined plant. The tusklike stem of the *hsi* is decorated with incised grooves and linear designs that suggest the tiger's stripes. The reverse side is similarly decorated and reveals the same excellent craftsmanship. In expression and execution this piece closely resembles the previous two pieces as well as several *hsi* excavated at Chin-ts'un.[1] Late Eastern Chou.

[1]S. Umehara, *Rakuyō Kinson kobo shūei* (Kyoto, 1937; rev. ed., 1943), pls.85:2, 4 and 86:1, 2, 4, 5.

### 137 *HSI* TIGER PENDANT

**Translucent, partially calcified yellowish jade; traces of earthlike substance.**
**Length $2\frac{5}{8}$ in; width $1\frac{3}{4}$ in; thickness $\frac{3}{16}$ in.**
**Bequest of Alfred F. Pillsbury, 50.46.347**

This pendant takes the form of a stylized tiger silhouette. The splayed axe shape of the lower jaw of the tiger is a feature that occurs in tiger designs of the Eastern Chou period, and the curved hooks that represent the legs of the

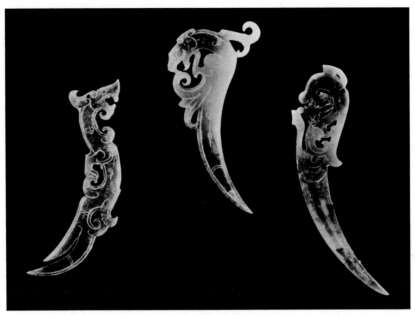

134–6

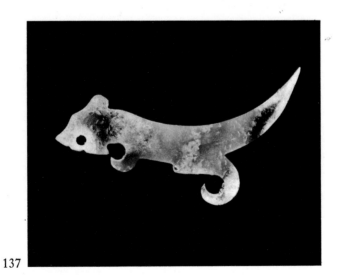

137

118

138

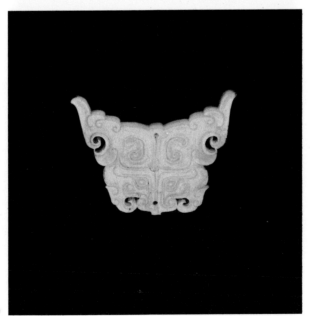

139

animal reflect the preference of the Eastern Chou craftsman for curvilinear decor. The long, sharp tail of the tiger identifies this piece as a *hsi* pendant, or knot-opener. Late Eastern Chou.

## 138 RULER

**Calcified green jade; traces of gluelike substance.**
**Length $3\frac{1}{2}$ in; width $\frac{9}{16}$ in; thickness $\frac{1}{16}$ in.**
**Bequest of Alfred F. Pillsbury, 50.46.362**

This short, narrow ruler has irregularly spaced incised lines marking off the units of measurement. A spiral-cloud design decorates the broken end of the ruler. The irregular spacing of the units suggests that the ruler was probably made in great haste and probably not for any practical use. Although the dating of this piece is problematic, the quality of the jade and the degree of calcification of the stone suggest that it tentatively may be considered a Late Eastern Chou product. Late Eastern Chou.

[1]A brief discussion of rulers is presented in Na Chih-liang, *Yü-ch'i t'ung-shih*, vol.1 (Hong Kong, 1964), 201.

## 139 PLAQUE

**Translucent white jade.**
**Height $1\frac{3}{8}$ in; width $1\frac{3}{4}$ in; thickness $\frac{3}{16}$ in.**
**Bequest of Alfred F. Pillsbury, 50.46.325**

The animal face of this small, thin plaque has prominently articulated, incised eyes symmetrically placed in the lower half of the plaque. The remaining surface of the plaque is covered with a combination of C-comma, cloud, hook, and curvilinear designs. Curved hooks in openwork emphasize the wide jaws of the creature and, along with the hooks, scallops, and curves that embellish the outline of the plaque, reveal highly skilled craftsmanship. Two perpendicularly placed perforations have been drilled in the piece, one at the top of the object, the other at the bottom.

In composition this plaque is similar to the earlike appendages that often adorn the handles of bronze vessels of the Warring States period.[1] In comparison with jade carvings, this piece is similar stylistically to jade objects from Shou Hsien and Liu-li-ko[2] and to a buckle in the collection of Chen Jen-dao.[3] Late Eastern Chou.

[1]Yü Shih-chi *et al.*, *Shou-hsien Ts'ai-hou mu ch'u-t'u i-wu*, Institute of Archaeology Monograph Series B, no.5 (Peking, 1956), pl.97.
[2]Kuo Pao-chün, *Shan-piao-chen yü Liu-li-ko*, Institute of Archaeology Monograph Series B, no.11 (Peking, 1959), pl.112.

[3]Chen Jen-dao, *Chin-k'uei lun-ku ch'u-chi* (Hong Kong, 1952), pl.91.

## 140 PLAQUE

**Mottled olive-green jade.**
**Height $1\frac{15}{16}$ in; width $1\frac{1}{2}$ in; thickness $\frac{9}{32}$ in.**
**Bequest of Alfred F. Pillsbury, 50.46.380**

Resembling a miniature shield, this oblong plaque is outlined with a plain circumferential band. The convex surface of the plaque is divided into four equal sections by two intersecting bands and decorated with a relief spiral-grain pattern. Breakage is visible at several points on the circumference. Slanted bore holes have been drilled in the undecorated back of the plaque.

The decorative surface pattern used here is composed of grain designs with short spiral tails and grain designs with lengthened S-shaped tails, a combination that creates a vividly rhythmical surface pattern quite unlike the more conventional, static Han patterns. Hui Hsien, the well-known Warring States site, has yielded a number of pieces of similar style.[1] Late Eastern Chou.

[1]Hsia Nai *et al.*, *Hui-hsien fa-chüeh pao-kao*, Archaeological Field Reports, no.1 (Peking, 1956), pls.78:20 and 93:1.

## 141 PLAQUE

**Highly calcified ivory-white jade; traces of earthlike substance mixed with glue; visible repair work.**
**Height $1\frac{1}{8}$ in; width $1\frac{3}{16}$ in; thickness $\frac{1}{16}$ in.**
**Bequest of Alfred F. Pillsbury, 50.46.351**

This small, rectangular plaque with two decoratively notched sides is adorned with incised striations and C-comma or cloud designs in relief. The four perforations, one in each corner, and the undecorated reverse side indicate that the plaque functioned as an appliqué ornament.

The C-comma or cloud pattern was popular from the Warring States period[1] through the Han Dynasty and can be seen on plaques similar to this one that have been excavated at Lo-yang[2] and other Warring States sites. Late Eastern Chou.

[1]Kuo Pao-chün, *Shan-piao-chen yü Liu-li-ko*, Institute of Archaeology Monograph Series B, no.11 (Peking, 1959).
[2]W.C. White, *Tombs of Old Lo-yang* (Shanghai, 1934), pl.cxxxiv, 327. This piece is now in the Royal Ontario Museum collection and is illustrated in D. Dohrenwend, *Chinese Jades in the Royal Ontario Museum* (Toronto, 1971), p.74. Other similar plaques can be seen in An

140

141

142

Chih-min *et al.*, *Lo-yang Chung-chou-lu*, Institute of Archaeology Monograph Series D, no.4 (Peking, 1959), p.113, fig.81:7, 12 and Kuo Pao-chün, *Shan-piao-chen yü Liu-li-ko*, Institute of Archaeology Monograph Series B, no.11 (Peking, 1959), pl.112:5.

that if the designs are viewed from the side, the birds become elephants and the birds' tails become elephants' trunks.
[2]Yü Shih-chi *et al.*, *Shou-hsien Ts'ai-hou mu ch'u-t'u i-wu*, Institute of Archaeology Monograph Series B, no.5 (Peking, 1956).

## 142 PLAQUE

**Opaque light brown jade with mottling; traces of red pigment.**
**Height 1⅝ in; width 1 9/16 in; thickness 1/16 in.**
**Bequest of Alfred F. Pillsbury, 50.46.338**

This rounded plaque with squared, notched corners and a circular central opening is incised with double-hooked spiral patterns that suggest abstract dragon heads. There are two small perforations aligned on either side of the central opening. The underside is plain.

The use of the double-hooked spiral pattern to suggest an abstract, stylized dragon head was popular during the Late Eastern Chou period. Similar flat pendants have been found among Warring States remains.[1] Late Eastern Chou.

[1]Yü Shih-chi *et al.*, *Shou-hsien Ts'ai-hou mu ch'u-t'u i-wu*, Institute of Archaeology Monograph Series B, no.5 (Peking, 1956), pl.106; Kuo Pao-chün, *Shan-piao-chen yü Liu-li-ko*, Institute of Archaeology Monograph Series B, no.11 (Peking, 1959), pl.112:5.

## 143 FINIAL

**Translucent white jade with brown markings.**
**Length 1 15/32 in; width 1 3/16 in; thickness 7/16 in.**
**Bequest of Alfred F. Pillsbury, 50.46.367**

This rectangular plaque is surmounted by a mushroom-shaped cap. A spiral-cloud and striation pattern adorns the surfaces of the plaque and cap, and a pair of birds decorates the front side of the cap.[1] The finial has two perforations, a large, socketlike perforation in the cap and a horizontal perforation in the plaque. Bronze incrustation in the plaque's perforation indicates that the finial was once an ornament attached to a bronze object. The combination of spiral-cloud designs and striations was commonly used as a surface decoration during the Late Eastern period, particularly on bronze vessels.[2] Late Eastern Chou.

[1]The highly stylized bird design, which is executed most delicately and elegantly, does not convincingly reveal any particular species. The two birdlike creatures, which are depicted facing one another, have narrow, curved beaks and tails that curl under their bodies. There is a stylized eye on the shoulder of each bird so

## 144 DRAGON ORNAMENT

**Translucent pale green jade with brown markings at the ear of the dragon and the middle of its serpentine body.**
**Diameter 2¼ in; height ⅜ in; thickness 3/16 in.**
**Bequest of Alfred F. Pillsbury, 50.46.320**

This semi-circular band has the form of a serpentine dragon body. A rectangular notch at the midpoint of the band suggests that the piece may have been used as a finial. The outer surface of the band is decorated with incised criss-cross and triangular *lei-wen* designs and the inner surface is decorated with simple striations. A biconical perforation in the neck of the dragon is in vertical alignment with the mouth opening.

Both in composition and expression this piece is comparable to the dragon pendant in the Freer Gallery of Art collection, sharing such characteristics as the squarishness of the dragon's head, the dragon's large upper jaws and small lower lips, and the incised linear designs.[1] Late Eastern Chou.

[1] A. Salmony, *Carved Jade of Ancient China* (Berkeley, 1938), pl.XLI:2.

## 145 FINIAL

**Slightly mottled yellow-grey jade.**
**Length 2 in; width ¼ in; thickness 5/32 in.**
**Bequest of Alfred F. Pillsbury, 50.46.319**

## 146 FINIAL

**Slightly mottled yellow-grey jade.**
**Length 2⅛ in; width ⅜ in; thickness 5/32 in.**
**Bequest of Alfred F. Pillsbury, 50.46.332**

The small perforation in the flattened, tapered end of each of these graceful, reverse-*S*-shaped objects suggests that the pieces were probably used as fittings or accessories for other objects. Two parallel, incised lines follow the entire outline of each piece and comprise the only surface decoration. These incised lines were well executed by a skillful hand and are reminiscent of the calligraphic elegance that characterizes Late Chou lapidary work, particularly the jades from Chin-ts'un. The two pieces are identical except for the slightly greater length and width of No.146. Late Eastern Chou.

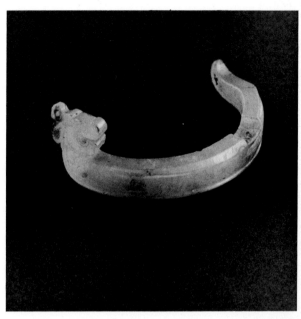

143

144

145

146

## 147 CYLINDRICAL OBJECT

**Translucent yellowish brown jade; traces of red pigment and earthlike substance.**
**Diameter $\frac{31}{32}$ in; height $\frac{17}{32}$ in.**
**Bequest of Alfred F. Pillsbury, 50.46.326**

## 148 CYLINDRICAL OBJECT

**Translucent yellowish brown jade; traces of red pigment and earthlike substance.**
**Diameter $\frac{31}{32}$ in; thickness $\frac{17}{32}$ in.**
**Bequest of Alfred F. Pillsbury, 50.46.327**

The surfaces of this pair of small, cylindrical objects with concave tops and bottoms are covered with a small interlocking twisted rope pattern, a popular Eastern Chou design. The function of the objects remains obscure. Without perforations they could not have been used as buttons or pendants, and the surface decoration on all sides makes it unlikely that they were used as plaques or finials. Late Eastern Chou.

## 149 *PI* DISC

**Mottled green-brown jade.**
**Diameter $9\frac{1}{4}$ in; inner diameter 4 in; thickness $\frac{3}{16}$ in.**
**Bequest of Alfred F. Pillsbury, 50.46.316**

This circular disc has two concentric decor zones, each enframed by a plain band set off on either side by incised lines. The inner decor zone is covered with a triangular grid that separates decorative hexagonal nipple bosses. The outer decor zone displays four evenly spaced monster masks with interlocking, serpentine bodies, a design usually referred to as a serpentine double-bodied animal mask. Although uncomplicated in design, each monster mask is executed with a combination of thick and thin incisions, the heavier incisions creating a *T*-design that represents the brow, eyes, and nose bridge, and the lighter incisions providing such details as the eyes, horns, and whiskers. The flanking, serpentine bodies are composed of a combination of heavy and light incisions in a curvilinear pattern.

The large decor field and correspondingly small perforation create a *pi* disc with proportions that do not conform to the standards for *pi* discs that were formulated during the Chou period, a fact that may suggest that the standards were not absolute. It is also possible, however, since the *Chou-li* makes no mention of elaborately adorned *pi* discs, that a disc like this was carved for aesthetic appeal rather than for a role in ceremonial functions. Similar *pi* are often found in Han tombs.[1]

The juxtaposition of delicate and heavy incisions on this disc appears to be a continuation of a Warring States tradition. Han.

[1] *Wen-wu*, 1956, no.5, p.23; *Wen-wu*, 1962, no.5, p.68; *Wen-wu*, 1972, no.5, p.39.

## 150 *PI* DISC

**Grey-green mottled jade.**
**Diameter $9\frac{5}{16}$ in; inner diameter $2\frac{11}{16}$ in; thickness $\frac{1}{8}$ in.**
**Bequest of Alfred F. Pillsbury, 50.46.315**

This thin *pi* disc is divided into two decor zones, an inner zone decorated with nipple bosses in low relief and an outer zone carved in openwork curvilinear designs that suggest pairs of dragons and phoenixes. Both sides are identical.

Openwork carving on the rim of the *pi* disc was an innovation that was passed on to the Han jade carver[1] by the Warring States artist.[2] Han.

[1] *Wen-wu*, 1972, no.1, p.8; *Wen-wu*, 1964, no.12, pl.2:4; A. Salmony, *Carved Jade of Ancient China* (Berkeley, 1938), pl.64:1; D. Dohrenwend, *Chinese Jade in the Royal Ontario Museum* (Toronto, 1971), p.72.
[2] An excellent example of openwork carving on the rim of a *pi* disc is preserved in the jade collection at the William Rockhill Nelson Gallery of Art in Kansas City, Missouri, and is illustrated in two works: S.H. Hansford, *Chinese Carved Jades* (London, 1968), pl.35; and *Handbook of the Collections in the William Rockhill Nelson Gallery of Art and Mary Atkins Museum of Fine Arts*, vol.2, *Art of the Orient* (Kansas City, Missouri, 1973), pp.22–24.

## 151 *HUAN* DISC

**Green mottled jade.**
**Diameter $12\frac{1}{3}$ in; inner diameter $4\frac{3}{4}$ in; thickness $\frac{1}{4}$ in.**
**Bequest of Alfred F. Pillsbury, 50.46.317**

Similar in decor to No.149, this *huan* disc differs, however, in that its central opening is larger in diameter than the width of its band. The disc is divided into two concentric decor zones by two incised lines that bound a narrow ring, half of which is unadorned and half of which is incised with a rope pattern. The inner decor zone is covered with a grain pattern in low relief, and the outer zone is incised with four evenly spaced animal masks with flanking bodies that interlock adjacently. These designs are uniformly and excellently executed and exhibit a unity of design that lends a fluid, curvilinear movement to the piece.

Although the proportionate sizes of the

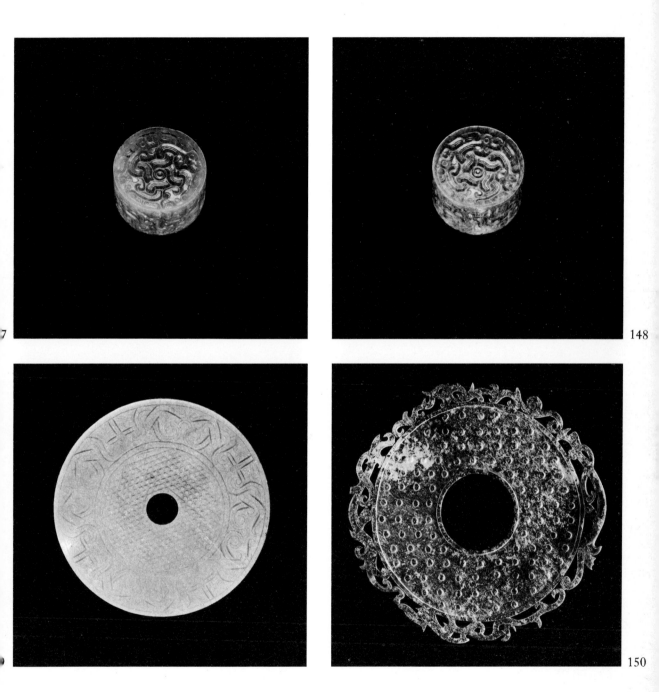

opening and the band of this disc identify it as a *huan*, the overall size of the piece makes it unlike other *huan*, which were usually used as pendants and are, therefore, smaller. This deviation in size, as well as the exuberant decor of the disc, illustrates a change in attitude that occurred after the Late Eastern Chou period. Prior to this change, the energies of the lapidary artist went into the creation of objects made in conformity to the rigid standards established for the production of ceremonial objects. The decor of this *huan* removes it both from the category of *huan* that served as ceremonial objects and those that served as administrative emblems, and also illustrates the post-Late Eastern Chou jade carver's interest in the creation of ornaments of a purely decorative nature. A *huan* disc of similar decor and size was found at Shantung and substantiates the dating of this piece to the Han Dynasty.[2] Han.

[1]Na Chih-liang, *Yü-ch'i t'ung-shih*, vol.1 (Hong Kong, 1964), 59.
[2]*Wen-wu*, 1972, no.5, p.55.

## 152 *TS'UNG*

**Translucent light green jade, partially calcified; visible crack line on one side.
Height 2$\frac{7}{8}$ in; width 3$\frac{1}{8}$ in; thickness 3$\frac{1}{4}$ in.
Bequest of Alfred F. Pillsbury, 50.46.306**

Of the seven *ts'ung* in The Minneapolis Institute of Arts Collection, Nos.52, 53, 54, 152, 153, and 179, this plain *ts'ung* is the shortest. *Ts'ung* similar to this, made of stone or jade, have been excavated at Pao-tê-hsien, a Shang site,[1] and the Ch'u site at Ch'ang-sha, a Western Chou site.[2] Similarly, the numerous *ts'ung* that survive in museum and private collections date from the Shang through the Han Dynasties, making the dating of *ts'ung* particularly problematic. This piece, therefore, has only tentatively been dated Western Chou. Early Western Chou.

[1]*Wen-wu*, 1973, no.4, p.62; *KKHP*, 1955, no.9, pl.88:a.
[2]*KKHP*, 1972, no.1, p.59, illus.12.

## 153 *TS'UNG*

**Brownish tan jade with red veins.
Height 6$\frac{9}{16}$ in; width 2$\frac{1}{2}$ in; thickness $\frac{3}{8}$ in.
Bequest of Alfred F. Pillsbury, 50.46.301**

Similar to the preceding piece (No.152) in its lack of surface decor, this *ts'ung* varies, however, in its slightly greater height and proportionately longer projecting collars. Han.

## 154 BLADE

**Brown jade; diagonal break in the handle.
Length 17 in; width 3$\frac{3}{4}$ in; thickness $\frac{5}{16}$ in.
Bequest of Alfred F. Pillsbury, 50.46.308**

This thick blade in the form of a *ko* dagger has only one sharpened edge. The blade body is slightly beveled and has a groove line that parallels the cutting edge. The slanted tang has a raised central ridge and a central perforation drilled from one side. Incised lines running across the blade, slightly below the tang, create a decor field for double-line incised diamond designs; both sides are identical. A crudely incised inscription, written in a script similar to that used on ancient bone carvings, appears just below the decor zone.

Although the jade of this piece is old, the blade appears to have been made in imitation of Shang or Chou style *ko* daggers,[1] and the inscription appears to have been done in imitation of the ancient script used on bone carvings. Han.

[1]Li Chi, 'Yin-hsü yu-jen shih-ch'i t'u-shuo,' *BIHP* 23 (1952), 523–620; Hsia Nai *et al.*, *Hui-hsien fa-chüeh pao-kao*, Archaeological Field Reports, no.1 (Peking, 1956), pl.15.

## 155 PENDANT OF *ÖNG-TZ'ON*

**Greyish translucent jade with brown spots.
Height 1$\frac{1}{4}$ in; width $\frac{1}{2}$ in; thickness $\frac{3}{8}$ in.
The John R. Van Derlip Fund, 69.97.3**

The guardian figure *öng-tz'on* is depicted in this pendant as a bearded old man wearing an ample garment and cape. His hands, which are crossed in front of his chest, are abstractly suggested under the large sleeves of his garment, and his facial features are simply suggested with short incisions. A perforation runs the length of the pendant.

According to the *Ming-i t'ung-chih* (*History of the Ming Dynasty*), *öng-tz'on*, whose surname was Yüan, came to the court of China during the Ch'in Dynasty.[1] He was an extremely tall and well-built man and quite naturally, therefore, became the guardian of the palace. After *öng-tz'on* died, images of him were carved out of stone and placed outside the doors of the palace. Later, during the Han Dynasty, stone images of this famous protector were placed in front of tombs as symbols of courage, and miniature jade images of him were worn as amulets to ward off evil. Han.

[1]Na Chih-liang, *Yü-ch'i t'ung-shih*, vol.1 (Hong Kong, 1964), 86–97.

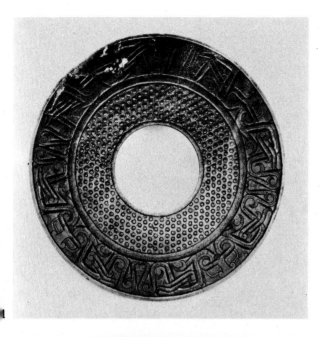

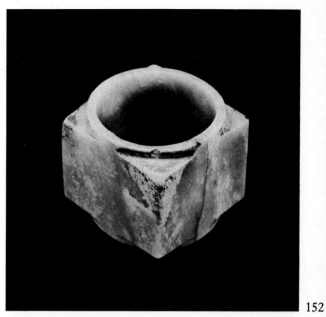

152

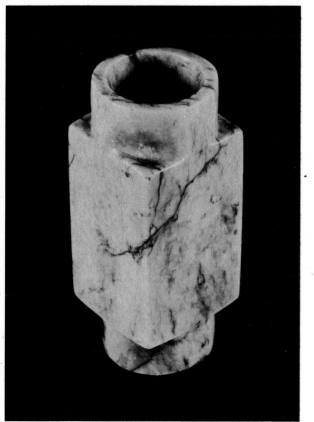

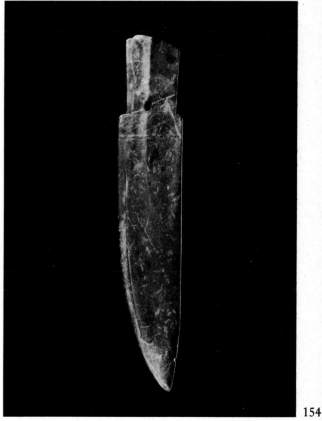

154

127

155

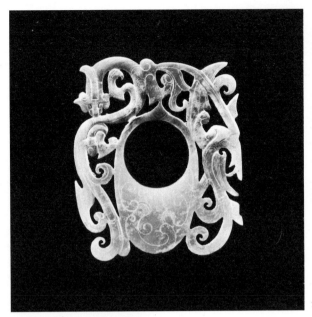

1

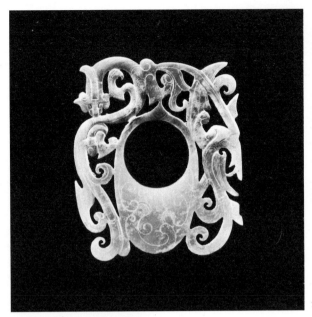

157

## 156 PENDANT IN THE FORM OF AN ARCHER'S THUMB RING

**Translucent yellow-grey jade; traces of earthlike substance.**
**Height $2\frac{3}{4}$ in; width $2\frac{1}{2}$ in; thickness $\frac{7}{32}$ in.**
**Bequest of Alfred F. Pillsbury, 50.46.371**

Elaborately carved in the form of an archer's thumb ring, this pendant is ornamented with ornately and exquisitely carved hooks and curvilinear designs in openwork, which reveal a dragon on the top left side of the ring and a phoenix on the lower right. Delicately incised spiral-comma variants adorn the ring.

The phoenix-and-dragon motif is common on Han carvings,[1] as are the sinuousity, elegance, and liveliness that characterize this piece. Similar pieces have recently been excavated at Tung-shan, a Western Han site,[2] and substantiate the dating of this piece to the Han Dynasty. Han.

[1]Although the Han depiction of the dragon displays distinctly lizardlike qualities and is usually referred to as a *ch'ih*, which identifies the creature as a member of the lizard family, when the animal is presented in conjunction with a phoenix, as it is in this piece, the animal is traditionally referred to as a dragon rather than a lizard.
[2]*Wen-wu*, 1973, no.4, p.26 and pl.8:10, 43, 44 (in the excavation report the pendant is referred to as a 'chicken-heart pendant').

## 157 OX PENDANT

**Translucent blue-green jade.**
**Height 1 in; length 2 in.**
**Bequest of Alfred F. Pillsbury, 50.46.321**

A very naturalistic representation of a seated ox seen from the side, this ox pendant is carved in the round with only the animal's characteristic features expressively accented in high relief. The piece has no incised surface decoration. A biconical perforation has been drilled in the animal's lower lip.

This charming pendant is quite similar in execution to the famous, small, jade horse head in the George Eumorfopoulos collection at the Victoria and Albert Museum.[1] The horse head is datable to the Han Dynasty and, although this ox is shown with greater naturalism, the stylistic similarities between the two strongly suggest a Han Dynasty date for this piece as well. Han.

[1]A. Salmony, *Carved Jade of Ancient China* (Berkeley, 1938), pl.LXVIII.

## 158 DRAGON PENDANT

**Dark green jade; traces of claylike substance.**
**Length $6\frac{3}{4}$ in; height 4 in; thickness $\frac{7}{32}$ in.**
**Bequest of Alfred F. Pillsbury, 50.46.296**

This pendant in the form of the silhouette of a double *S*-shaped dragon is ornamented with *C*-spiral grain pattern on the surface and hooked spirals that project from the perimeter of the piece. The back side is plain. A biconical perforation is located at the lower arch of the dragon.

Although the dragon is a familiar Warring States motif, in this pendant the serpentine dragon appears heavy and clumsy and lacks the vivid, moving spirit of other serpentine dragons. The double *S*-shaped curves of the dragon are unusually arranged, with the middle section of the dragon dropping downward into a U shape and the tail and head of the animal curving up and then down again. A more usual depiction would be that with the middle section of the dragon curving upward and the head and tail paralleling this arch at a lower position (see Nos.117 and 118). Variations on this standard arrangement of the animal's curves occurred freely during the Late Eastern Chou period, but in this particular piece the curves appear awkward and imposed: the long middle section is out of proportion with the following section, and the head appears unusually small making the neck seem overly long. Although this awkwardness could be the result of a particular artist's incompetence, lack of interest, or lack of understanding of the subject, it is more likely that these abnormalities as well as the monotonous and static decor of the piece, reflect a Late Han date. Han.

## 159 DRAGON PENDANT

**Dark green jade; traces of earthlike substance.**
**Length $5\frac{7}{8}$ in; height $4\frac{3}{4}$ in; thickness $\frac{11}{32}$ in.**
**Bequest of Alfred F. Pillsbury, 50.46.297**

Similar in design to the dragon of the previous pendant (No.158), the double *S*-shaped dragon of this pendant has relief lines accentuating the jaw and hooked spirals projecting from a body that is adorned with a comma-grain pattern in relief. The underside is plain. A biconical perforation is located at the lower curve of the dragon's body. Han.

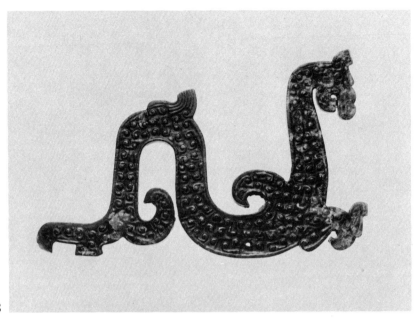

158

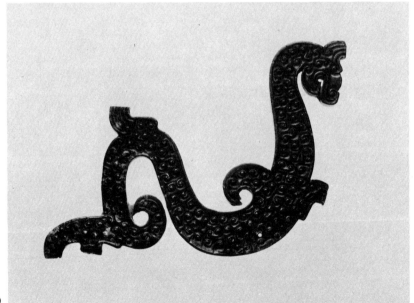

159

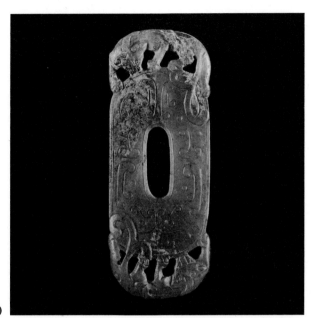

160

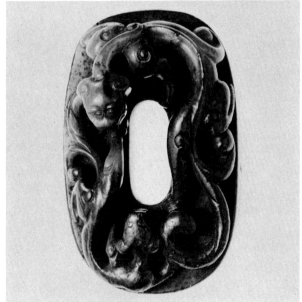

161

## 160 *HSI-PI* DISC

**White jade; traces of earthlike substance.**
**Height 3 in; width 1⅛ in; thickness ⅛ in.**
**Bequest of Alfred F. Pillsbury, 50.46.394**

This flat, oval pendant is carved on either of its short ends with a prowling tigerlike creature in openwork. An incised comma-spiral pattern covers the front surface of the piece and a cloud pattern in relief covers the reverse side.

Both the decor and the composition of this decorative pendant are commonly encountered in Han jade objects, particularly in the decorative accessories for swords.[1] Han.

[1]O. Karlbeck, 'Selected Objects from Ancient Shou Chou,' *BMFEA* 27 (1955), pl.61.

## 161 *HSI-PI* DISC

**Green jade with brown clouds.**
**Length 2 15/16 in; width 1 13/16 in; thickness 1 in.**
**Bequest of Alfred F. Pillsbury, 50.46.393**

A pair of *ch'ih* ('hornless dragons') carved in high relief crouch on the surface of this oblong *hsi-pi* pendant with an oblong central opening. A relief comma-grain pattern covers the reverse side of the pendant.

The *ch'ih* motif, particularly that with *ch'ih* featured in pairs, is most commonly encountered in Han carvings. Han.

## 162 RECTANGULAR PENDANT

**Pale grey-green translucent jade; partially calcified.**
**Length 5½ in; width ⅝ in; thickness 7/32 in.**
**Bequest of Alfred F. Pillsbury, 50.46.339**

This pendant in the form of a narrow rectangular band has a central lengthwise perforation. A small double-hooked cloud pattern is neatly incised on both sides of the pendant in a manner that lacks the excitement and fluency of the Late Eastern Chou style. Han

## 163 BELT HOOK

**Translucent white jade; traces of earthlike substance.**
**Length 4¾ in; width ⅞ in; thickness ⅜ in.**
**Bequest of Alfred F. Pillsbury, 50.46.360**

The hook end of this belt hook is decorated with incised *lei-wen* designs and a stylized dragon head articulated in relief; the top surface of the object is adorned with a linear double-comma pattern in relief. A square stub extends from the underside of the hook, near the midpoint of the piece, and two biconical perforations have been drilled from either side of the dragon's jaws.

Although the animal head on this hook bears a resemblance to a lion head, the ears are rendered in a flower-petal design, a characteristic feature of the tiger depictions of Han and later craftsmen. Han.

## 164 SWORD POMMEL *CHIEN SHOU*

**Translucent tan jade with brown markings.**
**Diameter 1⅞ in; thickness 3/16 in.**
**Bequest of Alfred F. Pillsbury, 50.46.288**

The addition of decorative jade ornaments to swords and scabbards that were used for ceremonial or burial purposes began as early as the Warring States period in China and continued through the Han Dynasty.[1] Each sword and scabbard set had four principal decorative accessories: the pommel of the sword (which this piece is); the sword guard, or *pêng* (No.165); the scabbard buckle, or *wei* (Nos.166, 167, and 168); and the scabbard chape, or *pi* (Nos.169 and 170).[2]

This circular pommel has a slightly raised medallion that is engraved with four double-comma spirals that form a floral design and a central diamond design that is rendered in criss-cross incisions. A relief rim bounds the perimeter of the pommel, and the intermediate decor field is adorned with a relief spiral-grain pattern. The slightly convex underside of the piece has three fitting perforations.

Similar jade pommels, all dating from the Late Eastern Chou or Early Han periods, have been excavated at Lo-yang,[3] at Ch'ang-sha (where a complete set of sword and scabbard ornaments was found *in situ*),[4] and at Shou Chou,[5] and serve to date this piece to that same time period. Han.

[1]Na Chih-liang, 'Yü-chien-shih ming-ming chih t'an t'ao,' *National Palace Museum Quarterly* 5, no.3 (1971), 9–20; A. Salmony, *Chinese Jade Through the Wei Dynasty* (New York, 1963), pp.121, 189.
[2]Na Chih-liang, *op. cit.*; *Ch'ang-sha ch'u wen-wu chan-lang t'u-lu-hsü* (Peking, 1954), pp.37–39, nos.71–75.
[3]W.C. White, *Tombs of Old Lo-yang* (Shanghai, 1934), p.138 and pls.CXXXIX:340a, b, c and CXL:340d, 341b.
[4]*Ch'ang-sha ch'u wen-wu chan-lang t'u-lu-hsü* (Peking, 1954), pp.37–39, nos.71–75.
[5]O. Karlbeck, 'Selected Objects from Ancient Shou Chou', *BMFEA* 27 (1955), p.125 and pl.60:4–8. 10.

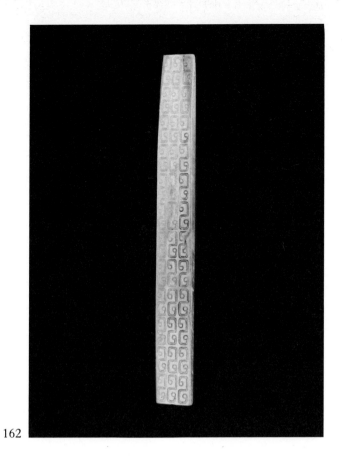

162

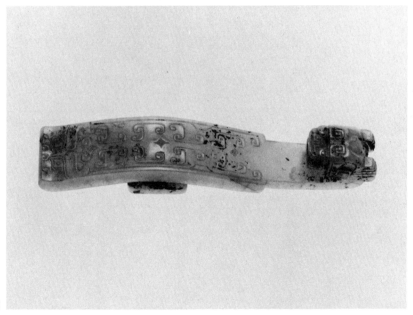

163

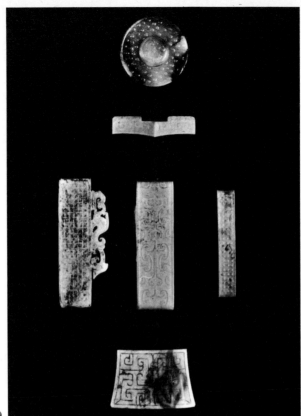

164–9

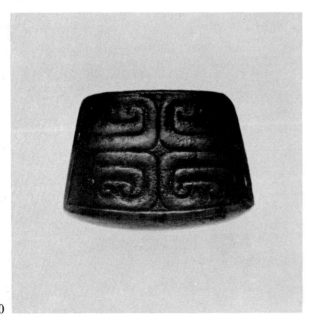

170

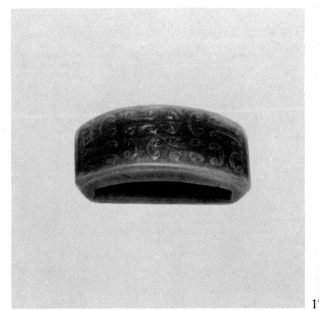

1

134

## 165 *PÊNG* SWORD GUARD

**Ivory jade; traces of earthlike substance.**
**Length 2¼ in; width ½ in; thickness ⅓ in.**
**Bequest of Alfred F. Pillsbury, 50.46.368**

This sword guard, or *pêng*, is adorned with a
network of *T*-shaped double-spiral designs, or
cloud designs, in incision and relief. The
lozenge-shaped cross section of the *pêng* is
drilled with a fitting slot at the center. Similar
sword guards have been found at the Warring
States site at Ch'ang-sha.[2] Late Eastern Chou
or Han.

Published: *The Minneapolis Institute of Arts
Bulletin* 31, no.33 (1924), 119.

[1]Na Chih-liang, 'Yü-chien-shih ming-ming
chih t'an t'ao,' *National Palace Museum
Quarterly* 5, no.3 (1971), 9–20.
[2]*Ch'ang-sha ch'u wen-wu chan-lang t'u-lu-hsü*
(Peking, 1954), p.39, no.75.

## 166 *WEI* SCABBARD BUCKLE

**Calcified ivory jade and semi-translucent
grey jade on the reverse side.**
**Length 3½ in; width 1 7/16 in; thickness ½ in.**
**Bequest of Alfred F. Pillsbury, 50.46.355**

On the underside of this decorative, rectangular
scabbard buckle, or *wei*,[1] is a slender loop used
to attach the scabbard to a belt.[2] The front
surface of the *wei* is adorned with a network of
incised *T* designs, and a birdlike creature is
revealed in the spiral-hook projecting from one
long side of the buckle. Similar scabbard
buckles have been found at various Late Eastern
Chou sites.[3] Late Eastern Chou.

Published: Alfred Salmony, *Carved Jade of
Ancient China* (Berkeley, 1938), pl.LVIII:1.

[1]A discussion of the terminology for and the
usage of the various decorative accessories for
swords and scabbards can be found in Na
Chih-liang, 'Yü-chien-shih ming-ming chih t'an
t'ao,' *National Palace Museum Quarterly* 5, no.3
(1971), 9–20.
[2]A similar fitting was found *in situ* at Loyang
and is illustrated in W.C. White, *Tombs of Old
Lo-yang* (Shanghai, 1934), p.137–138 and
pl.CXXXIX:339a.
[3]W.C. White, *op. cit.; Ch'ang-sha ch'u wen-wu
chan-lang t'u-lu-hsü* (Peking, 1954), p.39,
no.75:2.

## 167 *WEI* SCABBARD BUCKLE

**Ivory jade with brown clouds.**
**Length 3 7/16 in; width 1 in; thickness ½ in.**
**Bequest of Alfred F. Pillsbury, 50.46.353**

A scabbard buckle, or *wei*, of a very common
type, this buckle is decorated with a pattern of
spiral-comma variation on the surface and an
animal face at the top end, directly over the
belt loop.

In execution this piece is similar to scabbard
buckles excavated at Lo-yang, Honan, a Late
Eastern Chou site,[1] and Lo-lang, Korea, a Han
site.[2] Han.

Published: *The Minneapolis Institute of Arts
Bulletin* 31, no.33 (1942), 119.

[1]W.C. White, *Tombs of Old Lo-yang* (Shanghai,
1934), pp.137–138 and pl.CXXXIX:339a. This
piece is also similar to those from Shou Chou
[2]illustrated in O. Karlbeck, 'Selected Objects
from Ancient Shou Chou', *BMFEA* 27 (1955),
pl.61:1, 2.
Koizumi Akio, *The Tomb of the Painted Basket
of Lo-lang* (Seoul, 1934), pl.CXXI: 8 and p.105
(text in Japanese with English summary by
Hamada Kosaku).

## 168 *WEI* SCABBARD BUCKLE

**Opaque yellow jade with brown markings.**
**Length 2 29/32 in; width ½ in; thickness 3/16 in.**
**Bequest of Alfred F. Pillsbury, 50.46.354**

Adorned with nipple bosses and an incised
spiral-cloud variation pattern, this small,
narrow scabbard buckle, or *wei*, has a plain
rectangular loop projecting from its underside.
Han.

Published: *The Minneapolis Institute of Arts
Bulletin* 31, no.33 (1942), 119.

## 169 *PI* SCABBARD CHAPE

**Tan jade, now a yellowish opaque color.**
**Length 1½ in; width 2 5/16 in; thickness ⅝ in.**
**Bequest of Alfred F. Pillsbury, 50.46.291**

Having a slightly wider bottom than top, a
convexly beveled front and back surface, and a
cross section with an elongated oval shape, this
scabbard chape, or *pi*, is pierced on the top
cross-section with two slanted holes to be used
for attaching the chape to the lower end of a
scabbard.[1]

The incised spiral-hook pattern that covers
the surface of the chape bears similarities to the
surface patterns of the scabbard chape
excavated at Ch'ang-sha[2] and those recovered
from Shou Chou.[3] Han.

[1]Na Chih-liang, *Yü-ch'i t'ung-shih*, vol.1 (Hong Kong, 1964), 112. Among the decorative accessories for ancient Chinese swords, the *pi* scabbard chape is easily identified and has long been accepted and acknowledged by scholars.
[2]*Ch'ang-sha ch'u wen-wu chan-lang t'u-hsü* (Peking, 1954), p.38, no.74:2.
[3]O. Karlbeck, 'Selected Objects from Ancient Shou Chou,' *BMFEA* 27 (1955), pl.60:1–3.

## 170 *PI* SCABBARD CHAPE

**Green jade with black markings.**
**Height 1⅜ in; width 2 in; thickness ⅝ in.**
**The John R. Van Derlip Fund, 69.97.4.**

Similar in design to the previous scabbard chape (No.169), this chape also has a trapezoidal shape, a convex front and back, a narrow, oval cross section, and three holes in the top, to be used for affixing the chape to a scabbard. The front surface of the chape is decorated with a softly carved cloud-hook pattern executed in a manner characteristic of Late Han jade carving.[1] Han.

[1]A. Salmony, *Carved Jade of Ancient China* (Berkeley, 1938), pls. 66:5, 71:1.

## 171 BELT ORNAMENT

**Semi-translucent grey jade marked with brown clouds.**
**Length 1⅞ in; height ⅝ in; thickness ⅞ in.**
**The John R. Van Derlip Fund, 69.97.5**

Used as a decorative ring on a belt, this looplike object is adorned with a low relief spiral-cloud design on the convex front surface; the flattened back side is plain. The stone of this piece is old and of sound quality, but the workmanship of the piece, although quite fine, appears to be of a later date. Han.

## 172 CICADA AMULET

**Highly calcified green jade.**
**Length 2 3/16 in; width 1¼ in; thickness 9/32 in.**
**Bequest of Alfred F. Pillsbury, 50.46.335**

Scholars have never agreed on an explanation for the use of the cicada as a motif for mouth amulets in Chinese burial customs. The most accepted opinion is that the life cycle of the cicada was meant to metaphorically represent the idea of human cyclical rebirth or resurrection.[1] Mouth amulets, however, were originally made in a shape similar to that of the tongue and then, out of convenience, or perhaps coincidentally, began to be carved in the form of the cicada, because of the insect's essentially tonguelike shape. Only later was a conscious intellectual connection made between the function of the mouth amulet and the symbolic significance of the cicada, a relationship that is now well established and widely recognized.

The ancient *han-wo* burial ritual speaks of the practice of inserting rice or some other suitable object into the mouths of the deceased in order to prevent their leaving this world empty-handed. In the Shang period cowrie shells, symbolizing material richness, were placed not only in the mouths of the dead[2] but also often in the hands. As early as the Shang era, however, jade objects were also in use as mouth amulets and, in fact, a jade cicada amulet was excavated at Hsiao-t'un.[3] During the following Chou period, cowrie shells continued in use,[4] but jade objects were becoming more popular.

Stylistically the execution of jade cicada amulets changed from the relative simplicity of the cicada excavated at the Shang site of Ta-ssu-k'ung-ts'un[5] to a slightly more complicated style in the Chou period, as seen in the amulets found at Chung-chou-lu, Loyang.[6] By Han times the cicada took a more articulated and somewhat stylized form comparable to that of the piece shown here. Although the surface of this piece is highly corroded, its well-defined shape and the remnants of two groove lines along its back are still evident. Cicada amulets quite similar to this one have been excavated at various Han sites,[7] substantiating both the dating and stylistic atttribution of the three jade cicadas in The Minneapolis Institute of Arts Collection. Han.

[1]B. Laufer, *Archaic Chinese Jades Collected in China by A.W. Bahr* (New York, 1927), p.44; A. Salmony, 'The Cicada in Ancient Chinese Art', *Connoisseur* (American edition) 91, no.379 (March, 1933), 174–179.
[2]Na Chih-liang, *Yü-ch'i t'ung-shih*, vol.1 (Hong Kong, 1964), 130–134.
[3]Shih Chang-ju, 'Hsiao-t'un Yin-tai Ping-tsu chi-chih chi ch'i yu-kuan hsien-hsiang,' *BIHP*, Special Issue, vol.4, part 2 (1960), 464.
[4]*Kao-ku*, 1963, no.12, p.654; Wang Po-hung *et al., Feng-hsi fa-chüeh pao-kao,* Institute of Archaeology Monograph Series D, no.12 (Peking, 1962), p.133.
[5]Na Chih-liang, *Yü-ch'i t'ung-shih*, vol.2 (Taipei, 1970), 201, fig.111:a, b, c.
[6]An Chih-min *et al. Lo-yang Chung-chou-lu,* Institute of Archaeology Monograph Series D, no.4 (Peking, 1959).
[7]*Wen-wu*, 1964, no.12, pl.2:2, 3; Na Chih-liang, *Yü-ch'i t'ung-shih*, vol.2 (Taipei, 1970), p.202, fig.113:a, b.

2

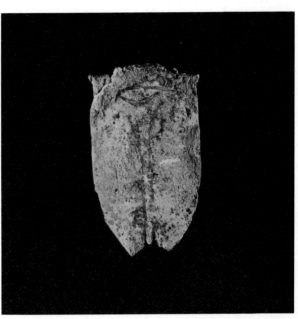

173

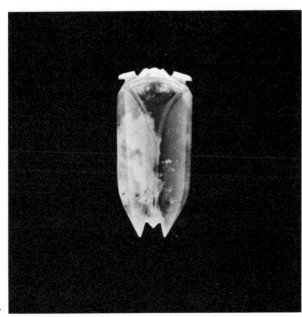

174

## 173 CICADA AMULET

**Ivory white jade.**
**Length 2 in; width 1½ in; thickness $\frac{9}{32}$ in.**
**Bequest of Alfred F. Pillsbury, 50.46.334**

Jade cicadas were used by the ancient Chinese as decorative ornaments as well as funerary mouth amulets. Unlike cicada amulets, which were usually unperforated, cicada ornaments had perforations located in several different positions depending on their intended function. Cicada pendants were drilled with slanted bore holes at the top of the underside, while cicadas to be used as decorative objects on hats and garments had a long perforation extending from the top of the piece to the center of the underside. The jade cicada shown here is highly calcified and now appears 'as white as chicken bone' (*chi-ku-pai*). The left eye has been broken off, and all surface decoration has been obliterated with the exception of a few incised lines indicating the head and wings. Even though the cicada is extensively damaged, there is no indication that there ever were perforations on the back; the piece was most likely a tongue amulet. Han.

## 174 CICADA AMULET

**Translucent mottled grey-green jade; traces of earthlike substance.**
**Length 2⅝ in; width 1 3/16 in; thickness 5/16 in.**
**Bequest of Alfred F. Pillsbury, 50.46.289**

The unperforated underside of this cicada serves to identify the piece as another funerary tongue amulet. The piece has a slightly convex center section and projecting, well-articulated eyes and mouth. Deep grooves on the back of the insect outline the folded wings; on the underside of the amulet similar incised striations indicate the cicada's skin texture. This piece from The Minneapolis Institute of Arts Collection is nearly identical with a cicada excavated from the Han sites of Shih-yen-li, Korea,[1] and T'ing Hsien in Hopei, China.[2] Han.

[1]Na Chih-liang, *Yü-ch'i t'ung-shih*, vol.2 (Taipei, 1970), 202, fig.113a.
[2]*Wen-wu*, 1964, no.12, p.26–40 and pl.1–2.

## 175 *CHIH* VASE

**Light olive green jade with dark brown clouds.**
**Height 4⅞ in.**
**The William Hood Dunwoody Fund, 16.10**

A good example of a Sung imitation in jade of an early bronze vessel, the form of this vase, which resembles that of a bronze *chih*, and the geometric spiral designs and medallions that compose the decorative band at the neck are carved in imitation of Han Dynasty bronze vessels and their decor. This jade *chih* was perhaps used as a drinking cup, as was the bronze *chih*. Sung.

Published: *The Minneapolis Institute of Arts Bulletin* 5, no.5 (1916), 36–38.

## 176 SEAL

**White and black jade.**
**Height 1½ in; length 1½ in; width 1⅝ in.**
**Bequest of Alfred F. Pillsbury, 50.46.399**

Surmounted by a four-footed animal that has the head of a dragon and the body of a beetle, this solid, square seal is carved with an inscription that reads, '*Tsui-ko fang-fei*,' or 'Drunken odes to floral beauty'. While the seal appears to be old, the rather clumsily carved inscription appears to be more recent. Sung.

## 177 DRAGON-HEAD FINIAL

**Green jade; traces of red pigment.**
**Length 3¼ in; height 1¼ in; thickness 5/16 in.**
**Bequest of Alfred F. Pillsbury, 50.46.391**

From the front, this finial displays the profile of a dragon head having forked prongs for horns, a long mane (a characteristic of Sung or later representations of the creature), and a fang that curves upward to push away a fold of the animal's lip;[1] the back side of the object is plain. Two slanted perforations and a slit opening at the base of the piece indicate the object's function as a finial. Sung.

[1]D. Gure, 'Selected Examples from the Jade Exhibition at Stockholm, 1963; A Comparative Study,' *BMFEA* 36 (1964), 150 and pl.27a, b. Gure possesses a similar piece, which he dates pre-Sung.

## 178 INK BED

**White jade.**
**Length 6¼ in; width 2½ in.**
**The John R. Van Derlip Fund, 44.5.4**

Used as a tray to hold a scholar's ink stone and ink, this rectangular tablet has rolled edges along its two long sides. A landscape carved in low relief shows an eagle standing atop a rock amidst the swirling waters of a fast stream; a peach tree graces the background. In the upper left corner of the tray an inscription suggesting longevity reads, '*T'ao-shih sui-san-ch'ien*,' or

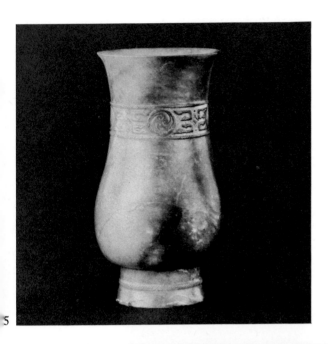

5

176

177

178

179

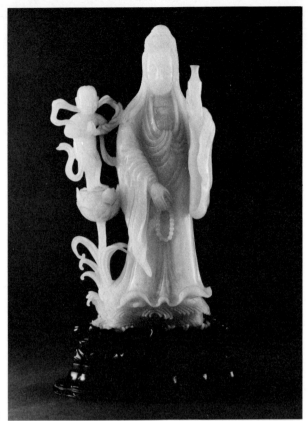

180

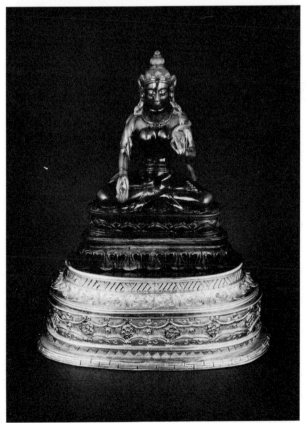

181

'Peaches of three thousand years.' A short poem inscribed on the reverse side is signed 'Tzǔ-kan', the foremost jade carver of the Ming Dynasty, well known both for his shallow relief carving and his delicate, intricate works.[1] Ming.

[1] Na Chih-liang, *Yü-ch'i t'ung-shih*, vol.2 (Tapei, 1970), 73.

## 179 DECORATIVE *TS'UNG*

**Translucent pale tan jade.**
**Height $2\frac{3}{16}$ in; diameter $2\frac{3}{4}$ in;**
**thickness $\frac{5}{32}$ in.**
**Bequest of Alfred F. Pillsbury, 50.46.307**

This extremely thin *ts'ung* is made in imitation of the ancient *ts'ung* (Nos.52, 53, 54, 152, and 153), but lacks the heaviness and squareness of its prototype. Each of the four outer surfaces is decorated with an incised animal-mask design and an abstract design in relief. A poem by Chien-lung of the Ch'ing Dynasty and two of Chien-lung's seals are inscribed on the inner surface and reveal that the *ts'ung* was made in imitation of the rare beauty of antiquity. It was particularly popular during Ch'ien-lung's reign (1736–95) to copy antiques, and frequently this was done with such success that the copies remain indistinguishable from the ancient pieces. In this particular piece, however, the advanced lapidary workmanship and the poem reveal the later date. Ch'ing.

## 180 KUAN YIN GODDESS

**White jade.**
**Height 10 in.**
**Gift of Mr and Mrs Augustus L. Searle, 28.41**

The Kuan Yin goddess is shown here standing on wavy water, holding prayer pearls in her right hand and a libation vase in her left hand. A lotus branch rises from the water, and a small child with hands held in a praying position stands on the lotus blossom. Ch'ing.

Published: *The Minneapolis Institute of Arts Bulletin* 18, no.5 (1929), 21–24.

## 181 BODDHISATTVA

**Green jade with gilt stand.**
**Height 4 in; width 3 in.**
**Gift of Mr and Mrs Augustus L. Searle, 36.5.1**

Seated on a lotus throne, this narrow-waisted, large-breasted boddhisattva wears an elaborate crown, a diaphanous garment, and

earrings, an image that is particularly Indian in influence. An inscription near the base of the carving reads, '*Yung-cheng yu chi*,' or 'Especially made for Emperor Yung-cheng.' A gilt stand accompanies the statue. Ch'ing.

## 182 *JU-I* SCEPTER

**Gilded bronze mounted with three green jadeite plaques.**
**Length $25\frac{1}{2}$ in; width $7\frac{1}{2}$ in; height 4 in.**
**Gift of Mr and Mrs Augustus L. Searle, 33.38.3**

The *ju-i* ('as you wish') scepter was a popular gift during the Ch'ing Dynasty. Both in form and symbolic significance the object is a derivation of the practical pronged back scratcher which, as it scratches the itch, fulfills and satisfies the need. The three plaques on this particular *ju-i* further suggest that the wishes are to be fulfilled three times ('*Shan-jao ju-i*').

This gilded bronze scepter displays three plain jadeite plaques, a top plaque having a cloud shape and two lower plaques having rectangular shapes with rounded corners. Flower designs adorn the handle of the scepter, and two rows of *shou*, characters for longevity, form a border around the setting of each plaque. The scepter was most probably a birthday gift. Ch'ing.

Published: *The Minneapolis Institute of Arts Bulletin* 23, no.5 (1934), 21–24.

## 183 *JU-I* SCEPTER

**Teakwood set with white jade plaque, handle, and inscription.**
**Length $13\frac{3}{4}$ in; width $3\frac{1}{4}$ in.**
**Gift of Mr and Mrs Augustus L. Searle, 38.44.2**

This *ju-i* scepter is made of teakwood and adorned with white jade. The cloud-shaped main plaque is carved with the old god of longevity, a peach tree, a pine tree, and a bat; all symbols of long life and good fortune. A low relief image of a bat adorns the trapezoidal cap of the scepter's handle, and a setting of four white jade characters reads, '*Shou-shan Fu-hai*,' or 'Long life as immortal as the mountains; great fortunes as abundant as the oceans.' The scepter was most likely exchanged as a birthday gift. Ch'ing, Chien-lung period.

Published: *The Minneapolis Institute of Arts Bulletin* 28, no.9 (1939), 45–46.

182

183

## 184 TABLE SCREEN

**White jade.**
**Height 12¼ in; width 8⅛ in.**
**Gift of Mr and Mrs Augustus L. Searle,**
**37.58**

This rectangular table screen is adorned on one
side with a pastoral scene that includes eight
horses, a bamboo tree, and pine trees carved in
relief; the branches of one of the pine trees
extend onto the reverse side of the screen in a
most delicate and elegant manner. A poem
attributed to Ch'ien-lung is inscribed in the
upper left corner of the screen, although the
rhythm and composition of the poem suggest
that the authenticity of the composition is
dubious. Ch'ing.

Published: *The Minneapolis Institute of Arts
Bulletin* 27, no.1 (1938), 3–4.

## 185 CIRCULAR TABLE SCREEN WITH STAND

**Spinach jade with wooden stand.**
**Diameter 8⅜ in; thickness ¼ in.**
**Gift of Mr and Mrs Augustus L. Searle**
**34.21.2 (a,b)**

Circular tablets supported by wooden stands
are often used in pairs as table decorations.
Both sides of this screen are decorated with
relief floral designs: peonies and butterflies on
one side, and peonies and ribbon streamers on
the other, popular Chinese motifs representing
abundance and longevity. Ch'ing.

Published: *The Minneapolis Institute of Arts
Bulletin* 21, no.5 (1932), 21–22; *ibid.*, vol.23,
no.27 (1934), 138–139.

[1]S.H. Hansford, 'Jade and Jade Carving in the
Ch'ing Dynasty,' *TOCS* 35 (1963–64), 35–37.
According to Hansford the Siberian *po-ts'ai yü*,
or spinach jade, was not traded to China until
1850.
[2]S.C. Nott, *Chinese Jade in the Stanley Charles
Nott Collection* (West Palm Beach, 1942),
fig.XIV:f. Nott refers to a similar floral design as
a red camellia.

## 186 CIRCULAR TABLE SCREEN WITH STAND

**Spinach jade with wooden stand.**
**Diameter 8⅜ in; thickness ¼ in.**
**Gift of Mr and Mrs Augustus L. Searle,**
**34.21.3 (a,b)**

Forming a pair with the preceding screen, this
screen is adorned on one side with a

cherry-apple vine and a phoenix, and on the
other side with hibiscus and butterflies,
popular Chinese motifs. Ch'ing.

Published: *The Minneapolis Institute of Arts
Bulletin* 21, no.5 (1932), 21–22; *ibid.*, vol.23,
no.27 (1934), 138–139.

## 187 VASE WITH COVER

**White jade.**
**Height 14⅝ in.**
**Gift of Mr and Mrs Augustus L. Searle,**
**38.43.3 (a,b)**

This large, ornate vase is shaped in imitation of
the ancient bronze wine vessel. Eight ears
project from the neck and shoulder of the vase:
the four at the neck carved in a bird form, those
at the shoulder in an animal mask form with
pendant loose rings. High relief borders define
the main decor zone, which is carved with
animal masks that resemble those commonly
found on ancient bronze vessels. Four vertical,
notched bands are carved in high relief on the
base, and the tall cover of the vase is adorned
with a band of phoenix designs and a stylized
lotus flower finial. Ch'ing.

Published: Joan Hartman, *Chinese Jade of Five
Centuries* (Rutland, Vermont, 1969), pp.110–
111, pl.28.

## 188 VASE WITH COVER

**White jade.**
**Height 10½ in.**
**Gift of Mr and Mrs Augustus L. Searle,**
**29.19.1 (a,b)**

Elaborately twisted coral branches are carved in
openwork on either side of this tall vase in
the form of a flattened *tsun* vessel. Four
small lions stand on the coral branches, and a
three-dimensional lion serves as a finial on the
cover of the vase. Stylized tigers carved in
openwork form ears on either side of the neck
of the vase. A low relief scene of a
hermit-gentleman travelling in a boat, under
overhanging clouds, decorates the body of the
base on the obverse side. Except for the lions,
which are somewhat distracting, the
workmanship of this piece is skillful and the
composition tasteful and elegant. Ch'ing.

Published: *The Minneapolis Institute of Arts
Bulletin* 18, no.23 (1929), 115.

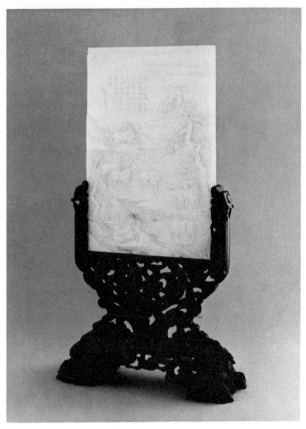

184

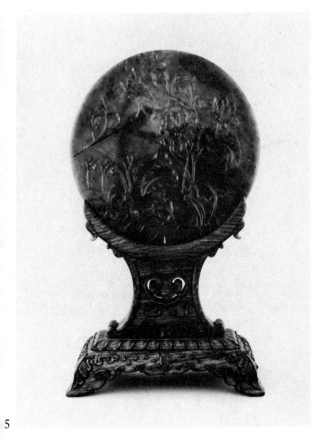

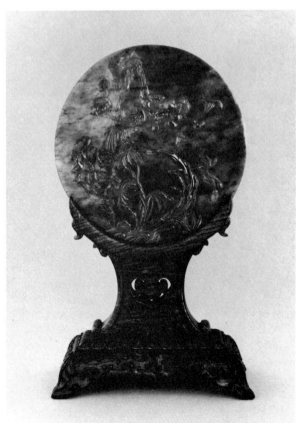

5

186

145

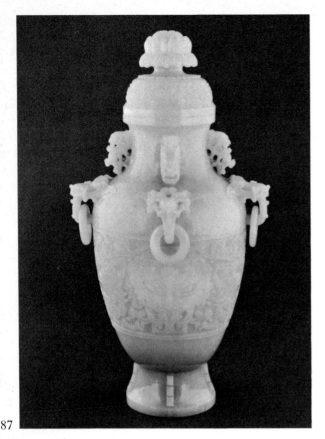

187

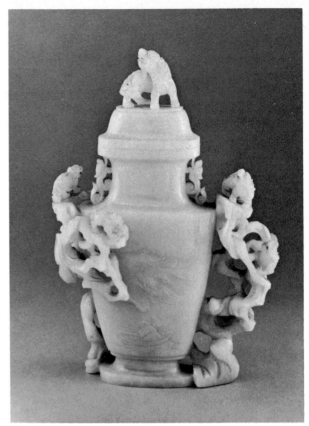

18

189

1

## 189 VASE

**Green jade.**
**Height 13⅜ in; width 8⅞ in.**
**Gift of Mr and Mrs Augustus L. Searle,**
**32.47.5 (a,b)**

This vessel, which is carved in imitation of an ancient bronze *hu*, has a flattened bulbous body and a quadrangular neck. A decorative ear in the form of a curvilinear leaf projects from either side of the neck.[1] The front and back of the vase are embellished with inlaid gold linear designs: on one side, a deer, symbolizing longevity and prosperity, and on the other side, an immortal crane and a pine tree, symbolizing purity and exuberance, much-favored themes of the Chinese literati. Ch'ing.

Published: *The Minneapolis Institute of Arts Bulletin* 21, no.4 (1932), 18–19; *ibid.*, vol.22, no.9, 41–43.

[1] S.C. Nott, *Chinese Jade in the Stanley Charles Nott Collection* (West Palm Beach, 1942), pp.206–228. Vessels of this shape are often referred to as pilgrim bottles after the ceramic vessels of similar form that have been in use since the Ming Dynasty.

## 190 VASE WITH A JADE STAND

**Greenish yellow jade with brown markings.**
**Height 9½ in; width 6⅛ in.**
**Gift of Mr and Mrs Augustus L. Searle,**
**36.7.4 (a,b,c)**

With a flared mouth, a flared base, a bulbous body, and flower-form ears that carry loose rings, the obverse side of this tall *tsun*-form vase displays a phoenix with a long tail and spread wings carved in openwork and deep undercut relief. The base of the vase is in the form of a large, irregularly-shaped rock carved out of the same piece of stone from which the vase is carved. An inscription on the underside of the vase reads, 'Made during the reign of Ch'ien-lung of the great Ch'ing.' The script, however, a variant of *Li-shu*, is unusual, and its authenticity is questionable. Ch'ing.

## 191 VASE WITH COVER

**Spinach jade.**
**Height 11½ in.**
**Gift of Mr and Mrs Augustus L. Searle,**
**38.43.1 (a,b)**

Both the front and the back of this tall, elaborate vase are adorned with a low-relief flying phoenix surrounded by swirling cloud streamers. The projecting ears, one on either side of the neck, are carved in openwork and high relief and are composed of a peony branch,[1] a bold flower, and four leaves, a design that is repeated to form the knob of the cover. Ch'ing.

Published: *The Minneapolis Institute of Arts Bulletin* 28, no.9 (1939), 41–46.

[1] S.C. Nott, *Chinese Jade in the Stanley Charles Nott Collection* (West Palm Beach, 1942), fig.xv:c.

## 192 VASE WITH COVER

**Yellow jade.**
**Height 6¾ in; width 5¼ in.**
**Gift of Mr and Mrs Augustus L. Searle,**
**32.47.1 (a,b)**

A climbing *ch'ih* carved in high relief and openwork serves as a handle on this slender vase. Similar feline creatures carved in high relief rim the neck and the remaining surfaces of the vase and create a lively surface decor. A small doglike creature carved in three dimensions extends from the lower side of the vase and carries a small, gourd-shaped secondary vase. Ch'ing.

Published: *The Minneapolis Institute of Arts Bulletin* 22, no.9 (1933), 43 and illus.

## 193 DOUBLE VASE

**Dark spinach green jade.**
**Height 8 in.**
**Gift of Mr and Mrs Everett H. Andreson,**
**67.62.3**

This angularly articulated double vase has a single lid that is surmounted by an elaborately sculpted dragonlike creature. The projecting flanges at the neck of the vase echo those of ancient bronze vessels. Ch'ing.

## 194 VASE WITH TEAKWOOD COVER

**Yellow jade.**
**Height 7¼ in; width 4½ in.**
**Gift of Mr and Mrs Augustus L. Searle,**
**32.47.2**

This squat, rectangular vase stands on three short legs and has two solid rectangular handles. Near the top of the obverse side of the vase are projecting plaques carved with relief nipple bosses, and beneath the plaques, a relief animal mask. The reverse side displays an animal mask and two phoenixes rendered in a cloud pattern. A small three-dimensional phoenix surmounts the wooden lid. These

191

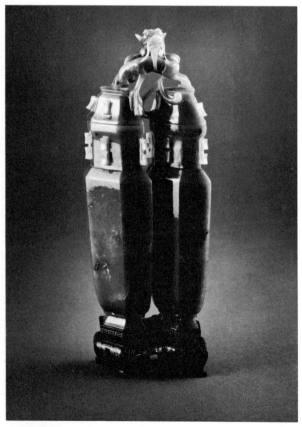

193

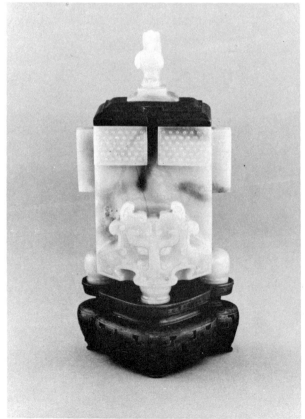

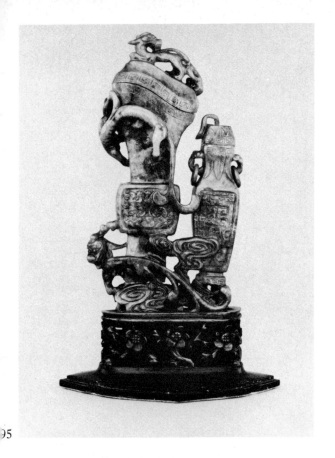

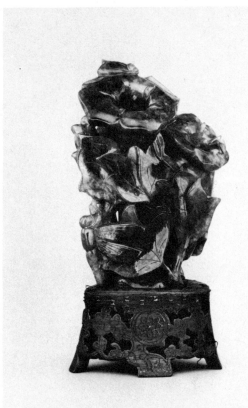

195

196

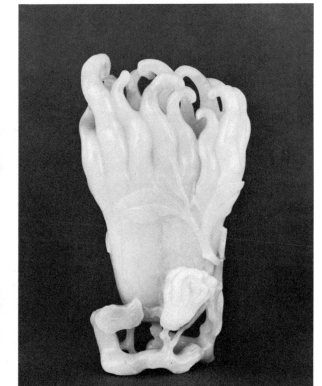

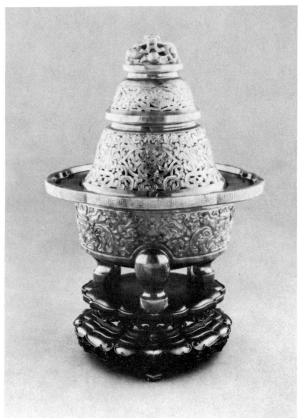

198

motifs, the phoenix, the animal mask, the nipple bosses, and the cloud designs, are obviously adapted from the decor of ancient bronze vessels, and together with the reserved, heavy appearance of the piece, lend a flavor of antiquity. The composition is unique and the carving excellent. Ch'ing.

Published: *The Minneapolis Institute of Arts Bulletin* 22, no.9 (1933), 43–44.

## 195 TWIN VASE

**Green jadeite.**
**Height 6½ in; width 3½ in.**
**Gift of Mr and Mrs Augustus L. Searle,**
**28.44 (a,b)**

In this double vase the large vase of the pair resembles a bronze *kuang*, and the small vase next to it resembles a bronze *tsun*. The front and back of the bulbous body of the large vase are each adorned with an animal mask design in relief; the mouth of the vase and the rim of the lid are encircled by bands of *lei-wen* designs; and the lid is surmounted by a crouching dragon. The front and back of the small vase are adorned with double dragons; the mouth of the vase and the rim of the lid are adorned with bands of *lei-wen* meander patterns and banana leaves; the neck displays small ears that carry loose rings; and the cap of this small vase is also surmounted by a feline creature. An overall sense of movement surrounds the two immobile vases, a result of the long-tailed animals and the stylized cloud patterns. Ch'ing.

## 196 FLOWER VASE

**Green jadeite.**
**Height 4⅛ in; width 2½ in.**
**Gift of Mr and Mrs Augustus L. Searle,**
**28.45**

This vase is cleverly carved in the form of a pair of upright morning glories entwined with vines and leaves carved in openwork. At the lower edge of the vase a dragonfly is vividly captured in high relief. Ch'ing.

## 197 VASE

**Yellow jade.**
**Height 5⅝ in; width 3 in.**
**Gift of Mr and Mrs Augustus L. Searle,**
**38.44.5**

Carved to be used as a flower vase, this vessel is in the form of an upright finger citron or Buddha's hand citron. Patterned leaves entwine the citron, and a second, miniature citron is

carved in relief at the base of the container. Ch'ing.

Published: *The Minneapolis Institute of Arts Bulletin* 28, no.9 (1939), 44.

## 198 INCENSE BURNER AND COVER

**Green jade.**
**Height 10¾ in; width 9⅜ in.**
**Gift of Mr and Mrs Augustus L. Searle,**
**36.7.1 (a,b)**

A wide projecting rim, the edge of which is engraved with a thunder pattern, separates the body of this short, three-footed incense burner[1] from the three-tiered, high cover. The surface of the burner is carved with relief floral designs, *shou*, character for longevity, and a bat, representing good fortune. The two lower sections of the cover are embellished with similar floral patterns, and a serpentine dragon forms the finial. Ch'ing.

Published: *The Minneapolis Institute of Arts Bulletin* 26, no.6 (1937), 26.

[1]S.C. Nott, *Chinese Jade in the Stanley Charles Nott Collection* (West Palm Beach, 1942), p.317, no.59.

## 199 BRUSH HOLDER

**White jade.**
**Height 7⅛ in; diameter 6⅞ in.**
**Gift of Mr and Mrs Augustus L. Searle**
**33.38.2**

The surface of this cylindrical brush holder is decorated in undercut relief with the popular Taoist scene of the birthday pilgrimage made by the Eight Taoist Patriarchs. The landscape of pine trees, a crane, and deer indicates their arrival in the Western Paradise. Ch'ing.

Published: *The Minneapolis Institute of Arts Bulletin* 23, no.5 (1934), 21–22.

## 200 WATER BASIN

**White jade.**
**Length 9 in; width 4¾ in; height 3 in.**
**Gift of Mr and Mrs Augustus L. Searle,**
**33.38.1 (a,b)**

This basin, which is in the form of an open gourd, is adorned with beautifully carved high-relief vines, leaves, and bats.[1] Ch'ing.

Published: *The Minneapolis Institute of Arts Bulletin* 23, no.5 (1934), 23–24; Joan Hartman,

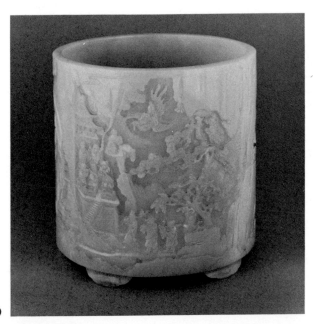

199

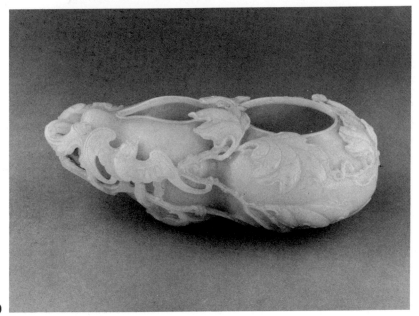

200

*Chinese Jade of Five Centuries* (Rutland, Vermont, 1969), pp.112–113, pl.29.

[1]A similar piece, dated to the reign of Yung-cheng (1723–1735 A.D.), is illustrated in S.C. Nott, *Chinese Jade in the Stanley Charles Nott Collection* (West Palm Beach, 1942), pp.371–372 and pl.LXXXII:72.

## 201 VASE

**Pale moss-green jade.**
**Height 4¾ in; width 4¼ in.**
**Gift of Mr and Mrs Augustus L. Searle, 29.19.4**

Carved in the form of a tall open lotus flower, this vase is encircled by smaller, half-opened lotus flowers, stems and leaves. Three mandarin ducks can be seen amidst the flowers, one reaching down affectionately from the top of the large lotus flower, another responding from below.

Both the mandarin duck and the lotus flower are highly appreciated by the Chinese: the mandarin duck, which usually appears with a mate, because it represents love and loyalty and suggests a long, lasting marriage; the lotus flower because it suggests beauty and purity as it elegantly flowers forth from the muddy reservoir. The fine, elaborate carving of the base is characteristic of the Ch'ien-lung lapidary style. Ch'ing, Ch'ien-lung period.

Published: *The Minneapolis Institute of Arts Bulletin* 18, no.23 (1929), 113–116.

## 202 BRUSH WASHER

**Celadon-colored jade.**
**Length 8¾ in; height 4¼ in.**
**Gift of Mr and Mrs Augustus L. Searle, 35.9.10**

This brush washer has the form of a hollowed lotus flower surrounded by lotus cupules and half-opened lotus blossoms; incising adds detail to the outer surfaces of the lotus petals. The rim of the vessel is irregularly shaped. The carving of the vase is simple and rough. Ch'ing.

## 203 WATER BASIN

**White jade with yellow-brown clouds.**
**Height 1¾ in; diameter 3½ in.**
**The John R. Van Derlip Fund, 44.5.3**

Carved in the form of a *ling-chih* fungus (*Fames japonica*), the plant of immortality, this water basin has smaller fungi carved in relief on its outer surface. The yellow-brown clouds on the surface of the jade are artificially created to enhance the object's aesthetic appeal.[1] Ch'ing.

[1]See Introduction p.12.

## 204 OVAL BOWL

**White jade.**
**Height 4 in; width 11⅝ in.**
**Gift of Mr and Mrs Augustus L. Searle, 31.119 (a,b)**

With an overall composition that is exquisitely simple and most pleasing, this short, oval bowl is gently grooved in the shape of an eight-petalled cherry-apple flower. The rim of the bowl is slightly recessed and the four wide, short supporting feet project outward slightly. The two handles are carved in a *Fames japonica* form. Ch'ing.

Published: Joan M. Hartman, *Chinese Jade of Five Centuries* (Rutland, Vermont, 1969), pp.28, 128–129 and pl.37; *The Minneapolis Institute of Arts Bulletin* 21, no.15 (1932), 74.

## 205 PAIR OF BOWLS

**Dark green jade.**
**Diameter 7 in; height 3 in.**
**Gift of Mr and Mrs Augustus L. Searle, 29.19.3**

The octagonally grooved bowls in this pair have relatively high bases, flaring sides, and two large projecting handles with loose rings. The main body of each bowl is adorned with a wild lotus design in relief,[1] a design that also appears in the handles. A petal-scallop design decorates the base. Bowls of this type are used in pairs, and are often given as wedding gifts. The wild lotus was originally a Buddhist decorative pattern, but from the Ming time onward has been widely used as a secular design. Ch'ing, Ch'ien-lung period (1736–95).

Published: *The Minneapolis Institute of Arts Bulletin* 18, no.23 (1929), 115.

[1]S.C. Nott, *Chinese Jade in the Stanley Charles Nott Collection* (West Palm Beach, 1942), p.355, no.68; *ibid.*, p.56, fig.XVI.

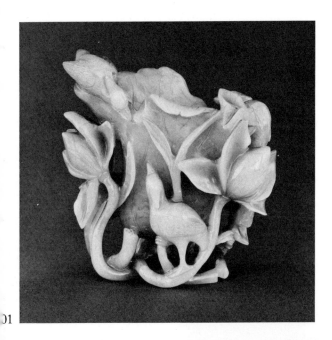

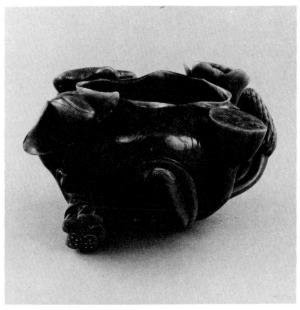

201

202

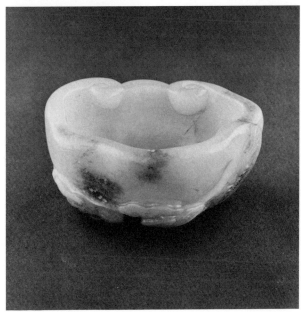

203

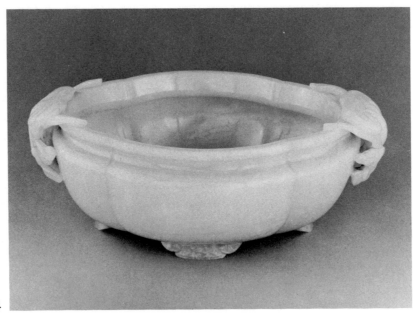

204

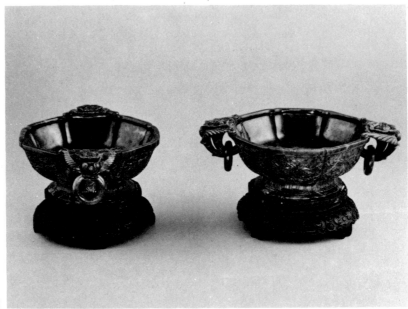

205

## 206 MINIATURE CUP

**Tan jade with reddish-brown markings.**
**Length 2½ in; height 1¼ in.**
**Bequest of Alfred F. Pillsbury, 50.46.396**

This small peach-shaped cup has a pointed
spout at one end and a dragon peering
backwards over the rim at the opposite end.
The dragon, which is rendered in openwork,
projects from the wider end of the cup and
serves as a handle. A second dragon is carved
in shallower relief near the base.

While the dragon motif indicates an
archaizing attempt, the intricate openwork
technique is characteristic of Ch'ing
craftsmanship; the artificially created reddish
tan color of the cup is also quite characteristic
of Ch'ing products. Symbolically, the peach is
the fruit of longevity and in China is always
associated with birthdays and anniversaries,
making it likely that this cup was a gift for such
an occasion. Ch'ing.

## 207 GLOBULAR BOX

**Green jadeite.**
**Height 5 in; width 5 in.**
**Gift of Mr and Mrs Augustus L. Searle,**
**37.55**

A Ch'ing *objet d'art*, this globular box displays
two large peony-form undercut handles with
pendant loose rings; three ball feet, each
grasped by the head and claws of an ogre; and
a lid surmounted by a ferocious lion.

The lion motif became popular in China
during the Han Dynasty. During the Ming
and Ch'ing Dynasties, sculptures of lions were
stationed at palace or temple doors. These
guardian figures were usually carved with large
heads and were shown grasping a ball or, in the
case of lionesses, standing with their cubs.
Ch'ing, Chia-ching period (1796–1821).

Published: *The Minneapolis Institute of Arts
Bulletin* 27, no.1 (1938), 2–3.

## 208 VASE WITH COVER

**Pale greyish green jade.**
**Height 4¼ in; diameter 4¼ in.**
**Gift of Mr and Mrs Augustus L. Searle,**
**29.19.2**

This short, circular vase with three stylized claw
feet recalls the common incense burner in its
shape. The handles are carved flowers, which
perhaps can be identified as peonies. A small,
loose ring hangs from each handle. A lioness
and her cub, both carved in high relief,
surmount the cover of the vase. Ch'ing.

Published: *The Minneapolis Institute of Arts
Bulletin* 18, no.23 (1929), 115.

## 209 SMALL CIRCULAR BOX

**White jade.**
**Diameter 3⅛ in; height 2½ in.**
**The John R. Van Derlip Fund, 44.5.9**

This plain, circular, covered box would
probably have been used for one of two
purposes: as a container for special
sandalwood incense, a favorite of Chinese
scholars,[1] or as a container for the ink used
with seals, another essential item for scholars,
and one that also requires the protection of a
covered vessel. Ch'ing, Ch'ien-lung period
(1736–95).

[1]The scholars incense set consisted of three
objects (*sǎn-shih*): an incense burner, a
container for sandalwood incense, and a small,
tall vase to hold the metal tongs used to pick up
the incense.

## 210 CIRCULAR BOX WITH COVER

**Translucent white jade.**
**Diameter 6¾ in; height 4 in.**
**Gift of Mr and Mrs Augustus L. Searle,**
**34.21.7**

This large, circular box has a short base and a
high cover. An inscription carved in low relief
on the top of the cover reads, '*Tai-ping yu
hsiang*, or 'Peace in sight'. On the outer surface
of the box and on the cover are eight Buddhist
symbols in low relief: a bell, a snail, an
umbrella, a flower, a vessel, a pilgrim bottle, a
fish, and a mystic knot. Ch'ing.

## 211 WINE EWER AND CUP

**White jade.**
**Ewer height 7¾ in; width 7¼ in.**
**Cup height 2¾ in; width 3½ in.**
**Gift of Mr and Mrs Augustus L. Searle,**
**28.42.1,2**

Similar to the bronze dove *tsun*[1] in the Stanley
Charles Nott collection, this ewer is elegantly
carved in the form of a phoenix. The head of
the phoenix forms the spout; the body, the
ewer; and the tail, the handle. A similar
phoenix of smaller size surmounts the lid, and a
third phoenix carries the cup. Both the ewer and
the cup exhibit complex compositions and
skillful workmanship and are examples of the
*objets d'art* popular during the Ch'ing period.
Ch'ing.

206

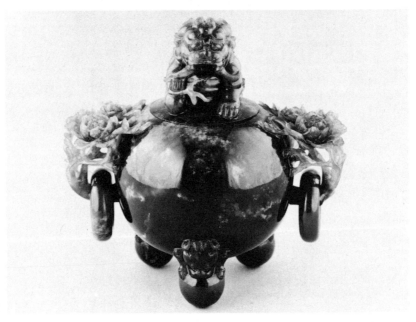

207

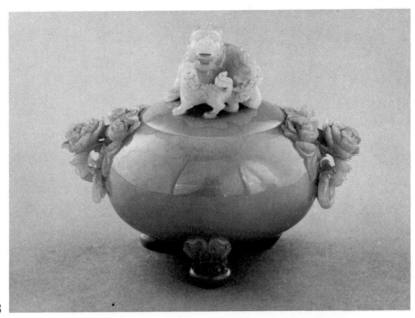

208

209

210

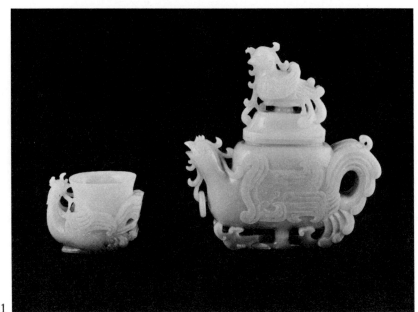

211

158

Published: *The Minneapolis Institute of Arts Bulletin* 18, no.23 (1929), 115–116.

[1] S.C. Nott, *Chinese Jade in the Stanley Charles Nott Collection* (West Palm Beach, 1942), pp.170–171.

## 212 MUSIC PICK

**White translucent jade.**
**Length $1\frac{3}{16}$ in; diameter $\frac{10}{16}$ in.**
**Bequest of Alfred F. Pillsbury, 50.46.395**

An unadorned music pick for stringed instruments. Ch'ing.

## 213 PENDANT

**White jade with brown markings.**
**Height $2\frac{3}{8}$ in; width $1\frac{5}{16}$ in.**
**The John R. Van Derlip Fund, 69.97.2**

Bearing a resemblance to a small shield, this pendant has a triangular shape, a convex front, and a concave back. Spiral-cloud patterns in relief cover the front surface. A lively *ch'ih*, a lizardlike hornless dragon, perches on top of the pendant, with the back part of its body hanging down on the reverse side of the pendant. There is a wide central slit in the piece. Ch'ing.

[1] Wu Ta-ch'eng, *Ku-yü t'u-k'ao* (modern reprint edited by Na Chih-liang, Tapei, 1971), p.122. Wu Ta-ch'eng refers to similar pendants as 'chicken heart pendants.'

## 214 BIRD PENDANT

**White jade with black markings.**
**Height $2\frac{1}{8}$ in; width $1\frac{3}{4}$ in; thickness $\frac{3}{8}$ in.**
**The John R. Van Derlip Fund, 69.97.1**

This oblong disc reveals an elaborate relief and openwork composition of a peony, a phoenix, and the sun, a combination representing 'all beauty under the brilliant sun' (*tan-fung chao-yang*). The pendant, with its suggestions of opulence and prosperity, could have been used as a gift or as a personal pendant. Openwork carving was popular during the Ming Dynasty, but reached its peak of popularity during the Ch'ing. Ch'ing.

## 215 PAPERWEIGHT

**Grey and black jade.**
**Length $5\frac{1}{2}$ in; height $2\frac{1}{2}$ in.**
**Gift of Mr Charles L. Freer, 17.128**

The two deer in this paperweight have *ling-chih* fungi (*Fames japonica*) protruding from their mouths and sun-disc designs adorning their bodies. Both the deer and the *ling-chih* are common Chinese symbols of long-lasting prosperity. Ch'ing.

## 216 CAT

**White translucent jade.**
**Length $1\frac{1}{4}$ in; width $\frac{5}{8}$ in; height $\frac{11}{16}$ in.**
**Bequest of Alfred F. Pillsbury, 50.46.397**

Simply executed in the round, this plump cat has small ears, round eyes, and a long narrow tail resting on its back. Ch'ing.

## 217 BIRD

**White translucent jade.**
**Length $1\frac{3}{8}$ in; height $\frac{3}{4}$ in.**
**Bequest of Alfred F. Pillsbury, 50.46.390**

This elegant and charming bird has round eyes, a pointed beak, a bifurcated tail, and articulated wing feathers. Ch'ing.

## 218 VASE

**Mutton fat white jade.**
**Height $3\frac{1}{4}$ in; width 4 in.**
**Gift of Mr and Mrs Augustus L. Searle, 35.57**

Carved in imitation of a bronze *tsun* vessel, this globular vase has two handles, each in a flower form. Six dahlia sprigs adorn the main body of the vase, and a short poem by Ch'ien-lung, which is carved around the neck, is dated, 'the fifty-eighth year of Ch'ien-lung.' The carving of this piece is exquisite and, although the vase reflects certain Indian influences, both the shape of the vase and the floral decoration are Chinese in taste. The lustrous white color of the jade, usually referred to as mutton fat white, is much favored by the Chinese. Ch'ing.

Published: *The Minneapolis Institute of Arts Bulletin* 27, no.1 (1938), 2–4.

212

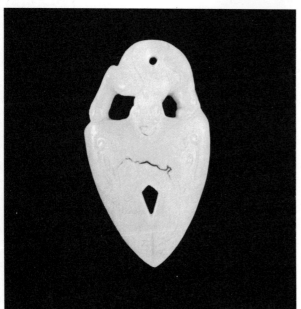

213

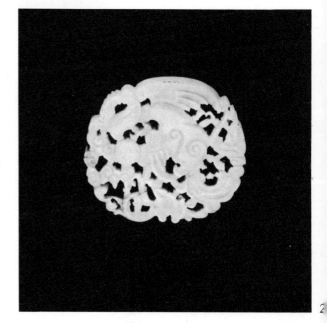

2

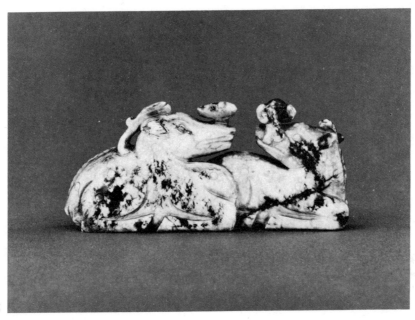

215

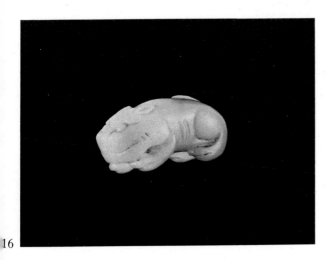

16

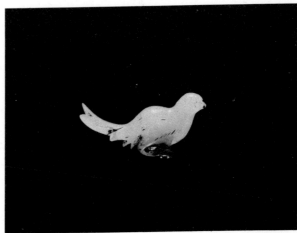

217

## 219 VASE

**White camphor jade.**
**Height 11 in; width 4½ in.**
**Gift of Mr and Mrs Augustus L. Searle,**
**37.56**

This tall, flattened vase has a shape similar to that of a *tsun* vessel. It has, however, been carved to an extreme thinness in the Indian style, and is adorned with fluted open petal designs on the cover, poppy and foliage designs on the neck, and a chain of vine leaves enframing the main decor area on the body of the vase. On one side of the vase a boddhisattva blowing a horn stands upon the double wheels of the law, his diaphanous garment flowing easily in the wind. On the reverse side of the vase a boddhisattva holding a canopy umbrella stands on a lotus flower. Small narrow ears, each carrying a loose ring, extend from either side of the neck, and two feathered ferns, each adorned with a loose ring, extend from either side of the vase. The base is fluted and carved with an inscription that reads, '*Hsuan-ho nien-chih*,' or 'Made in the reign of Hsuan-ho.' Although this inscription would indicate a Sung date, stylistically, carving of this type didn't appear until the reign of Ch'ien-lung (1736–95). Ch'ing.

Published: *The Minneapolis Institute of Arts Bulletin* 27, no.1 (1938), 1–4.

## 220 VASE WITH COVER

**White camphor jade.**
**Height with cover 4¼ in; width 4 in.**
**Gift of Mr and Mrs Augustus L. Searle,**
**39.44 (a,b)**

This paper thin, flattened vase is adorned with chrysanthemum petals at the base and collar; a floral design in relief on the body;[1] and floral designs on the handles. The handles have since been damaged. Ch'ing.

Published: *The Minneapolis Institute of Arts Bulletin* 29, no.5 (1940), 26–27.

[1]S.C. Nott refers to a similar floral design as a poppy design in *Chinese Jade in the Stanley Charles Nott Collection* (West Palm Beach, 1942), p.56, fig.XVI:c.

## 221 CYLINDRICAL BOX WITH COVER

**Spinach green jade.**
**Diameter 4⅛ in.**
**Gift of Mr and Mrs Augustus L. Searle,**
**36.7.7**

## 222 CYLINDRICAL BOX WITH COVER

**Spinach green jade.**
**Diameter 4⅛ in.**
**Gift of Mr and Mrs Augustus L. Searle,**
**36.7.8**

The lids of this pair of shallow, plain cylindrical boxes are carved in centrifugal tiers of fluted petals creating a stylized chrysanthemum design, a characteristic Indian-style motif.[1] (See Introduction p.12.) Ch'ing.

Published: *The Minneapolis Institute of Arts Bulletin* 26, no.6 (1937), 25–30.

[1]A discussion of spinach green jade is presented in S.H. Hansford, 'Jade Carving in the Ch'ing Dynasty,' *TOCS* 35 (1963–64), 35–37; and a discussion of the chrysanthemum motif appears in S.H. Hansford, *Chinese Carved Jades* (London, 1968), pp.94–97.

## 223 OVAL DISH

**Translucent camphor-colored jade with**
**crystalline markings.**
**Length 7⅝ in; height 1¼ in.**
**Gift of Mr and Mrs Augustus L. Searle,**
**36.7.5**

## 224 OVAL DISH

**Translucent camphor-colored jade with**
**crystalline markings.**
**Length 7⅝ in; height 1¼ in.**
**Gift of Mr and Mrs Augustus L. Searle,**
**36.7.6**

These extraordinarily thin, fluted dishes, carved in the Indian style, have inside surfaces that display a central crocus-and-leaf design[1] and an outer border of chrysanthemum petals. The handles are elaborated in a deep-cut openwork floral design. Ch'ing.

Published: *The Minneapolis Institute of Arts Bulletin* 26, no.6 (1937), 26–27.

[1]The floral design used in these dishes resembles a simplified poppy design as identified by S.C. Nott in *Chinese Jades in the Stanley Charles Nott Collection* (West Palm Beach, 1942), p.56, fig.XVI:3.

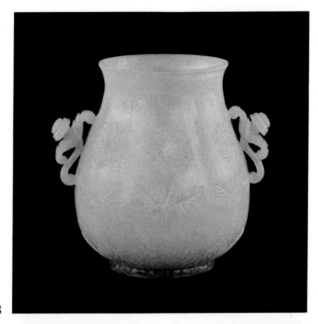

218

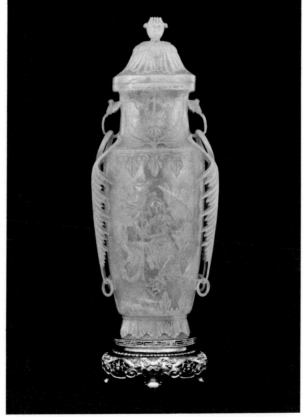

219

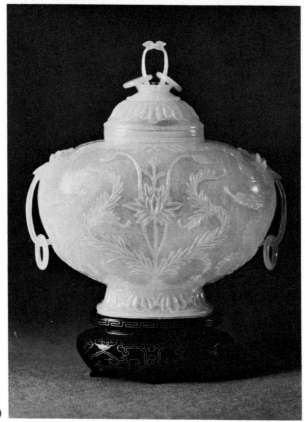

220

221,222

## 225 PLATE

Spinach jade.
Diameter $12\frac{1}{4}$ in; height $\frac{7}{8}$ in.
Gift of Mr and Mrs Augustus L. Searle,
34.21.1

Centrifugal tiers of fluted petals form a
chrysanthemum design on both sides of this
thin, Indian-style plate,[1] the petals of the
flower curling under at the rim. In this piece
the quality of the jade is good, and the
workmanship is excellent. Ch'ing.

Published: *The Minneapolis Institute of Arts
Bulletin* 23, no.27 (1934), 138.

[1]S.H. Hansford, *Chinese Carved Jades* (London,
1968), pp.94–97.

## 226 CIRCULAR DISH

White camphor jade.
Diameter 5 in; height $\frac{15}{16}$ in.
Gift of Mr and Mrs Augustus L. Searle,
36.7.2

## 227 CIRCULAR DISH

White camphor jade.
Diameter 5 in; height $\frac{15}{16}$ in.
Gift of Mr and Mrs Augustus L. Searle,
36.7.3

These two shallow, circular dishes, a pair
carved in the Indian style, are extremely thin
and have both inner and outer surfaces
carved in a chrysanthemum design composed of
centrifugally radiating petals. The inverted
rim is fluted, and the small base is carved with a
petal design.[1] Ch'ing.

[1]White camphor jade is discussed in S.C. Nott,
*An Illustrated Annotation on the Working and
Dating of Chinese Jade* (St Augustine,
Florida, 1941), p.9; Indian-style jades are
discussed in S.H. Hansford, *Chinese Carved
Jades* (London, 1968), pp.94–97 and S.C. Nott,
*op. cit.*, pp.8–9.

## 228 BOWL

White jade.
Diameter $4\frac{15}{16}$ in; height $1\frac{9}{16}$ in.
Gift of Mr and Mrs Augustus L. Searle,
39.47

This small bowl, which exhibits extremely
refined and skillful workmanship, is decorated
only on the outer surface. Near the rim of the
bowl a decor zone is enframed by a narrow
relief line that runs between four symmetrical
foliage knots. Relief lines define eight
cartouches, four large and four small, which
alternate in size around the bowl. The large
cartouches enframe water animals: a snail, a
frog, a fish, and a crab, and the small cartouches
contain the inscription, '*Ch'ien-lung yü-wan*,' or
'Made for Ch'ien-lung.' Relief floral and foliage
designs surround the cartouches, and
chrysanthemum petals form the base. Ch'ing.

Published: *The Minneapolis Institute of Arts
Bulletin* 29, no.5 (1940), 25–26.

## 229 BOWL WITH COVER

White jadeite with green flecks ('moss
entangled in melting snow').
Diameter of bowl $4\frac{1}{2}$ in; height $2\frac{3}{8}$ in.
Diameter of cover 4 in; height $1\frac{1}{4}$ in.
Gift of Mr and Mrs Augustus L. Searle,
34.21.5 (a,b)

## 230 BOWL WITH COVER

White jadeite with green flecks ('moss
entangled in melting snow').
Diameter of bowl $4\frac{1}{2}$ in; height $2\frac{3}{8}$ in.
Diameter of cover 4 in; height $1\frac{1}{4}$ in.
Gift of Mr and Mrs Augustus L. Searle,
34.21.6 (a,b)

Carved in the Indian style, these fragile, thin
bowls have inner and outer surfaces adorned
with centrifugally radiating petals that form a
chrysanthemum design. The base of each bowl
and the knob of each cover are also delicately
fluted. Bowls of this type are used for drinking
tea, with the cover of the bowl conveniently
functioning as a strainer for the tea leaves.
Ch'ing.

Published: *The Minneapolis Institute of Arts
Bulletin* 21, no.5 (1932), 138–139.

223,224

225

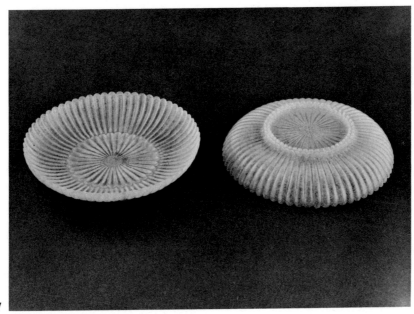

226–7

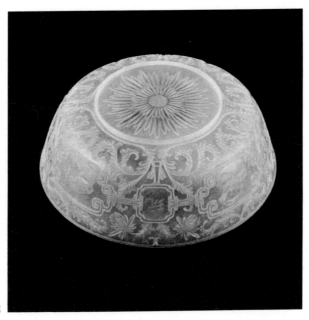

228

## 231 BOWL

**Greenish white jade with greyish mauve cast.**
**Height 2¾ in; diameter 6⅝ in; diameter of base 3 in.**
**Gift of Mr and Mrs Augustus L. Searle, 35.20.1 (a,b)**

## 232 BOWL

**Greyish green jade with mauve cast.**
**Height 2¾ in; diameter 6⅝ in; diameter of base 3 in.**
**Gift of Mr and Mrs Augustus L. Searle, 35.20.2 (a,b)**

The natural beauty of the jade, the simplicity of form, and the perfection of execution in these two unadorned bowls are particularly pleasing. Ch'ing.

## 233 BOWL

**Camphor white jade.**
**Height 2¾ in; diameter 7⅜ in.**
**Gift of Mr and Mrs Augustus L. Searle, 34.21.4**

Although thicker than other Indian-style carvings in the collection (Nos.219, 220, 223, 224, 226), this bowl is carved in the Indian style. The outer surface of the bowl is adorned with a leaf-and-vine pattern in relief and a lower border of long chrysanthemum petals; the base of the bowl is fluted in a petal design. Ch'ing.

Published: *The Minneapolis Institute of Arts Bulletin* 21, no.5 (1932), 21.

## 234 PAIR OF BOWLS

**Greyish white translucent jade with green flecks.**
**Diameter 6½ in; height 2¾ in.**
**Gift of Mr and Mrs Augustus L. Searle, 33.38.5 (a,b)**

The two extremely thin and delicate bowls of this pair are well finished and unadorned. Ch'ing.

Published: *The Minneapolis Institute of Arts Bulletin* 23, no.5 (1934), 23–24.

## 235 VASE

**Red and white agate (or carnelian).**
**Height 4¼ in; length 5 in.**
**Gift of Mr and Mrs Augustus L. Searle 35.21 (a,b)**

In a clever composition that admirably exhibits the virtuosity of Ch'ing workmanship, this elaborate red and white vase displays a large and a small finger citron or Buddha's hand citron carved from the white areas of the stone, and pomegranates, peaches, and a bat in deep undercut and openwork carved from the red areas of the stone.

The numerous auspicious symbols: the Buddha's hand in a votive gesture; the pomegranates, which suggest numerous descendants; the bat which represents good fortune; and the peaches, which suggest longevity, would have made this vase a most welcome gift. Ch'ing.

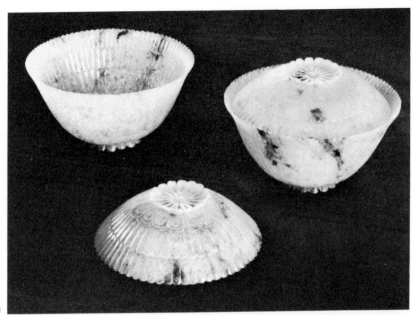

229–30

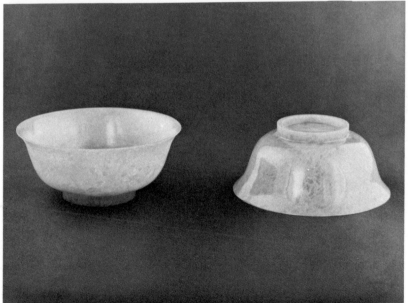

231–2

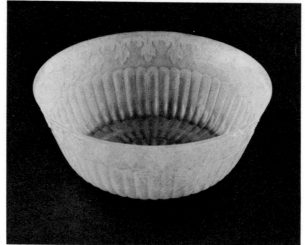

233

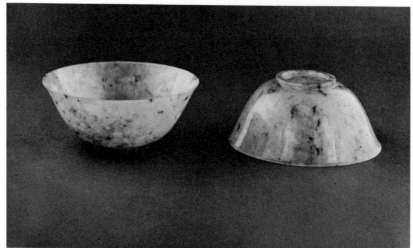

234

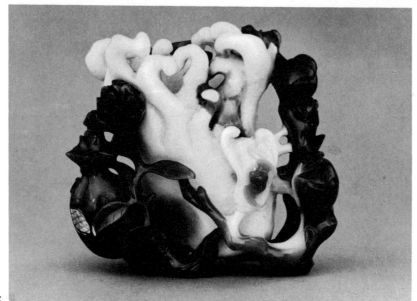

235

# BIBLIOGRAPHY

Abbreviations

BIHP     *Bulletin of the Institute of History and Philology*

BMFEA   *Bulletin of the Museum of Far Eastern Antiquities*

KKHP   *K'ao-ku Hsüeh-pao*

TOCS   *Transactions of the Oriental Ceramic Society*

WWTKTL *Wen-wu Ts'an-k'ao Tzu-liao*

Note

For detailed references to articles appearing in the following journals:
*K'ao-ku (K'ao-ku T'ung-hsün)*
*The Minneapolis Institute of Arts Bulletin*
*Wen-wu*
see individual catalogue entries.

Alexander, Richard. *Jade, Its Philosophy: Shine of the Star of Life.* New York, 1928.

An Chih-min *et al. Lo-yang Chung-chou-lu* [Chung-chou-lu, Lo-yang]. (Archaeol. Monograph Ser. D, no.4.) Peking, 1959.

Andersson, J.G. 'Prehistory of the Chinese.' *BMFEA* 15 (1943), 252–255.

*Archaic Chinese Jades.* Catalogue of a special exhibition at the University Museum, University of Pennsylvania, 1940.

Arden Gallery. *3000 Years of Chinese Jade.* Catalogue of a loan exhibition at the Arden Gallery, New York, January 10–February 11, 1939.

*The Art of the T'ang Dynasty.* Catalogue of an exhibition organized by the Los Angeles County Museum of Art from collectors in America, the Orient, and Europe, January 8–February 17, 1957.

Bedford, John. *Jade and Other Hardstone Carving.* London, 1969.

Bishop, Heber Reginald. *Investigations and Studies in Jade, the Bishop Collection.* New York, 1906.

Bosch-Reitz, S. C. 'Tomb Jades of the Chou Period'. *Bulletin of the Metropolitan Museum of Art* 19, no.5 (May 1924), 121–122.

Buhot, Jean. 'L'exposition de jades au Musée Cernuschi.' *Revue des Arts Asiatiques* 4 (June 1927), 110–111.

Bushell, Stephen W. 'Carving in Jade and Other Stones'. *Chinese Art.* Second edition. London, 1924.

Chang, H. T. *Lapidarium Sinicum: A Study of the Rocks, Fossils and Metals as Known in Chinese Literature.* (Memoirs of the Geological Survey of China. Ser. B, no.2.) Peking, 1927.

Chang Jên-hsia. *Chung-kuo ku-tien i-shu* [Ancient art of China]. Shanghai, 1954.

*Ch'ang-sha ch'u wen-wu chan-lang t'u-hsü.* Peking, 1954.

Chen Jen-dao. *Chin-k'uei lun-ku ch'u-chi* [Essays on Chinese antiquities]. Hong Kong, 1952.

Ch'ên Ta-nien. *Ch'ên Ta-nien so-tsang yu-ch'i shih ch'i liu-li shou-ming shu* [Catalogue of an exhibition of jades, stones, and glasses collected by Ch'ên Ta-nien]. Nanking, 1937.

*Cheng-chou Erh-li-kang* [Archaeological report from Erh-li-kang, Cheng-chou]. By Honan Wenhuachü. (Archaeol. Monograph Ser. D, no.7). Peking, 1959.

Chêng Tê-k'un. *Archaeology in China*, vol. 2, *Shang China.* Cambridge, 1960.

—— · *Chinese Archaeology, Supplement to Volume One: New Light on Prehistoric China.* Cambridge, 1960.

—— · *Chinese Jade.* Guide to an exhibition at the West China Union University in Chengtu, May 6–13, 1945.

—— · *Jade Flowers and Floral Patterns in Chinese Decorative Art.* Hong Kong, 1969.

—— · 'Seven Yin Sculptures from Anyang.' *Archives: Chinese Art Society of America* 2 (1947), 6–10.

—— · 'T'ang and Ming Jades.' *TOCS* 28 (1953–1954), 23–35.

Chia Lan-p'o. *Shang-ting tung-jen* [Cavemen of the mountaintops]. Shanghai, 1951.

*Chinese Jade Collection.* Catalogue of the collection in the Seattle Art Museum, 1962.

*Chou-li* [Rites of Chou]. Attributed to the Duke of Chou, Chou Dynasty.

Ch'ü Chung-jung. *Ku-yü t'u-lu* [Illustrated catalogue of ancient jades]. n.p. 1832.

Chu Teh-jun. *Ku Yü T'u* [Illustrations of ancient jade]. 2 vols. A.D. 1341.

*Ch'u wen-wu chan-lan t'u-lu* [Illustrated catalogue of an exhibition of cultural relics from Ch'u]. Peking, 1954.

d'Argencé, René-Yvon Lefèbvre. *Chinese Jades in the Avery Brundage Collection.* San Francisco, 1972.

—— · 'Chinese Jades from Shang to Ch'ing in the Avery Brundage Collection'. *Apollo*, n. s. 84, no.54 (August 1966), 134–139.

David, Madeleine. 'Sculptures et jades à l'exposition des arts de la Chine.' *Cahiers d'Art* 6–7 (1937), 211–217.

Davidson, J. Leroy. *Jades of the T. B. Walker Collection at the Walker Art Center, Minneapolis, Minnesota*. 1945.

Dohrenwend, Doris. *Chinese Jades in the Royal Ontario Museum*. Toronto, 1971.

*Early Chinese Jades*. Catalogue of a loan exhibition presented by the University of Michigan Museum of Art, March 22–April 22, 1953.

Ecke, Gustav. 'Early Chinese Jades Selected from Alfred Salmony's Posthumous Works.' *Connoisseur* (American ed.) 147 (March 1961), 61–67.

Erkes, E. 'Some Remarks on Karlgren's Fecundity Symbols in Ancient China.' *BMFEA* 3 (1931), 63–68.

*Exhibition of Chinese Jade Carving, Sung to Ch'ien-lung*. Catalogue of an exhibition of Chinese jade carving loaned by a private American collector, organized by the China Institute in America, New York, May 3–June 23, 1954.

*Exhibition of Chinese Jades*. Catalogue of a loan exhibition arranged by the Oriental Ceramic Society, London, April 14–June 9, 1948.

*Feng-hsi fa-chüeh pao-kao* [Report on excavations at Feng-hsi]' By Wang Po-hung *et al.* (Archaeol. Monograph Ser. D, no.12.) Peking, 1962.

Gieseler, G. 'Le jade dans le culte et les rites funéraires en Chine sous les dynasties Tcheou et Han.' *Revue Archéologique* 4 (July 1916), 118.

Goette, John. *Jade Lore*. Shanghai, Singapore, Hong Kong, 1936. New York, 1937.

Gump, Richard. *Jade, Stone of Heaven*. New York, 1962.

Gure, Desmond. 'Jades of the Sung Group.' *TOCS* 32 (1959–1960), 39–50.

—— ·'Notes on the Identification of Jade.' *Oriental Art* 3, no.3 (1951), 115–120.

—— ·'Selected Examples from the Jade Exhibition at Stockholm, 1963; A Comparative Study.' *BMFEA* 36 (1964), 117–192.

—— ·'Some Unusual Early Jades and Their Dating.' *TOCS* 33 (1960–1961), 41–59.

*Handbook of the Collections in the William Rockhill Nelson Gallery of Art and Mary Atkins Museum of Fine Arts*, vol. 2, *Art of the Orient*. Kansas City, Missouri, 1973.

Hansford, S. Howard. *Chinese Carved Jades*. London, 1968.

—— ·*Chinese Jade Carving*. London, 1950.

—— ·*Jade: Essence of Hills and Streams; the von Oertzen Collection of Chinese and Indian Jades*. London, 1969.

—— ·'Jade and Jade Carving in the Ch'ing Dynasty.' *TOCS* 35 (1963–1964), 29–40.

—— ·'Jade and the Kingfisher.' *Oriental Art* 1, no.1 (1948), 12–17.

Hardinge, Sir Charles. *Jade, Fact and Fable*. London, 1961.

Hartman, Joan M. *Chinese Jade of Five Centuries*. Rutland, Vermont, 1969.

—— ·*Chinese Jade Through the Centuries*. Catalogue of a loan exhibition at the China Institute of America, New York, October 4, 1968–January 26, 1969.

Hayashi Minao. 'Deities that Originated in the Middle Shang Period.' *Tōhō Gakuhō* 41 (1970), 1–70 (text in Japanese).

—— ·'The Dress and Head Ornament of the Statue of Man Made of Nephrite in the Western Chou Period.' *Shirin*, 1972, no.2, pp.1–38 (text in Japanese).

Honan Wenhuachü. *Cheng-chou Erh-li-kang* [Archaeological report from Erh-li-kang, Cheng-chou]. (Archaeol. Monograph Ser. D, no.7.) Peking, 1959.

Hsia Nai *et al*. *Hui-hsien fa-chüeh pao-kao* [Report on excavations at Hui-hsien]. (Archaeological Field Reports, no.1). Peking, 1956.

*Hsin Chung-kuo ti k'ao-ku shou-huo* [Archaeology in New China]. (Archaeol. Monograph Ser. A, no.6) Peking, 1961.

*Hsün-hsien Hsin-ts'un* [Hsin-ts'un, Hsün-hsien]. By Kuo Pao-chün. (Archaeol. Monograph Ser. B, no.13.) Peking, 1964.

Huang Chün. *Heng-chai ts'ang-chien ku-yü t'u-lu* [Illustrations of ancient jades collected or seen in the Heng-chai studio]. Peking, 1939.

—— ·*Ku-yü t'u-lu ch'u-chi* [Illustrated catalogue of ancient jades, part 1]. Peking, 1939.

—— ·*Yeh-chung p'ien-yü* [Remains from Yeh]. Peking, 1935, 1937, 1942.

*Hui-hsien fa-chüeh pao-kao* [Report on excavations at Hui-hsien]. By Hsia Nai *et al*. (Archaeological Field Reports, no.1) Peking, 1956.

*Illustrated Catalogue of Chinese Government Exhibition for the International Exhibition of Chinese Art in London*. 2 vols. London, 1936.

Jenyns, R. Soame. *Chinese Archaic Jades in the British Museum*. London, 1951.

Kao Ch'ü-hsün. 'Chan-kuo mu-nei tai-ko yung-tu te tui-t'sê' [A hypothesis on the use of the belthooks discovered in the excavated tombs of the Chan Kuo period, 480–222 B.C.]. *BIHP* 23 (1952), 489–510.

Karlbeck, Orvar. 'Selected Objects from Ancient Shou Chou.' *BMFEA* 27 (1955), 41–130.

Karlgren, Bernhard. 'Notes on a Kin-ts'un Album.' *BMFEA* 10 (1938), 65–81.

—— ·'New Studies on Chinese Bronzes" *BMFEA* 9 (1937), 1–118.

—— ·'Some Fecundity Symbols in Ancient China.' *BMFEA* 2 (1930), 1–54.

—— ·'Some Weapons and Tools of the Yin Dynasty.' *BMFEA* 17 (1945), 101–184.

Kelley, Charles F. 'Loan Exhibition of Jade.' *The Art Institute of Chicago Bulletin* 31 (November 1937), 82–86.

——·'The Sonnenschein Jade Collection at the Chicago Art Institute.' *The Art Institute of Chicago Quarterly* 46 (September 1952), 49–54.

Koizumi Akio. *The Tomb of the Painted Basket of Lo-lang*. Seoul, 1934 (text in Japanese with English summary by Hamada Kosaku).

Kuo Pao-chün. *Hsün-hsien Hsin-ts'un* [Hsin-ts'un, Hsün-hsien]. (Archaeol. Monograph Ser. B, no.13). Peking, 1964.

——·'Ku-yü Hsin-chuen.' *BIHP* 20 (1948), 1–46.

——· *Shan-piao-chen yü Liu-li-ko* [Shan-piao-chen and Liu-li-ko]. (Archaeol. Monograph Ser. B, no.11.) Peking, 1959.

Laufer, Berthold. *Archaic Jades Collected in China by A. W. Bahr now in the Field Museum of Natural History, Chicago*. New York, 1927.

——· *Jade: A Study in Chinese Archaeology and Religion*. Chicago, 1912.

Lee, Sherman E., and Wai-kam Ho. *Chinese Art Under the Mongols: The Yüan Dynasty, 1279–1368*. Catalogue of an exhibition at the Cleveland Museum of Art, 1968.

Li Chi. 'Chi Hsiao-t'un ch'u-t'u chih ch'ing-tung ch'i' [Studies of bronze objects excavated at Hsiao-t'un, Honan]. *KKHP*, 1949, no.4.

——·'Kuei-tsuo tun-chü yü chi-chü' [Seiza squatting and sitting on the ground]. *BIHP* 24 (1953), 283–301.

——·'Yin-hsü pai-tao fa-chan chih' [Evolution of white pottery of the Yin Dynasty]. *BIHP* 28 (1957), 853–876.

——·'Yin-hsü yu-jen shih-ch'i t'u-shuo' [Illustrated catalogue of sharp-edged stone tools excavated from Yin-hsü]. *BIHP* 23 (1952), 526.

——·'Yü-pei ch'u-t'u ch'ing-t'ung kou-ping fen-lei t'u-chieh' [Typological studies of bronze *kou-ping* excavated from northern Honan]. *BIHP* 22 (1950), 1–19.

Liang Ssu-yung, and Kao Ch'ü-hsün. *Hou Chia Chuang* [The Yin-Shang Cemetery Site at Anyang, Honan], vol.2, *HPKM 1001*. Taipei, 1962.

Lin Shou-chin *et al. Shang-ts'un-ling Kuo-kuo mu-ti* [The Cemetery of the State of Kuo at Shang-ts'un-ling]. (Archaeol. Monograph Ser. D, no.10.) Peking, 1959.

Ling Shu-sheng. 'Chung-kuo ku-t'ai jui-kuei tê yen-chiu' [Study of the scepter *kuei* of ancient China]. *Bulletin of the Institute of Ethnology* 20 (Autumn 1965), 163–205.

'Chung-kuo ku-tai shên-chu yü yin-yan hsing-chih ch'ung-pai' [Ancestral tablet and genital symbolism in ancient China]. *Bulletin of the Institute of Ethnology* 8 (1959), 1–46.

Lippincott, J. B. *The Curious Lore of Precious Stones*. Philadelphia and London, 1913.

Lo Chen-yü. 'Shih-yüan'. *Yung-feng hsiang-jen kao chia; Yün-ch'uang man-kao*. Tientsin, 1918.

Loehr, Max. *Ancient Chinese Jades*. Cambridge, Massachusetts, 1975.

——· *Chinese Bronze Age Weapons*. Ann Arbor, Michigan, 1956.

Loo, C. T. *Chinese Archaic Jades*. New York, 1950.

*Lo-yang Chung-chou-lu* [Chung-chou-lu, Lo-yang]. By An Chih-min *et al.* (Archaeol. Monograph Ser. D, no.4) Peking, 1959.

Lung Ta-yüan *et al. Ku-yü t'u-p'u* [Illustration of Chinese jades]. 100 vols. A.D. 1779.

Lyons, Elizabeth. *Mr. and Mrs. Ivan B. Hart Collection: Archaic Chinese Jades*. Edited by Robert Poor. Northampton, Massachusetts, 1963.

Mizuno Seiichi. *In-sho seidoki yo gyoku* [Bronze vessels and jades of the Shang-Yin period]. Tokyo, 1959.

Morgan, Harry Tilterton. *The Story of Jade*. Los Angeles, 1941.

Na Chih-liang. 'The Ch'i-Pi or Battle-Axe *Pi* Disc.' *The National Palace Museum Bulletin*, 1966, no.5, pp.1–7.

——· *Yü-ch'i t'ung-shih* [General history of Chinese jade]. 2 vols. Hong Kong, 1964, and Taipei, 1970.

——·'Yü-chien-shih ming-ming chih t'an t'ao.' *National Palace Museum Quarterly* 5, no.3 (1971), 9–20.

Nott, Stanley Charles. *Chinese Jade Carving in the Collection of Mrs. George Vetlesen*. London, 1939.

——· *Chinese Jade in the Stanley Charles Nott Collection*. West Palm Beach, 1942.

——· *Chinese Jade Throughout the Ages*. New York, 1937.

——· *An Illustrated Annotation on the Working and Dating of Chinese Jade*. St Augustine, Florida, 1941.

Pelliot, Paul. *Jades archaïques de Chine appartenant à M. C. T. Loo*. Paris and Brussels, 1925.

——·'Note on the *Ku Yü t'u P'u*.' *T'oung Pao* 29 (1932), 199.

Pope-Hennessy, Dame Una. *Early Chinese Jades*. New York, London, 1923.

Salmony, Alfred. *Archaic Chinese Jades from the Edward and Louise B. Sonnenschein Collection*. Chicago, 1952.

——· *Carved Jade of Ancient China*. Berkeley, 1938.

——·'A Chinese Jade Bear of the Early Han Period'. *Artibus Asiae* 10, no.4 (1947), 257–265.

——· *Chinese Jade Through the Wei Dynasty*. New York, 1963.

——·'The Cicada in Ancient Chinese Art.' *Connoisseur* (American ed.) 91, no.379 (March 1933), 174–179.

——·'Collecting Ancient Chinese Jades'. *Hobbies* (Buffalo, 1944), fig.5.

——·'The Identification of an Ancient Chinese Jade'. *Journal of the Indian Society of Oriental Art* 15 (1947), 77–83.

——·'Jades archaïques chinois.' *Cahiers d'Art* 7–8 (1931), 341–347.

*Shan-piao-chen yü Liu-li-ko* [Shan-piao-chen and Liu-li ko]. By Kuo Pao-chün. (Archaeol. Monograph Ser. B, no.11.) Peking, 1957.

*Shang-ts'un-ling Kuo-kuo mu-ti* [The Cemetery of the State of Kuo at Shang-ts'un-ling]. By Lin Shou-chin *et al.* (Archaeol. Monograph Ser. D, no.10.) Peking, 1959.

Shih Chang-ju. 'Hsiao-t'un Yin-tai Ping-tsu chi-chih chi ch'i yu-kuan hsien-hsiang' [Section C of the Hsiao-t'un remains of Anyang and its related phenomena]. *BIHP*, Special Issue, vol.4, part 2 (1960), 783.

——·'Hsiao-t'un yin-tai tê ch'êng t'ao ping ch'i' [Yin weapon sets excavated from Hsiao-t'un]. *BIHP* 22 (1950), 35–39.

——·'Yin-tai t'ou-shih chü-lih' [Examples of headdress of the Yin Period]. *BIHP* 28 (1957), 611–670.

*Shou-hsien Ts'ai-hou mu ch'u-t'u i-wu* [Objects excavated from the Tomb of the Marquis of Ts'ai in Shou-hsien]. By Yü Shih-chi *et al.* (Archaeol. Monograph Ser. B, no.5.) Peking 1956.

Sirén, Osvald. *Histoire des arts anciens de la Chine*, vol. 1, Paris, 1929.

Soper, A. C. 'Early, Middle and Late Shang: A Note.' *Artibus Asiae* 28, no.1 (1966), 5–52.

T'an Tan-ch'ung. 'T'ao-t'ieh wen te kou-ch'êng' [The composition of *T'ao-t'ieh*, an animal head decoration]. *BIHP*, Special Issue, vol. 4, part 1 (1960), 271–317.

Trousdale, W. B. 'Chinese Jade at Philadelphia.' *Oriental Art* 10, no.2 (Summer 1964), 107–114.

Trubner, Henry. *Handbook of the Far Eastern Collection of the Royal Ontario Museum.* Toronto, 1968.

Tuan Fang. *T'ao Tuan-fang Ku-yü-t'u* [Ancient Chinese jades in the collection of Tuan Fang]. Shanghai, 1936.

Tung Li. *Archaic Chinese Jades: Explanatory Notes on Mr. C. T. Liu's Unique Collection of Examples of Chinese Art.* Shanghai, 1933.

Umehara Sueji. *Inkyo* [Yin-hsü, Ancient Capital of the Shang Dynasty at Anyang]. Tokyo, 1964.

——·*Kanan Anyō ibutsu no kenkyū* [A study of relics from Anyang, Honan]. Kyoto, 1941.

——·*Rakuyō Kinson kobo shūei* [Selection of tomb finds from Chin-ts'un, Loyang]. Kyoto, 1937. Rev. edn., 1943.

——·*Shina kogyoku zuroku* [Illustrated catalogue of ancient Chinese jades]. Kyoto, 1955.

Wang Po-hung *et al.* *Feng-hsi fa-chüeh pao-kao* [Report on excavations at Feng-hsi]. (Archaeol. Monograph Ser. D, no.12). Peking, 1962.

Waterbury, Florance. *Early Chinese Symbols and Literature: Vestiges and Speculations, with Particular Reference to the Ritual Bronzes of the Shang Dynasty.* New York, 1942.

Weber, George W., Jr. *The Ornaments of Late Chou Bronzes: A Method of Analysis.* New Brunswick, New Jersey, 1973.

White, William C. *Bone Culture of Ancient China.* Toronto, 1945.

——·*Tombs of Old Lo-yang.* Shanghai, 1934.

Whitlock, Herbert P., and Ehrmann, Martin L. *The Story of Jade.* New York, 1949.

Wu, Henry H. *Ancient Chinese Jades: Explanatory Notes on C. T. Liu's Collection.* Shanghai, 1933.

Wu Ta-ch'eng. *Ku-yü t'u-k'ao* [Illustrated study of ancient jades]. Preface dated 1889. Modern reprint edited by Na Chih-liang. Taipei, 1971.

Yü Shih-chi, *et al. Shou-hsien Ts'ai-hou mu ch'u-t'u i-wu* [Objects excavated from the Tomb of the Marquis of Ts'ai in Shou-hsien]. (Archaeol. Monograph Ser. B, no.5.) Peking, 1956.

Yü Yüeh. *Yü-p'ei k'ao* [A study of jade girdle pendants]. Ch'ing Dynasty.

# CHINESE CHRONOLOGY

| | | |
|---|---|---|
| Neolithic Period | | ? to 1765 or 1522 B.C. |
| Shang-Yin | | 1766–1122 B.C. |
| Chou | | 1122– 221 B.C. |
|     Western Chou | 1122–722 B.C. | |
|     Eastern Chou | 722–221 B.C. | |
|         Spring & Autumn Period | 722–481 B.C. | |
|         Warring States Period | 481–221 B.C. | |
| Ch'in | | 221–206 B.C. |
| Han | | 206 B.C.–A.D. 220 |
|     Former Han | 206 B.C.–A.D. 8 | |
|     Hsin (Wang Mang) | 9–24 | |
|     Later Han | 25–220 | |
| The Three Kingdoms | | 221–280 |
|     Shu (Han) | 221–263 | |
|     Wei | 220–265 | |
|     Wu | 222–280 | |
| Chin | | 265–420 |
|     Western Chin | 265–316 | |
|     Eastern Chin | 317–420 | |
| Northern and Southern Dynasties | | 420–581 |
|     South:   Sung (Liu Yü) | 420–479 | |
|               Southern Ch'i | 479–502 | |
|               Liang | 502–557 | |
|               Ch'en | 557–589 | |
|     North:   Northern Wei | 386–534 | |
|               Eastern Wei | 534–550 | |
|               Western Wei | 535–557 | |
|               Northern Ch'i | 550–577 | |
|               Northern Chou | 557–581 | |
| Sui | | 581–618 |
| T'ang | | 618–907 |
| The Five Dynasties | | 907–960 |
|     Later Liang | 907–923 | |
|     Later T'ang | 923–936 | |
|     Later Chin | 936–946 | |
|     Later Han | 947–950 | |
|     Later Chou | 951–960 | |
| Liao | | 907–1125 |
| Sung | | 960–1279 |
|     Northern Sung | 960–1126 | |
|     Southern Sung | 1127–1279 | |
| Chin (Ju-chên, or Golden Tartars) | | 1115–1234 |
| Yüan (Mongols) | | 1277–1368 |
| Ming | | 1368–1644 |
| Ch'ing | | 1644–1911 |
| Republic | | 1912– |

# LIST OF CHINESE TERMS

| | |
|---|---|
| *chien shou* | 劍首 |
| *chi-huan* | 齒環 |
| *chi* axe | 戚斧 |
| *chih* | 觶 |
| *chüeh* | 玦 |
| *hêng* | 珩 |
| *hsi* | 觿 |
| *hsi-pi* | 系璧 |
| *hu* | 笏 |
| *huan* | 環 |
| *huang* | 璜 |
| *ju-i* scepter | 如意 |
| *ko* | 戈 |
| *mi* (bow tip) | 珥 |
| *pêng* | 琫 |
| *pi* | 璧 |
| *pi* (scabbard chape) | 珌 |
| *tsun* | 尊 |
| *ts'ung* | 琮 |
| *wei* | 瓅 |
| *ya-chang* | 牙璋 |
| *yüan* | 瑗 |
| *yüan-lê* | 圓瓅 |